⟫⟫ WELCOME
TO THE ARTIST'S GUIDE TO PHOTOSHOP

PHOTOSHOP'S SECRETS REVEALED

Welcome to the first in our brand-new series of *Artist's Guides* – unlocking the powerful tools of the creative suites you use and helping you to produce your best art ever. In this edition, you'll discover techniques for Adobe's fantastic Photoshop application that will allow you to develop your skills into new areas – and learn tricks that will enable you to get creative faster and with better results.

Brought to you by the same superb creative team as *Digital Arts* magazine, our selection of the best digital artists from around the world reveals how they have created the incredible artworks you see throughout this edition. Follow step-by-step as they detail their favourite ways for producing art and illustrations with a wealth of different looks.

Alongside these tutorials, you'll also find inspiring guides to the latest hot styles in areas such as digital painting and photomanipulation – plus a wealth of tips as artists across a wide range of traditions disclose the secrets of how they come up with their best ideas.

To help you've complete these tutorials, we've compiled their project files into a handy resource – plus given you over £750 of amazing stock images and Photoshop video training. There's far more than could possibly fit on a CD, so we've created a Download Zone just for readers of this edition to gain access to these files. See page 162 for details.

The Artist's Guide to Photoshop is your handbook to becoming a better digital artist. Get ready to be inspired!

To discover how Markie Darkie created this image see page 122.

> CONTENTS
INSIDE THE ARTIST'S GUIDE TO PHOTOSHOP

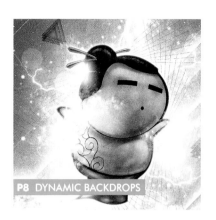
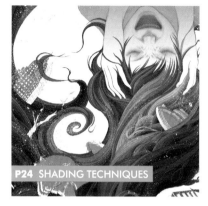
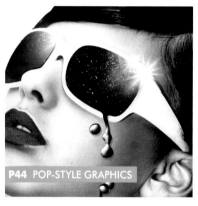
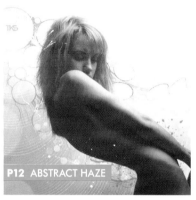
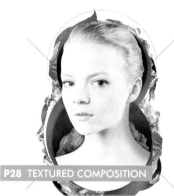
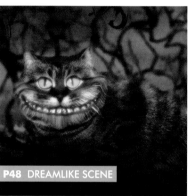
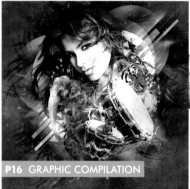
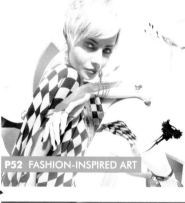
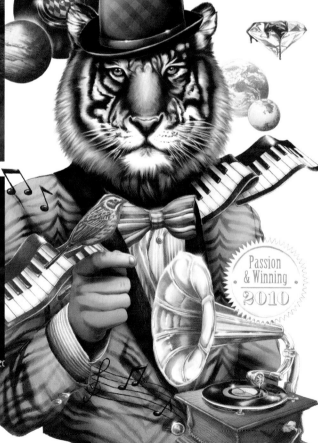
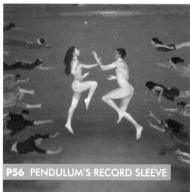

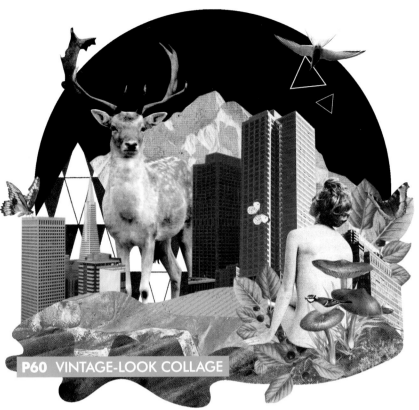

P60 VINTAGE-LOOK COLLAGE

INSIDE

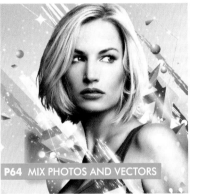

P64 MIX PHOTOS AND VECTORS

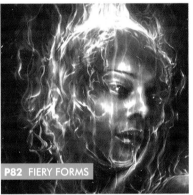

P82 FIERY FORMS

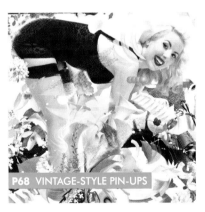

P68 VINTAGE-STYLE PIN-UPS

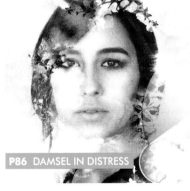

P86 DAMSEL IN DISTRESS

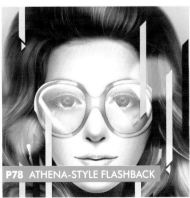

P78 ATHENA-STYLE FLASHBACK

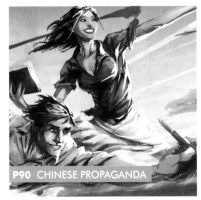

P90 CHINESE PROPAGANDA

CONTENTS

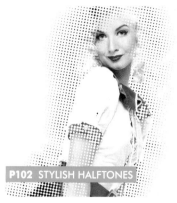

P102 STYLISH HALFTONES

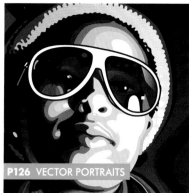

P126 VECTOR PORTRAITS

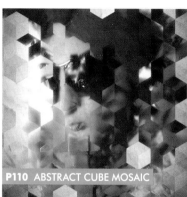

P110 ABSTRACT CUBE MOSAIC

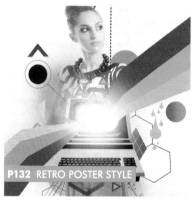

P132 RETRO POSTER STYLE

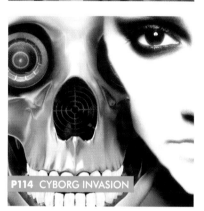

P114 CYBORG INVASION

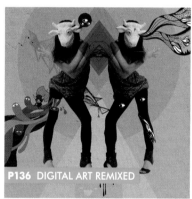

P136 DIGITAL ART REMIXED

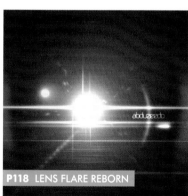

P118 LENS FLARE REBORN

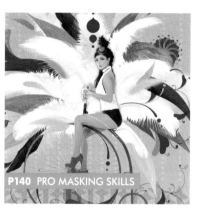

P140 PRO MASKING SKILLS

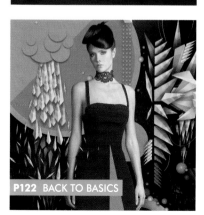

P122 BACK TO BASICS

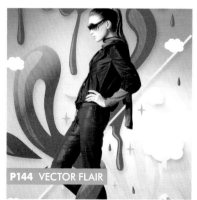

P144 VECTOR FLAIR

EDITORIAL
Editor Neil Bennett
neil_bennett@idg.co.uk
Art editor Johann Chan
johann_chan@idg.co.uk

With thanks to Jon Lysons

ADVERTISING
Group advertising manager
James Poulson jamesp@idg.co.uk
Deputy group ad manager
Selen Sevket selen_sevket@idg.co.uk
Sales executive Michael Fletcher
michael_fletcher@idg.co.uk

Contact *Digital Arts* advertising
on 020 7756 2835

MARKETING
Assistant marketing manager
Emma van Beurden
emma_vanbeurden@idg.co.uk

PRODUCTION
Head of production Richard Bailey
richard_bailey@idg.co.uk
Deputy production manager
Fay Harward fay_harward@idg.co.uk

PUBLISHING
Editor-in-chief Mark Hattersley
mark_hattersley@idg.co.uk
Publishing director Mustafa Mustafa
mustafa@idg.co.uk
Managing director Kit Gould

PRODUCTION SERVICES
Printed by St Ives (Roche)

SUBSCRIPTIONS/BACK ISSUES
Call the hotline on 01858 438 867

ADDRESS
101 Euston Road, London, NW1 2RA
Tel: 020 7756 2800
Fax (ads): 020 7756 2838

IDG COMMUNICATIONS

LIGHTING EFFECTS

MASTER LIGHT AND ILLUMINATE YOUR IMAGES

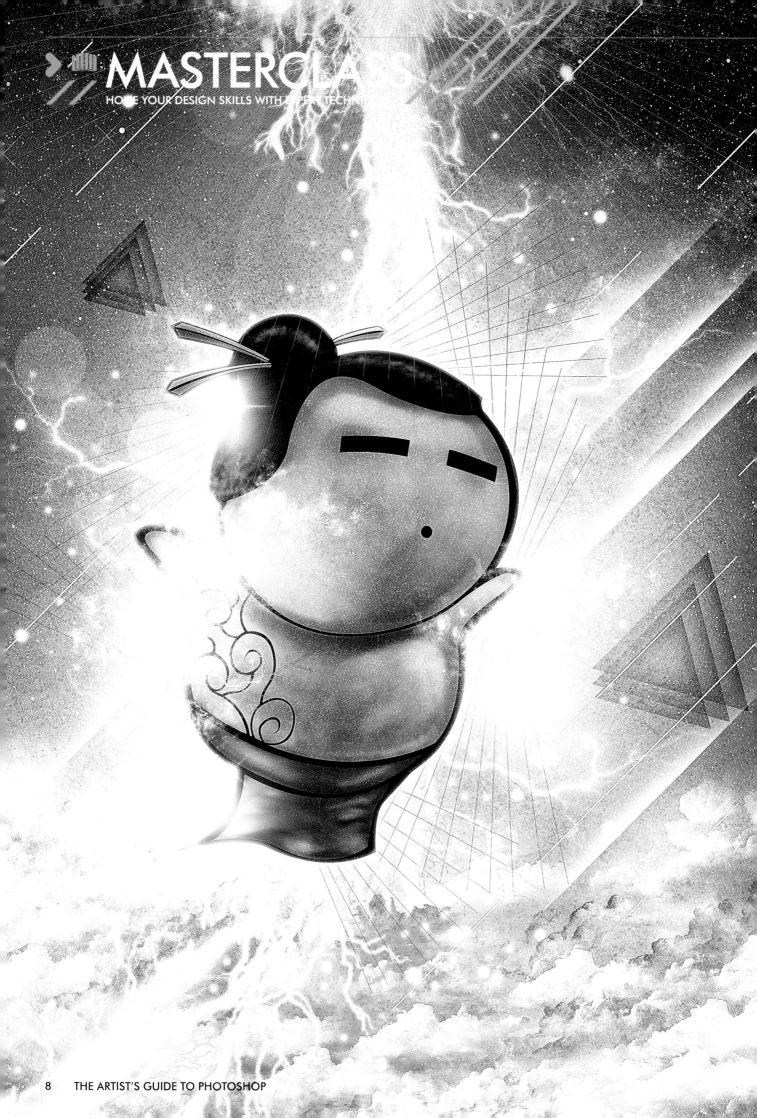

Create dynamic backdrop lighting

Take your lighting effects to the next level, creating a deep, rich background for this fantastic rising sumo wrestler image

small character can tell a big story – but traditional character art can be rather flat and one-dimensional, tending towards a cartoonish feel.

In this tutorial, Ricardo Ajcivinac shows how to recreate our brilliant cover image, and how to give your character art extra punch by using lighting and layer styles.

The principle of this tutorial is to create a complex background with a focal point that hints at a story behind a character. Once you've mastered it, it's a highly versatile technique.

Light effects are very trendy these days but you can avoid clichés by mixing them with something different and interesting; the result will always be an amazing image that gets everybody's attention.

02 Download the cloud brushes created by JavierZhX on deviantArt at *bit.ly/5U9drV* then load them. Create a new layer and use the brushes to start creating some clouds in white and various tones of grey.

01 Create a Photoshop document measuring 934 x 1,280 pixels and fill the background layer with a greenish grey (#bec7bb). Paint this with a large yellowish grey brush (#c9c3ad), then create a new layer.

Set the blending mode to Soft Light and paint with a black brush around the top right corner, and white brush for the middle and bottom.

03 Create a new layer, and download the nebula brushes created by Matkraken from deviantArt at *bit.ly/8Bjqlw*.

Load the brushes as shown on the palette and use the different settings to make some stars in the sky. Next create sofog around the central area where we'll be placing the character.

04 Go to *bit.ly/412VkX* and download the lightning brushes created by *Adaae-stock. Load the brushes and paint lighting forks around the area where you are going to set your character. Double-click on the layer in the Layers Palette to open the Layer Styles dialog box. In the Drop Shadow menu, set the blending mode's opacity to 65%, the angle to 120°, and tick both the Use Global Light and the Layer Knocks Out Drop Shadow boxes. In the Outer Glow menu, set the blending mode to Screen, the opacity to 75%, the colour to solid, and the range to 50%. The drop shadow should be #ff7814, and the outer glow should be #fffecc.

05 Create a new layer and set the blending mode to Soft Light, then use a round brush to add some black in the corners. In a new layer, use an off-white brush to add some dots around the lightning, then copy the layer styles you applied in step 4.

❯

06 Create a new layer and, using the polygonal lasso tool (**L**), make a selection like the one you see here – with one side straight at 45°. To do this, hold Shift and move the cursor to create a perfectly angled line. Now pick a round white brush and brush a little around the straight line.

07 Repeat Step 6 until you have a number of striking diagonal lines going across the image like the example shown above.

Open the Layer Style dialog and in the Outer Glow menu, set the blending mode to Screen, the opacity to 77%, the colour to solid, the technique to Softer, and the range to 30%. The glow's colour should be #ff0000.

08 Create a new layer and, using the Polygon tool (**U**) set to three-sided shapes, create a triangle. Set the layer fill to 0% and its blending mode to Overlay. In the Layer Styles palette set the values to those shown in the screengrab. Repeat this three times to get three triangles in separate layers.

09 Open *abstract lines.psd* from the project files, and copy-and-paste these into the area where the figure will be. Set the layer's opacity to 17%.

10 Create a new layer and make some white lines at a 45° angle, using the Line tool (**U**) set to two pixels wide. As in step 6, hold Shift to make a straight line. Now the background is completed.

11 Now open the Rise of Sumo character from the project files, copy it and place it where the abstract lines are so that it's above all the previous layers. With the Magic Wand tool (**W**) make a selection around the character and invert the selection (**Cmd/ Ctrl + Shift + I**), create a new layer and fill the selection with black.

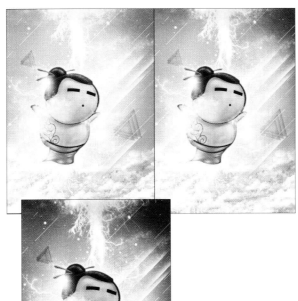

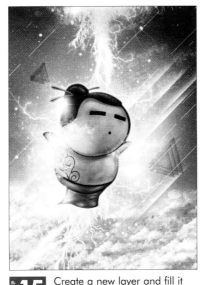

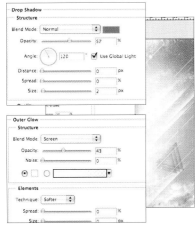

12 Set the layer fill to 0% and open the Layer Style dialog. In the Outer Glow menu, set the blending mode to Screen, the opacity to 75%, the colour to solid, the technique to Softer, the size to 16 pixels, and the range to 50%. The colour should be #c6faff. Set the Inner Glow palette's settings as shown immediately above, in #fefecc.

13 Create a new layer and use the Matraken Nebula brushes to add some stars and fog around the character and the top. Add the layer styles shown in these screengrabs (drop shadow #ff570d, outer glow #fffecc).

14 Create a new layer and set the blending mode to Color. Add some red and blue around the character's head and the top lightning with a round brush. In a new layer, set the blending mode to Soft Light, and paint a little around the top right corner with black. Create another layer and do the same, this time adding more black around all the corners and some around the character.

15 Create a new layer and fill it with black. Add some noise (**Filter > Noise > Add Noise**) and set its opacity to 40%, then erase small areas around the character and the top and bottom lightning. Now go to File and save your image as a JPEG document.

16 Now open the JPEG file you created and download the free Actions set 50 Photoshop Postwork Actions by Manicho from *bit.ly/6700w9*. Experiment with these to get different colour results: when you've found one you like, you've finished. ■

INFO RICARDO AJCIVINAC

> Designer and art director Ricardo Ajcivinac works at TBWA Guatemala. He combines Adobe Photoshop with traditional illustration and graffiti principles to create pieces that jump off the screen. Ricardo is also a graffiti writer and has a blog that he uses to showcase street art from all around the world.

CONTACT
• hemisferio-urbano.com/portfolio

TIME TO COMPLETE
• 2-3 hours

SOFTWARE
• Adobe Photoshop

PROJECT FILES
• Download the files from *theartistsguide.co.uk/downloads*

> **LEARN** OVERLAY EFFECTS

Create a euphoric abstract haze

Inject a depth of emotion into simple photography

O t doesn't take a wealth of graphic complexity to produce an image charged with meaning. In this design, self-employed artist Tom Starley uses basic colours, shapes and brush strokes to create a well balanced, euphoric image with a hint of the fetal about it. This isn't a technically complex piece – the original photograph does most of the work, but its graphic accessories enhance the emotion that is hinted at in the original.

The techniques in this tutorial will teach you how to subtly use Overlay effects and Selective Color to change the mood of your image. You'll also learn how to place shapes to aid visual abstract design, how to use brushes to aid movement through the composition, and how to add depth to the foreground. We'll also throw in a great trick to mask hair.

01 First off, download the In The Moment brush set from the Download Zone and double-click to install it. You'll need a model shot, preferably one with a limited tonal palette. I've gone with a nude from iStockphoto that you can buy here: *bit.ly/8XssvN*.

> **INFO**

TIME TO COMPLETE
• 2-3 hours

SOFTWARE
• Adobe Photoshop CS4/5

PROJECT FILES
• Download the brush set from *theartistsguide.co.uk/ downloads*

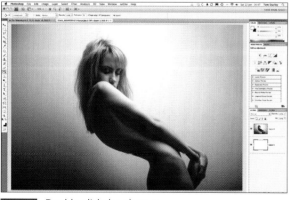

02 Double click the photo to unlock it. In Photoshop, create a new layer beneath it. Fill this layer with white. Simple.

03 Now we are going to cut out our model and paste her onto a new layer but also keep her background beneath. Select the photo, zoom in (**Cmd/Ctrl + +**) to 300% then hit (**P**) to select the Pen tool. Carefully create a path around the woman, ignoring any wayward strands of hair – be ruthless, as we will add them back in later.

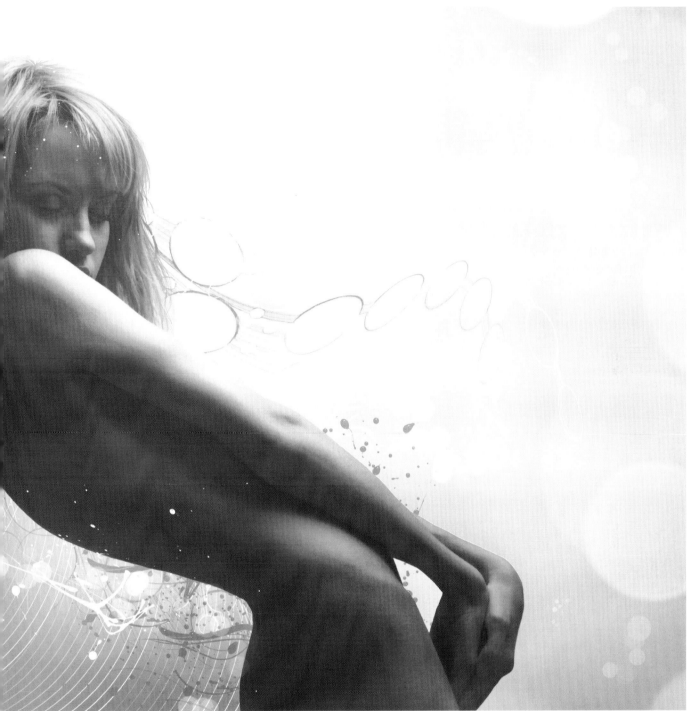

04 Once you've created a path around the woman, Right-click in the middle of her, then choose Make Selection. Hit OK. This separates the two images. Hold **Cmd/Ctrl + X** to cut, and **Cmd/Ctrl + V** to paste into a new layer. Reduce the opacity of the photo background to 64%.

05 Now we can add any hairs back to the model's head. Turn off all layers except for our cut-out model. Select the Smudge tool, use brush sizes 1 or 2, set the strength to 95% and select Sample All Layers in the Options bar.

LIGHTING EFFECTS

06 Re-draw the strands of hair that couldn't be cut out with the Pen tool. Going with the flow of her hair, flick your mouse or pen across the severed tips to re-draw hairs (the more the better). Once this is done, turn the other layers back on.

07 Next we're going to add colour to the design using the Overlay Blend Mode – select this either in the Layers palette drop-down menu or by going to **Layer > Layer Style > Blending Options**. Create a new layer, fill it with yellow (#ffff0), reduce the opacity to 16% and set the Blend Mode to Overlay. Mmm, yellowy.

08 Create a new layer and use the Brush tool to softly scatter pink (#ffe02b1) around the image. Reduce the opacity to 37% and set Blend Mode to Overlay. Repeat the above process over the model's body with a blood red, adjusting the opacity accordingly. Set to Overlay. Group these layers and keep them at the top of your document.

09 Now we've set the scene and added the colour overlays, we can start to add the abstract brushes and shapes to the design. Instead of giving you precise instructions as to where to place these effects, the following steps and tips will give you the basis from which to work using your own artistic licence.

> This handy box allows you to quickly select the tool you wish to use

10 Locate one of the paint splatter brushes provided in the Download Zone. Create a new layer above the model and add a couple of splatters around her back. I've used white for this but you can use any colour you like.

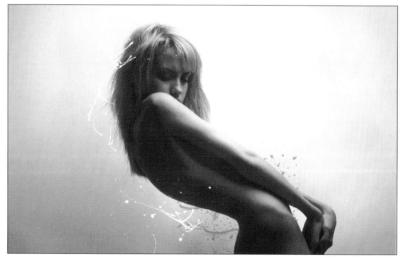

11 Using the brushes provided, place more splatters and shapes around the model in an aesthetically pleasing way. Alter their colour, duplicate or rotate them, or warp the applied brush to make the shapes fit the contours of the model's body. Make sure you create a new layer for each brush as this will give you total control. It also allows you to remove any brush layer later on.

12 Now add a layer under the model and repeat the above, experimenting with the brushes provided. Try not to go over the top with effects, less is more. The main point of focus is the model, so make sure your effects don't drown her out. Don't worry about getting an exact likeness to my example, just experiment and have fun.

13 If you're not happy, stop. Take a break, have a think, come back to the piece later and experiment with it until you are. I find listening to relaxing music helps me get in the right frame of mind. Try and make your brushwork fluid, as if it's really there in the image.

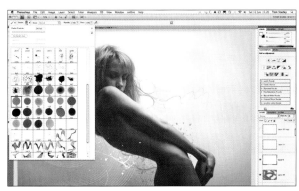

14 Now you've added the colour and the shapes, we can create the orbs of light that look like lens flare. Create a new layer above the model and set its Blend Mode to Overlay. Locate one of the orb brushes, set the size quite large, then just flick the brush around the page.

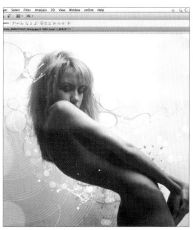

15 Repeat the above with a smaller size brush. This is very simple yet effective and is a great brush for adding depth to an image. A lot of effects like this are very easy to apply, but add so much to the design.

16 So you've added everything now and it's looking great, but you want the image to pop just that little bit more. You may be thinking that the colours could be brighter or some don't work at all. In this case, navigate to the Adjustment Layer panel and at the top of your stack, add a Selective Color layer (**Layer > New Adjustment Layer > Selective Color**).

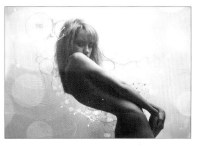

17 Set the Selective Color layer to work on all the layers beneath it. This allows you to alter each colour in your design easily – go through all the options and adjust them until you get the look you want. Then you're done. Export and send the image to everyone you know (including me), upload it to a website, or send it in to *Digital Arts*. ∎

PROFILE TOM STARLEY

> "Art has always been my thing," says Tom Starley, from Stratford, Warwickshire. "I've always loved mixing creative thinking with modern technology."

The 25-year-old graphic and web designer runs his own business besides taking on freelance jobs for a range of companies, having been self-employed for six years. In his work, the tech-savvy designer likes to play with different styles, amalgamating them and pushing boundaries with shapes and composition.

CONTACT
• tkstarley.co.uk

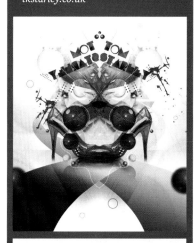

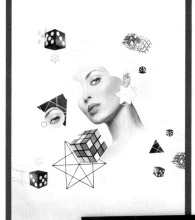

Many of Tom's other design explorations, **above** and **right**, follow an abstract theme.

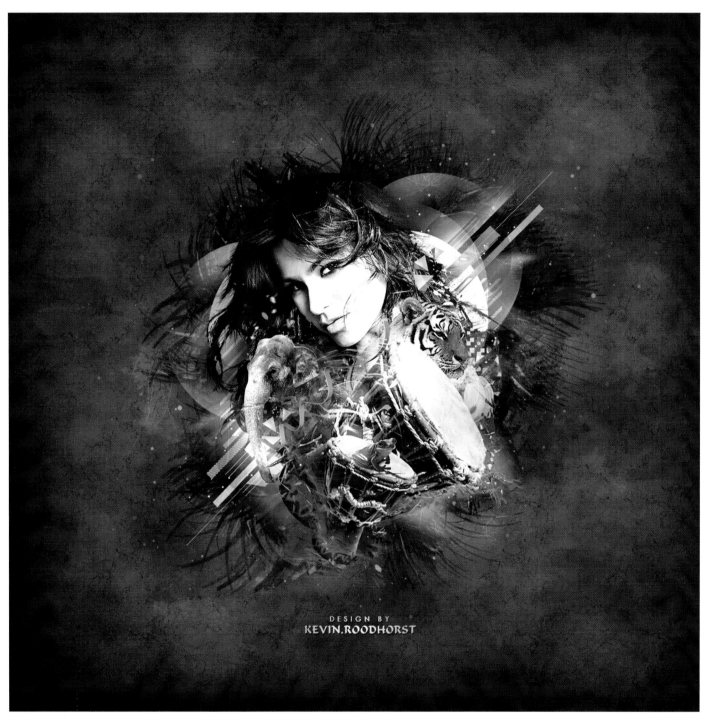

DESIGN BY
KEVIN.ROODHORST

> **INFO**

TIME TO COMPLETE
• 8-9 hours

SOFTWARE
• Adobe Photoshop & Illustrator

PROJECT FILES
• Download the files from
*theartistguide.co.uk/
downloads*

> **LEARN** COMPOSITE IMAGES

Lighting effects

Work with layered photographs and simple effects to create
a textured graphic compilation

ant to merge a number of
images seamlessly into one
design? In this tutorial, Kevin
Roodhorst illustrates how to make
an Africa-inspired graphic compiled

from a number of photographic
elements. You will be shown how
to add several textures and effects,
including lighting effects, using
Photoshop and Illustrator.

01 In Photoshop, start with a dark background that has grungy textures. Download the images you want – I chose an elephant (*bit.ly/9SZhD1*), a frog (*bit.ly/9YoxOa*), bongos (*bit.ly/a0dLB4*) and a tiger (*bit.ly/cLyWHT*). You will also need a model shot. Paste them into the image and desaturate using **Image > Adjustments > Desaturate**.

> When merging black and white objects, adjust highlights and shadows to make the elements look like they fit together

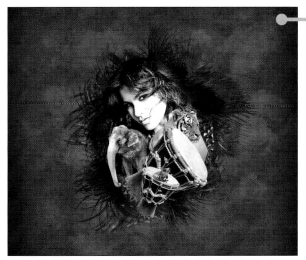

02 Now add a background image. Here, I wanted the hair of the model to combine with shapes in the background, so behind the objects I have placed a 3D design that I made using Cinema 4D.

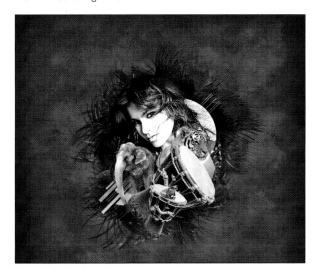

03 Begin to add more detail. Make some shapes in Photoshop, such as circles and lines, and copy them to the project. The purpose is to use these elements to focus attention on the objects.

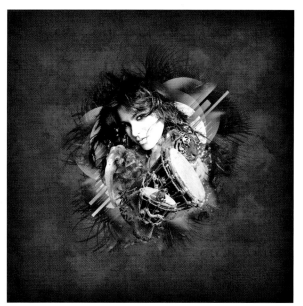

04 Try adding some small particles behind each object, to create more unity. Here I've used two different kinds of particles. One with the Lasso tool (**L**) in Photoshop, in which you grab the Lasso tool and select tiny particles and copy and paste them elsewhere. The other way is to create particles in Cinema 4D using the Explosion FX effect.

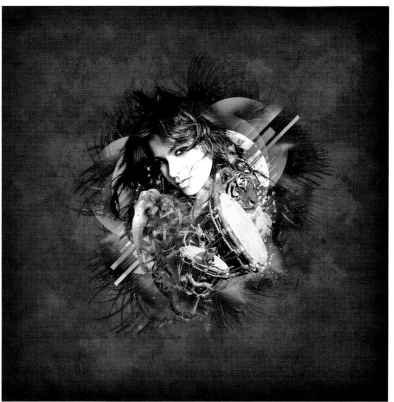

05 Create some light effects to add to the project. Go to **Layer > Layer Style > Blending Options** and set each light effect's Blend Mode to Screen, which should have a nice effect on the colours. Create other 3D shapes in Illustrator and place them in the image – the combination of Photoshop and Illustrator components should form a good balance of variation in the work. ❯

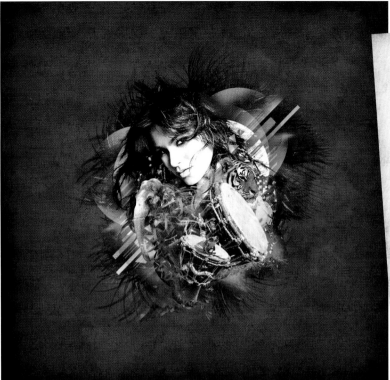

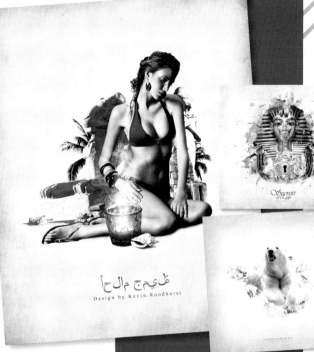

06 Add more vibrance to the design by adding layers of colour on top – I used four: red, green, brown and orange. For every colour layer, experiment with different opacities and blending modes. In this design I opted for a brownish hue to best fit with the African theme.

> Work coloured nuances and speckled effects into the image to give it texture and added interest

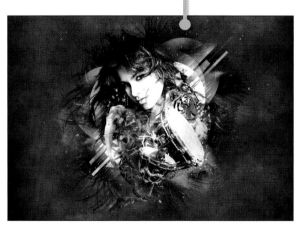

07 To highlight the light effects much more, increase the contrast in some places. Next, add clouds by going to **Filter > Render > Clouds**. Set the Blend Mode of this layer to Overlay, again by going to **Layer > Layer Style > Blending Options**. Around the design you can add all kinds of small particle and star effects.

PROFILE KEVIN ROODHORST

> Dutch 19-year-old Kevin Roodhorst is studying graphic design in Amsterdam, with hopes of moving on to an advertising agency or into the world of freelancing when finished.

Kevin likes to experiment with different graphic effects on photographed subjects and in particular using Cinema 4D to make 3D objects, light effects and renders.

CONTACT
• *kevinroodhorst.com*

Examples of Kevin's experimentation with effects and textures on layered stock or photographed images: **Above** *Beautiful Dreams;* **top right** *Secrets of Egypt;* **above right** *Cold Memories;* **below** *Ancient Rituals.*

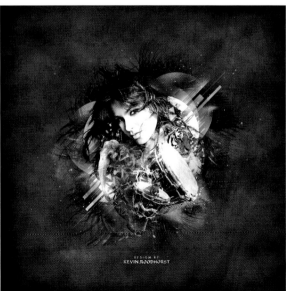

08 Use the Sharpen tool (**Filter > Sharpen > Sharpen**) to clarify the design in specific places, like the eyes of the model, the elephant and the tiger. Then check if more can be done using the brightness, contrast and colour options, found in **Image > Adjustments**. In this case I decreased the colour using Vibrance. ∎

abduzeedo

Create a children's book illustration

Fabio Sasso shows how to give a soft edge to composited images

Transforming run-of-the-mill stock photos into dreamy, fantastical compositions is easy when you know how.

In this brilliant tutorial, Photoshop wizard Fabio Sasso puts layer masks and Photoshop's built-in filters to good use to create a beautiful, enchanting image that wouldn't be out of place in a children's book.

Before you start you'll need to download your stock images – Sasso has bought images from Shutterstock (*shutterstock.com*), although you can also use similar images of your own.

The girl image is at *bit.ly/91S4Kx*; the moon is at *bit.ly/7Nfwch*; some of the clouds are at *bit.ly/5qJMFc*. You'll also need a star flare; NASA (*nasa.gov*) is a good source for these.

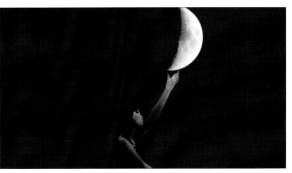

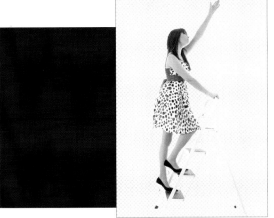

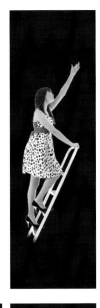

01 Open Photoshop and create a new A4 document. Fill the background layer with a very dark grey (#0d0e10). Import the image of a girl on a ladder you downloaded from Shutterstock (*bit.ly/91S4Kx*). Extract the backround using the Lasso Tool (**L**) or any other method. Then remove the back strut of the ladder as shown here.

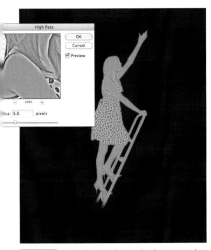

02 Duplicate the girl's layer and go to **Filter > Other > High Pass**. Set the radius to 5, and change the blending mode to Vivid Light. Then go to **Layer > Create Clipping Mask**. This will increase the amount of detail.

03 Add a layer at the top of the layer stack and go to **Layer > Create Clipping Mask**. Using a large soft black brush (**B**) paint over the girl. She will be almost touching the moon, so her face and arms should be shinier, while the bottom half of her body will be almost entirely in darkness.

To boost the contrast go to **Layer > New Adjustment Layer > Gradient Map**. Change the blending mode to Soft Light. This adjustment layer will also need to be a clipping mask.

04 In a new layer, place the photo of the moon that you dowloaded at the start. Change the layer's blending mode to Screen. Go to **Image > Adjustment > Hue/Saturation**, select Colorize, and make the moon bluer. Also go to **Image > Adjustment > Brightness/Contrast**. Increase the brightness to 54 and the contrast to 51.

05 Fill a new layer with pink (ff80b6), then with a big soft brush, paint a light blur (61a5fb) where the moon will be. Change the layer's blending mode to Soft Light. This layer will be on top of the others.

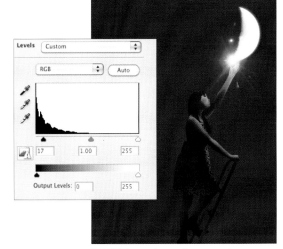

06 Duplicate the moon layer and go to **Filter > Blur > Gaussian Blur**, setting the radius to 10 – this will give the moon a nice glow. Now import the star flare. Change the blending mode to Screen and go to **Image > Adjustment > Levels**. Increase the black input to 15. With the Eraser Tool (**E**) delete all of the image except the flare.

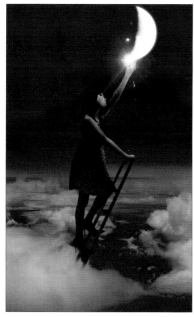

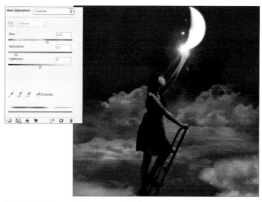

07 Open *IMG_1466.jpg* from the cover CD – this is a cloud photo taken by Fabio Sasso. Go to **Image > Adjustments > Brightness/ Contrast**. Reduce the Brightness to -5 and increase the contrast to 80. Also go to **Image > Adjustments > Hue and Saturation**. Select Colorize, then move the Hue to 270, reduce the saturation to 4 and the lightness to -12.

09 Go to **Image > Adjustments > Hue/Saturation**. Select Colorize, then increase the hue to 220, reduce the Saturation to 12, and keep the lightness at 0. The idea is to match the colour of the clouds.

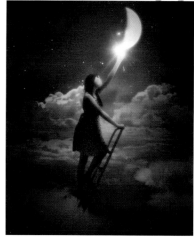

12 Add a layer at the top of the layer stack and use a large, soft black brush to paint the edges of the image. The idea is to create a subtle framing effect for the image.

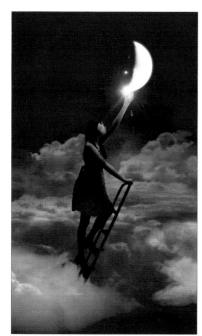

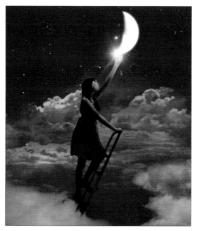

10 Open *stars.tif* from the cover CD, import the image and place it beneath the other layers but in front of the background. Change the blending mode to Color Dodge and the opacity to 80%. Also select the lens flare layer and go to **Image > Adjustments > Hue/Saturation**. Reduce the saturation to -60.

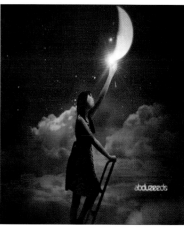

13 You can even add your own logo or pattern on top of the image. A nice tip for pattern overlay is to apply the Liquify filter and distort the pattern according to the image beneath – this creates a great effect. ■

08 Add more clouds to your composition: the idea is to create a fluffy horizon. You can use the cloud image you downloaded from Shutterstock at the start or any similar ones of your own – just be careful to make sure the colours fit in. Import the image and place in the document. Then with the Eraser tool (**E**) delete the edges of the image until it's well blended with the other clouds.

11 Now let's add a glow effect. Select all the layers and duplicate them, then merge the duplicated layers. Go to **Filter > Blur > Gaussian Blur**, setting a radius of 20 pixels. Change the blending mode to Screen. With the Eraser tool (**E**) delete most of the image, leaving only the areas that are illuminated by the moon.

INFO FABIO SASSO

❯ Based in Porto Alegre, Brazil, Fabio Sasso is a graphic and web designer. As well as running Zee, a small web-design studio, Sasso has an arts blog, Abduzeedo, which he uses for digital art experiments and tutorials.

CONTACT
• abduzeedo.com

SOFTWARE
• Adobe Photoshop

TIME TO COMPLETE
• 3 hours

PROJECT FILES
• •Download the files from theartistsguide.co.uk/ downloads

CHAPTER 2

TEXTURE EFFECTS

USE TEXTURES TO ADD DEPTH TO YOUR ART

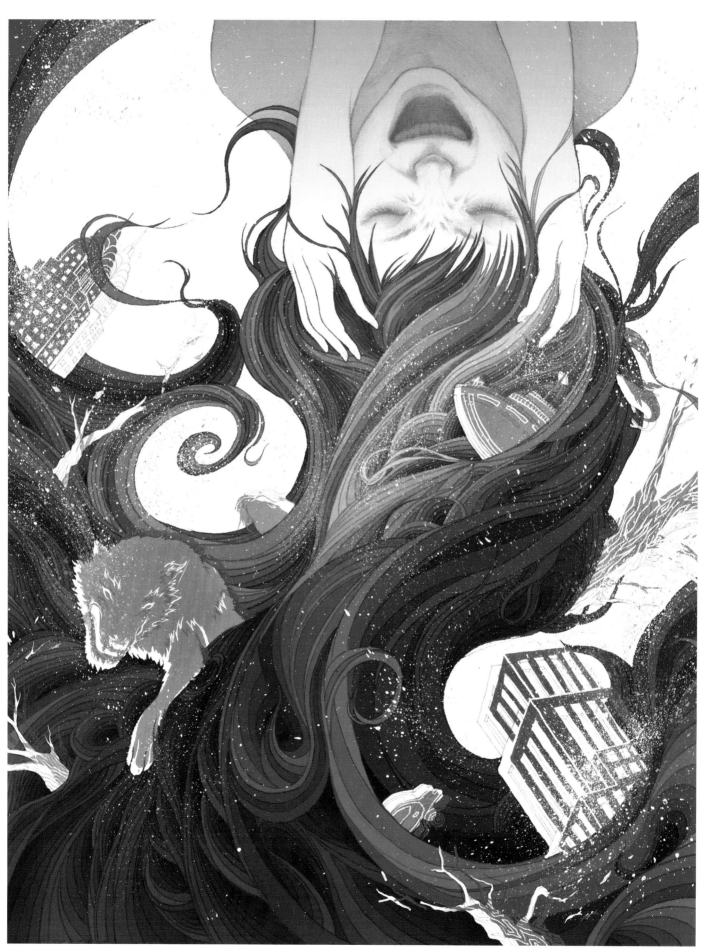

Learn gorgeous new shading skills

Take your shading to the next level using masks and selections, with **Yuta Onoda**

One of the hardest parts of Photoshop art – or indeed much other art – is creating subtle, detailed shading. However, layer masks make the process much easier, allowing you to select and modify certain areas without affecting the rest of your canvas.

In this tutorial, Yuta Onoda shows how you can transform a pencil sketch into a gorgeous, textured digital artwork using layer masks and

blending modes. You'll also learn how to add realism to your artwork by faking print offsets and paint spatters.

You can use any sketch for this tutorial, although you may find it easier to follow some of the steps if you use one that's as detailed as Onoda's. Note how in Onoda's sketch the face has a fair amount of subtle shading, while the hair and the elements in the hair are made up of straightforward linework.

02 Now change the black linework to blue. With the linework layer selected, click on the Channels tab in the Layers palette. At the bottom of the window is a button called 'Load Channel as Selection'. Click this, then return to the Layers tab and create a new layer. Now you can draw with any colours you want. Next, go to **Select > Save Selection**. Then invert the mask (**Cmd/Ctrl + Shift + I**).

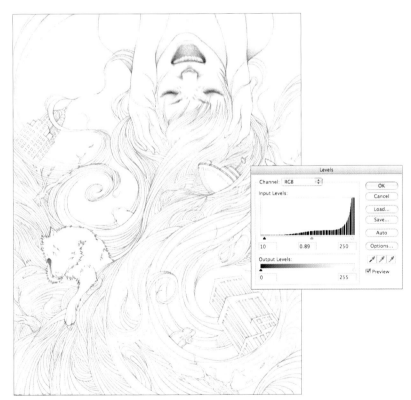

01 First, do a pencil drawing – this can be of whatever you like. I've found that quite detailed, intricate images such as this one work well for this technique. Scan in your sketch: we'll need the linework to be quite defined, so you'll need to adjust the levels of lightness and darkness (**Image > Adjustments > Levels**).

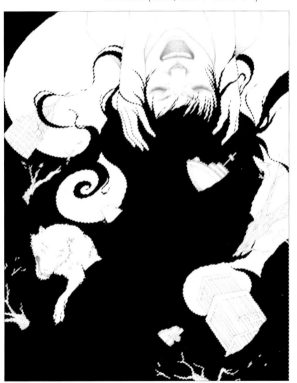

03 Start separating out the shapes – in this case, the waves, the objects and the figure – with masks. You'll need to use the same method as in step 2 to create a mask (fill the shape with black, load the Channel as a selection and then create a mask). Again, make sure you save each mask (**Select > Save Selection**) as you'll need them later on. ➤

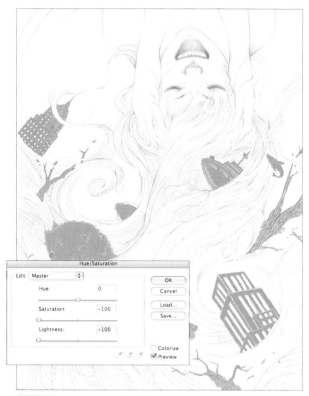

04 Now we need to fill the shapes of the objects. If you get bored of just using black to fill the space, you can use colours instead. Once you've finished the filling in, go to **Image > Adjustments > Hue/Saturation**, then change the saturation and lightness to -100. This will make all the colours you've used instead black.

06 Now we need to give more depth and some rich, subtle colour to the background (here, the waves). One of the simplest ways to do this is to duplicate the wave layer several times, and set each duplicate layer's blending mode to Multiply.

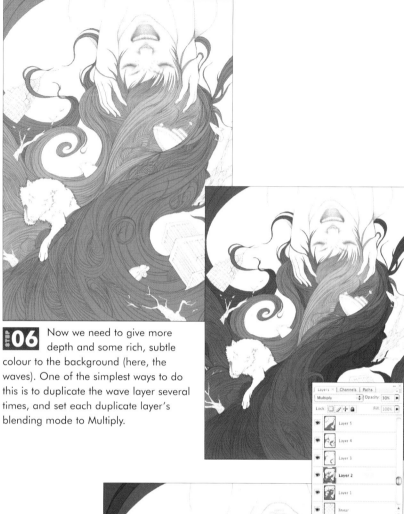

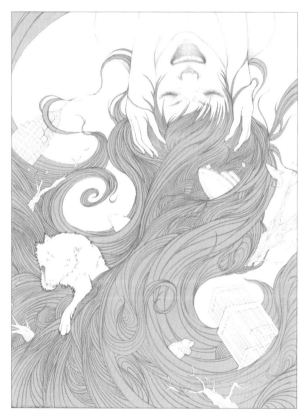

05 Once you've created all the masks, start colouring your shapes using the mask layer that you created for the detailed background (in this case the waves of hair) in step 3. To load the saved selection, go to **Select > Load Selection**.

07 Now set the opacity of each of these wave layers to between 25% and 30%, and start adding colour on each of these layers. The aim is to create a shifting, deep backdrop with subtly varied colours.

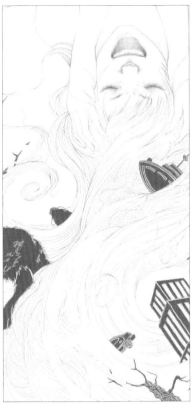

08 Now turn your attention to the objects. Make all the layers for the waves invisible, then add a new layer and load the mask for the objects that you created in step 3 (**Select > Load Selection**). Define the shapes by filling them with red.

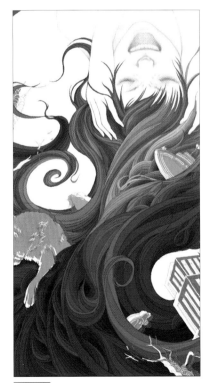

09 Now turn on all the layers you created for the background (here, the waves) and move the layers for the objects slightly, to create that offset effect.

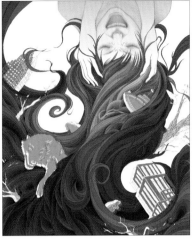

10 Make a new layer and load the mask for the figure that you created in step 3. Next use a gradient to fill the shape – here I've used colour #bb818b. Then set the layer's blending mode to Multiply and set the opacity to 80%.

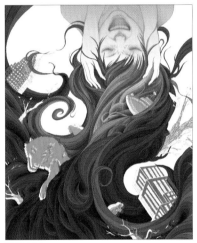

11 At this stage the colour on my figure is too bright; to knock the tone down, repeat the method from step 11. Add a new layer and set a gradient (colour #8d9db1). Set the layer's blending mode to Multiply and the opacity to 45%.

12 To create the spatter texture, I splashed black ink onto paper and scanned the image – the file is in our project files. Using the method from step 2, change the black to green and save it; then use the same method again to create a white splash effect.

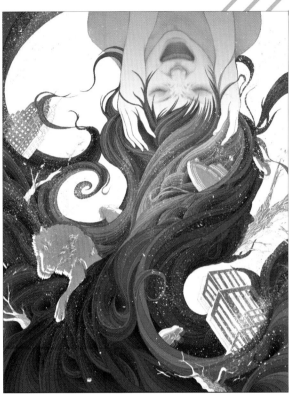

13 Finally, combine the green and white splash layers and import them into your canvas to finish your piece.

INFO YUTA ONODA

> Originally from Japan, Yuta Onoda has recently graduated from Bachelor of Applied Arts Illustration at Sheridan College, Canada. He has been shaping his art aesthetic through various forms of media, finding new avenues to express himself.

CONTACT
• *yutaonoda.com*

SOFTWARE
• Adobe Photoshop

TIME TO COMPLETE
• 15-20 hours

PROJECT FILES
• Download the files from *theartistsguide.co.uk/ downloads*

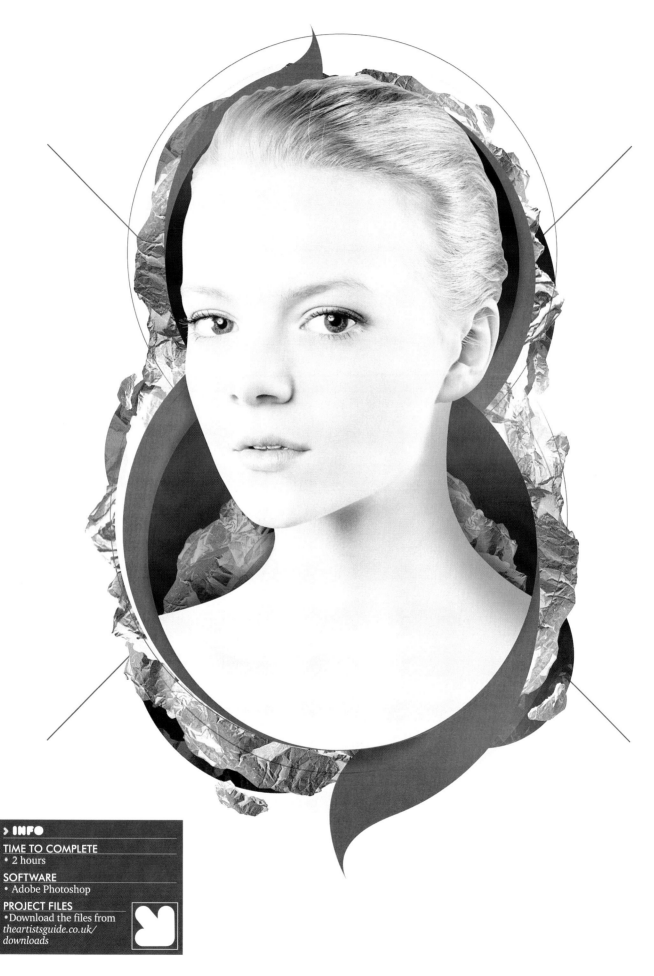

> INFO

TIME TO COMPLETE
• 2 hours

SOFTWARE
• Adobe Photoshop

PROJECT FILES
• Download the files from
*theartistsguide.co.uk/
downloads*

Texture effects for beautiful compositions

Use textures, layers and masking to add depth to your images

On this tutorial we will be taking a look at masking and how you can give your work a sense of depth using this technique, as well as layering textures and elements to help lift your piece – in this case using paper to create rock and mountain-like elements.

This tutorial is an example of how a few simple techniques can be used to create more elaborate illustrations using multiple layers, masking, the Pen tool, some basic lighting and one simple texture. Using the processes here, you will be able to apply the same techniques to your work, hopefully giving you the confidence to use masks and create your own textures to give greater scope to your work.

For this masterclass you'll need a headshot of a model. Max Spencer has used a shot by Pasi Lehtinen (*designsapiens.com*). You'll also need access to a digital camera and some paper, though we've included Max's photos of scrunched-up tissue paper in our project files.

03 Once you have finished tracing the paper ball, select the Marquee tool and **Cmd/Ctrl + click** the outline you've created in the Layers palette. This will bring up the outline you created as a selection. Click back on the layer of the image and simply copy (**Cmd/Ctrl + C**) and paste (**Cmd/Ctrl + V**) and your paper ball will now be on a layer of its own.

01 To create a textured background element for this piece, I've simply scrunched up some tissue paper into a ball: this is a good way of using up old pieces of paper lying around. Some great effects can be achieved using paper that already has images or scribbles on.

02 Import your paper texture to Photoshop. Desaturate the image using **Cmd/Ctrl + Shift + U**. Change the contrast if you feel your texture needs it. Now invert the texture by pressing **Cmd + I**. Once you're satisfied, select the Pen tool (**P**) and trace around the paper ball.

04 Open up the image of your model. Select the Pen tool (**P**) and trace the outline of the image. Try and be as accurate as you can; in this case I've purposely avoided cutting out her ponytail, taking into consideration the composition of the piece. Using the same technique as Step 3, put the cut-out of the model onto its own layer.

05 Create a new A4 document at 300dpi. This is where we use the Ellipse tool (**E**) to create our basic composition. I find circles easier to work with when laying out the different areas. ❯

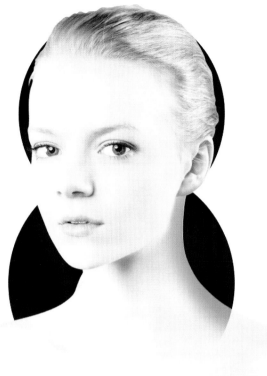

UNIQUE DIY TEXTURES

> Making your own textures is one of the easiest ways of giving your piece a unique edge. It's a great idea to have your own library; it helps keep costs down and you'll be able to use them when and where you want, as you own the copyright.

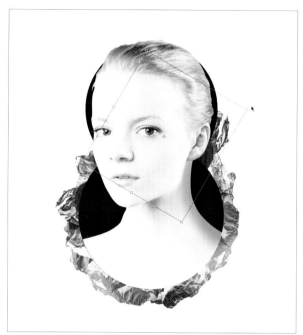

06 Open up the image of the model you cut out earlier and drag the cut-out layer into your new document on top of the circles you've created. Position the model where you want her to sit within your piece.

07 Click Add layer mask on the model layer on your new document.

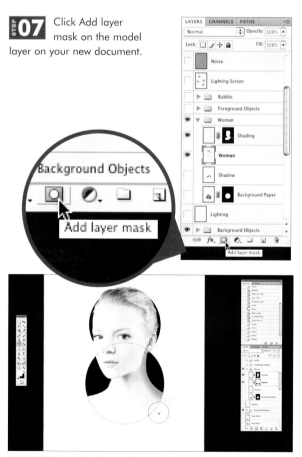

08 Select background shape the same way you selected the paper ball in Step 3. Perform a **right click > Select Inverse**. Select the Eraser tool (**E**) with a white foreground and black background and erase the shoulders and any other parts you don't want to find in the final piece.

09 Open up the image of your paper ball and drag the layer into your main document. Invert the paper texture and position the layer at the bottom. Select the Marquee tool (**M**) and on the paper ball **right click > Free Transform**. Position the ball so it peeks out behind the model. Create additional balls using copy and paste and place them on the canvas until you have a texture like the one shown above.

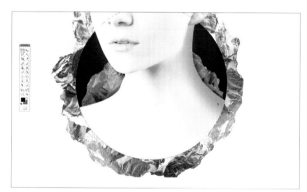

10 Using the same masking technique as in Step 8, you can add texture on the layers behind your model. I've used the same circle to mask in the paper ball texture. Using masks in this way is a great way to add depth to 2D pieces you've created.

11 Using the Pen tool (**P**), create some shapes that complement the flow of the piece. This is a great opportunity to add a splash of colour as at the moment the piece is pretty much black and white. Move the layer so it's just below the circles you created at the beginning.

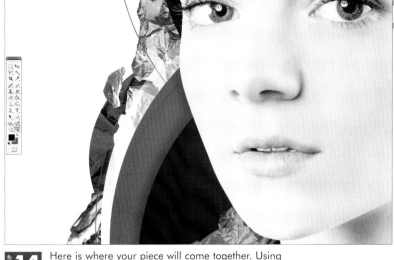

STEP 12 Create a new layer above the shape and change the opacity to 50%. Select your flowing shape the same way you did in Step 3. Choose a soft brush roughly 200px in size, making sure your foreground colour is black. Paint around the appropriate edges of your shape to create a shadow.

STEP 14 Here is where your piece will come together. Using the techniques learned in this tutorial, you will be able to add smaller details. Here, I've used masking techniques to add small bits of paper around the edges as well as some larger circles which have had parts erased away.

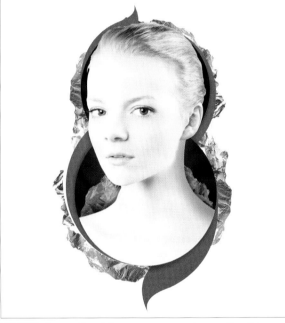

STEP 13 Repeat Step 12 to create more shapes. Use this stage to tweak the final placement of elements.

STEP 15 To finish the piece, create a layer above all of the other layers and set the blending mode to Screen – this is located in the top left-hand corner of the Layers palette; the default is Normal. Choose a large, soft brush between 600 and 1000px wide and a vivid colour, in this case orange. Apply the colour around the composition in places that you want to highlight or bring some colour to. ∎

PROFILE MAX SPENCER

❯ An illustrator and graphic designer currently living on the coast of south-west England, Max Spencer's work consists of central composition, bold images and lots of textural detail, while maintaining a sense of minimalism. Max has been freelancing for the past three years and has worked on projects for Nike, Sprite, Charles Schwab and The KDU, among others.

CONTACT
• *maxspencer.co.uk*

Far left: Part of the *Plastic Porcelain* series, this image was created simply as a visual experiment working with new textures and compositions.

Left: *Skully* was created for a short story illustrating the theme of time and space.

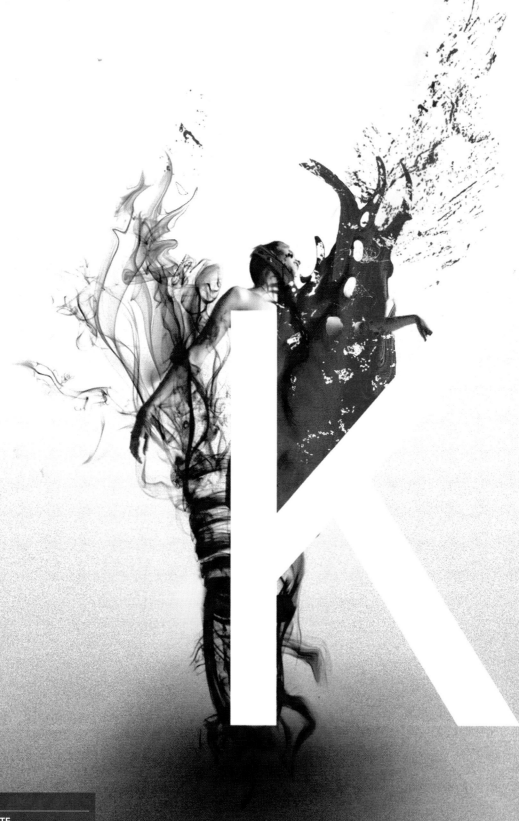

> **INFO**

TIME TO COMPLETE
• 2-3 hours

SOFTWARE
• Adobe Photoshop

PROJECT FILES
• Download the files from
*theartistsguide.co.uk/
downloads*

Organic smoke and spatter

Create stunning images and compositions filled with movement and realistic textures with just a few easy tools and techniques

It doesn't take much to make a great looking piece if you have a strong initial concept and some nifty tricks to cover the technical side. In this tutorial Arturas Petkevicius shows you quick and easy techniques ranging from the Warp tool to clipping masks and adjustment layers to create a stunning final image. While the techniques seem simple at first glance they offer many opportunities: you can use them to create a sense of movement in your composition, to create realistic effects and textures, or to add a specific sense of colour to your final composition. Best of all, these techniques are flexible and easy to learn.

Arturas has provided a self-shot photo that forms the basis of this tutorial. You can find this image in our project files.

02 Download Falln-Stock's Smoke Brushes sets from *bit.ly/9bk6K2* and *bit.ly/coB3LE*. Use them to add smoke to the left side of the photo. Erase parts of the legs and add smoke in-between for a more dynamic effect. Use the Brushes window (**F5**) to adjust the angle of the brush stroke to fit with the flow of the photo.

STRONG CONCEPTS

> Having a solid initial concept is crucial to a great piece. Spend a lot of time sketching and brainstorming — in the morning, in front of the TV — great ideas always come at unusual times, so have your sketchbook handy with you everywhere.

03 Ensure you put each brush stroke on its own layer. To make the smoke more realistic, select the strokes close to the arm and use the Warp tool (**Edit > Transform > Warp**) to play around with the positioning of the smoke. Use the Eraser tool (**E**) to delete parts of the smoke around the arm to give the composition more depth.

01 First we will need to find the right image to work with. Try getting an image that has some sort of a story in it, this always adds to the effect. I've used a photo that I shot, which you can find in the project files if you want to follow this completely, or you can use one of your own. Mask it out with the Pen tool in Photoshop – although I also used Vertus' Fluid Mask 3 plug-in to make the job easier.

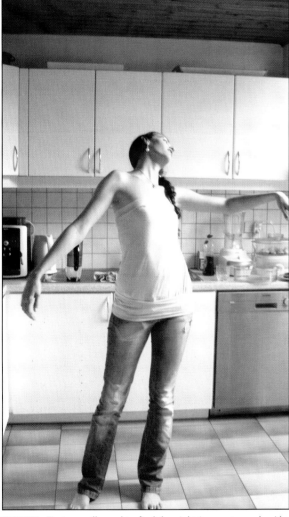

04 Add a large letterform in front of the figure to add visual interest. I've used a 'K' in a font comprised of straight lines to contrast with the organic movement of the other elements.

Next we'll do the paint effects. Download the stock image of a red bird by rml-stock from *bit.ly/cm5cgX*. Load it into Photoshop and mask out the background. Copy and paste the image on the right side of the stock and rotate it to an interesting angle that works with the composition, erase the rest. ▶

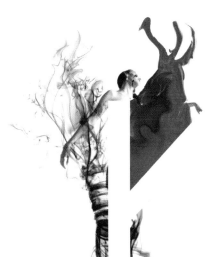

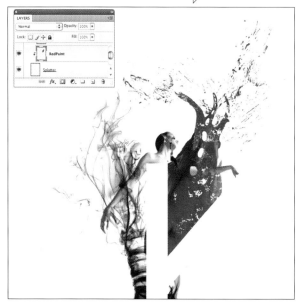

PROFILE ARTURAS PETKEVICIUS

❯ Based in Canada, Arturas Petkevicius is a freelance designer and illustrator. He's currently studying Graphic Design at Ontario College of Art and Design, graduating in 2014. He says: "My style varies all the time. Once I find that I can't push my design further I move on and find something better."

CONTACT
• arturasp.com

Be Master Of Mind Rather Than Mastered By Mind, 2010: an experimental mixed media piece.

05 The red paint is still not convincing enough. Use the **Liquify** filter (**Filter > Liquify**) and play around with the image by adding swirls and pushing it in different directions. This will add more flow to the image.

07 Next we want to add some splash effects at the top. Do this by creating a new layer and, using a splatter brush, paint with white in the top area. Next load the image we used for the red paint, copy and paste it as a new layer on top of the splatter, **right click** and create a clipping mask (**Layer > Create Clipping Mask**).

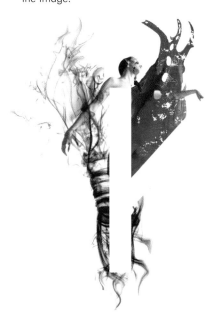

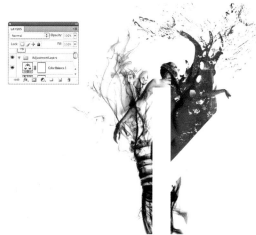

06 Still working with the paint effect, begin by creating holes with the Eraser tool (**E**) around the arm. This will create the feeling of the arm coming through the paint and thus give more interest to the image.

The image still looks pretty flat. To change this, select a splatter brush from the Eraser tool and add a few brush strokes.

08 Create some more clipping masks and using the Move tool (**V**) play around with the positioning. You can also use **Free Transform (Edit > Free Transform)** to scale, rotate and distort the clipping mask. When I'm finished, I like to use a colour adjustment layer (**Layer > New Adjustment Layer > Colour Balance**) to add unity to the image. ∎

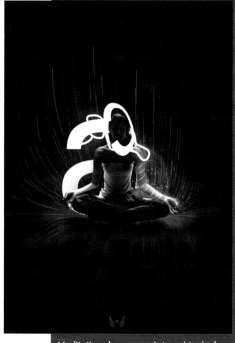

Meditation showcases Arturas' typical mix of a haut-graphic style with otherworldly textures.

CHAPTER 3
># LAYERS &
BLENDING MODES
MASTER PHOTOSHOP'S COMPOSITING TOOLSET

Masters of Collage

There are myriad ways to exploit Photoshop's incredible power. Here four experts tell **Graeme Aymer** their techniques for outstanding compositions

Collage techniques, arguably, have been around since humans started drawing on paper, but the art form really took off in the early 20th century. Popular among the Russian constructivists, European surrealists and Dadaists, the collage enabled its exponents to make their point by recontextualising 'real' images. For some, the motivation was political; others just wanted to make an aesthetic statement.

Photoshop revolutionised collage and photomontage, and it's easy to see why. "If it wasn't for Photoshop I'd probably be doing collage on my studio floor," says London-based Caroline Tomlinson. "Photoshop means I can create wherever I am."

"You can take any image that you have, you can chop it up and put it back together, you can throw paint all over it and wipe it right off," adds Rob Shields from Philadelphia. "Using Photoshop gives you a lot more freedom."

Some artists see the wealth of filters in Photoshop as an excuse to indulge in 'whizz-bang' effects just because they're there – but the best practitioners know it's wise to use them in moderation.

EXPRESS YOURSELF

This doesn't mean eschewing Photoshop's tools, as the well-considered use of effects can enhance your composition even if you're going for a hard cut-and-collage style.

The artists we've featured here take a number of different approaches to creative expression. Caroline's approach is explicitly reminiscent of early 20th-century collage artists. For some, including Andrew Williams

from Toronto, photorealism is the order of the day, while others, such as Rob, create crafted, blended pieces.

Paris-based artist Brice Chaplet, better known as Mr Xerty, takes the best aspects of the absurdists to create finely blended work that demands wonder and a pinch of salt in equal measure. "I love textures, drips, scratches, vintage stuff, old sepia postcards," says Brice. "With collage you can use all of these elements and mix it together."

"You can bypass all the technical skills you need to be an artist," adds Rob. "You don't have to learn how to draw hands and feet, which is a really long process."

The approaches are as different as the reasons for creating collages in the first place. To provide a snapshot, we've spoken to these innovators to find out what they do, and how.

Right *Dr Parnati* is an example of Brice Chaplet's approach to mixed media, which entails both photo-manipulated imagery and vector illustration.

Centre right Caroline Tomlinson created a work for the first anniversary of Jelly, the agency that represents her.

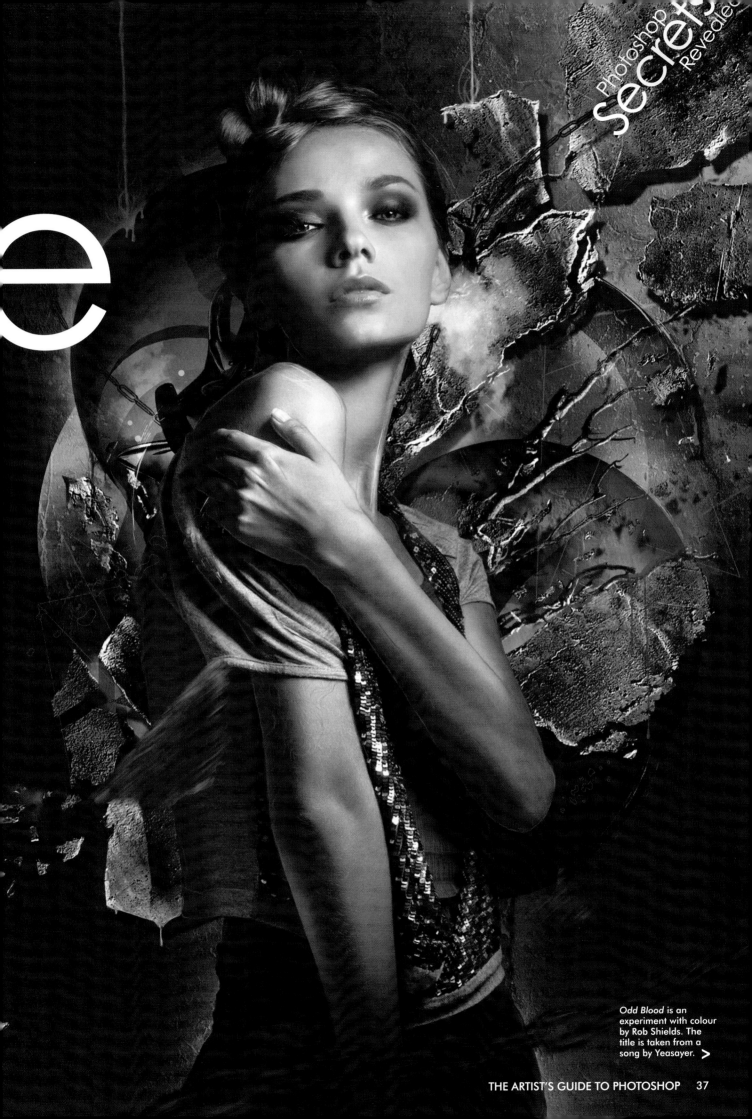

Odd Blood is an experiment with colour by Rob Shields. The title is taken from a song by Yeasayer. >

 It's all about Peter Blake, as far as Caroline Tomlinson is concerned. He is "the king of collage!" she effuses. She is equally enthusiastic about early 20th-century Russian constructivism and surrealism.

Following undergraduate and master's degrees at Norwich School of Art and Design (now Norwich University College of the Arts) and Central St Martins respectively, Caroline has been working in London as both designer and illustrator. The Royal Mail is one of her most important clients.

Collages make up most of her work, and for these she uses photographs bought from antiques markets or ones she has taken herself. This, and her love of scanned hand-drawn elements, add a tactile element to her work. "If I didn't do that, it would feel to me as if it lacked emotion," she explains. "Sometimes I can get a little too particular about straight lines and compositions. Once I add a scribble or a paint splodge, it feels less sterile."

Caroline begins by making notes on the job at hand, highlighting any keywords that appear. This is a way to set the tone of the work. Then she will sketch "a very scribbly scamp of an idea", which helps create a shopping list of images to seek from her collection.

As her work has an almost pre-computer-era feel, she is not that concerned about the pixel-precision of cut-outs. "A couple of years ago I considered it really important," she says. "Now I don't mind the imperfection of an inaccurate cut-out. I actually prefer it and want to push this further, almost to see how far I can go before it starts to look unfinished. I'm moving towards a slightly looser and more surreal approach."
carolinetomlinson.com

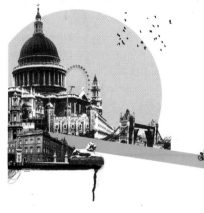

1.

2.

3.

To celebrate London's new Cycling Superhighways, Caroline experimented with a number of layouts to show the relationship between existing green road markings, cyclists and the city.

5 Top tips Caroline Tomlinson

1. Don't be afraid to experiment. There are many different ways to combine images; try them out.

2. Get messy! Precision and tidiness are not always the answer.

3. Make sure you have a central idea. A computer may make your image look faultless, but it won't provide conceptual thinking.

4. Have a style and approach that is yours alone. That's going to be why you get hired.

5. Have fun. If you don't enjoy creating your work, people won't enjoy looking at it.

"Mine is a Cinderella story of sorts," says Toronto-based Andrew Williams, before recounting his convoluted route into a design career. In summary: schoolboy goes from sketches to graffiti, branches off at anime, prepares to do a film degree but gets seduced by computer graphics and interactive design. Nowadays he produces collages that are pretty much totally Photoshop-based for the likes of BMW, Mercedes-Benz and Calvin Klein, though he says he still gets a kick out of film, particularly from the output of producers Jerry Bruckheimer and JJ Abrams.

His work typically begins with an idea and some research into what's hot on design sites. It is, he says, a matter of being discerning in order to figure out how to remain current and not appear derivative.

Andrew is a fan of traditional design rules, though he will transgress them as necessary. He allocates around half the time on a job to retouching images, and also puts a great deal of effort into cut-outs, making sure he is pixel-perfect. "It's very important as I am an attention-to-detail freak," he says. He is also careful about feathering, as he feels it makes all the difference between the achieving the right look and being blighted by the "cheese factor".

For Andrew, collage is about getting the colour right and understanding depth of field. "These are most important in my mind," he explains. "I always have a focal point in my collages and then use it to draw attention to details. So I take a lot of time choosing that specific object.

"I approach my work with a design style that is the same as many out there today, but I try to make it different by using methods that most don't use," he says. "I prefer work that looks real, rather than something that looks fake just for the sake of making something look cool."

What is that certain something that makes a piece an Andrew Williams piece? "I can't really say what that is," he muses, "but I do use a lot of women in my work."

williamsdesignstudios.com >

1.
Not unlike John the Apostle, Andrew Williams found himself contemplating Armageddon, caused by a cosmic event. To start visualising that, he needed a suitable image of Toronto's CN Tower.

2.
Once he'd found the right image, Andrew added appropriate effects to make the tower look as though it had collapsed and was decaying.

3.
Andrew then extended his apocalyptic vision to the rest of the world, bringing in iconic structures from all continents.

4.
Now Andrew began introducing more colour to the scene, adding a bronze haze as well as cracks and flames to the buildings.

5.
Andrew created the sky by feathering several sky images together and colouring as before. He also added items on the ground and had them sinking slightly, to denote the crumbling earth.

6.
Andrew was originally going to add an Adam-and-Eve couple for human interest, but he felt the leather-jacketed model was perfect.

7.
The model seemed to be looking at something, so he added a butterfly. The finished work above, entitled *Global Sin,* was entered for an iStockphoto competition.

5 Top tips Andrew Williams

1. Make sure you choose colours well and understand the concept of depth of field.

2. The focal point is hugely important. Take some time and choose it wisely.

3. For inspiration, look beyond design – think about, for example, camera angles in films.

4. Pay attention to detail and get the retouching right. But don't overdo the feathering.

5. Don't work solo; have a trusted someone around to bounce ideas off. It will make you a better designer.

1.

The surrealist

Paris-based designer Brice Chaplet, better known as Mr Xerty to his fans, started out studying geography, which he describes as "not a big love affair". It was graffiti and poster design for electro rave parties that gave rise to his passion for computer-based design.

Big on surreal and dystopian visions – he cites Aldous Huxley, George Orwell, Tim Burton, Salvador Dali and René Magritte as influences – he has worked for Sony and the French magazine *Science & Vie*, among others.

He considers most of his work to be mixed media, which he calls "modern collage", involving both Photoshop and Illustrator-derived vector images. "I feel free with this creative process because I'm not a perfect drawer," he explains. "With collage or mixed media I can express what I want by playing with a picture, adding colour vector shapes or paper textures to add an old-fashioned touch."

Brice has a very open-ended approach to working in Photoshop. "I'm not a purist," he declares. "The most important thing for me is to have a good, well-executed and balanced composition. Technique is important in order to be at ease with the types of client demands you can receive."

He also advises taking time over mixing textures and colours so that your final result doesn't look like "a basic Photoshop exercise".

All his work starts out in a small book, where he keeps notes and sketches. Thereafter, he consults stock libraries or his personal collection of photographs for images.

"There are no rules in particular," he says. "Feel free and crazy! But mainly, you have to choose the right photos."

nomastaprod.com >

2.

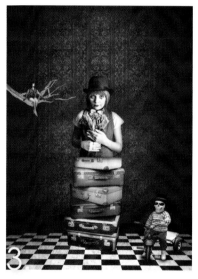

3.

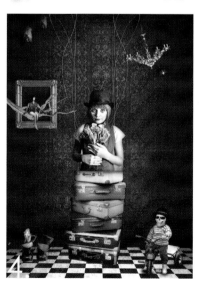

4.

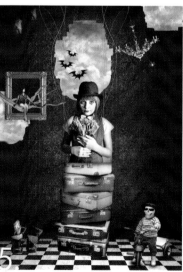

5.

Brice's collage *For You* began life as a poster for a friend's Halloween party. The party was cancelled, but the image developed a life of its own. The strange goings-on depicted were assembled from the elements shown above top, and take place in a room that was itself composited from a couple of stock images.

5 Top tips Mr Xerty

1. Find a theme. It will help to keep your composition holistic.

2. Search for some really appropriate photos. Choose wisely.

3. Choose a good colour scheme. Again, it's all about a unified creation.

4. Mix your elements in a homogeneous way. Make sure everything on the page looks like it belongs there.

5. Be creative, and a little crazy. Make sure you go for it big time.

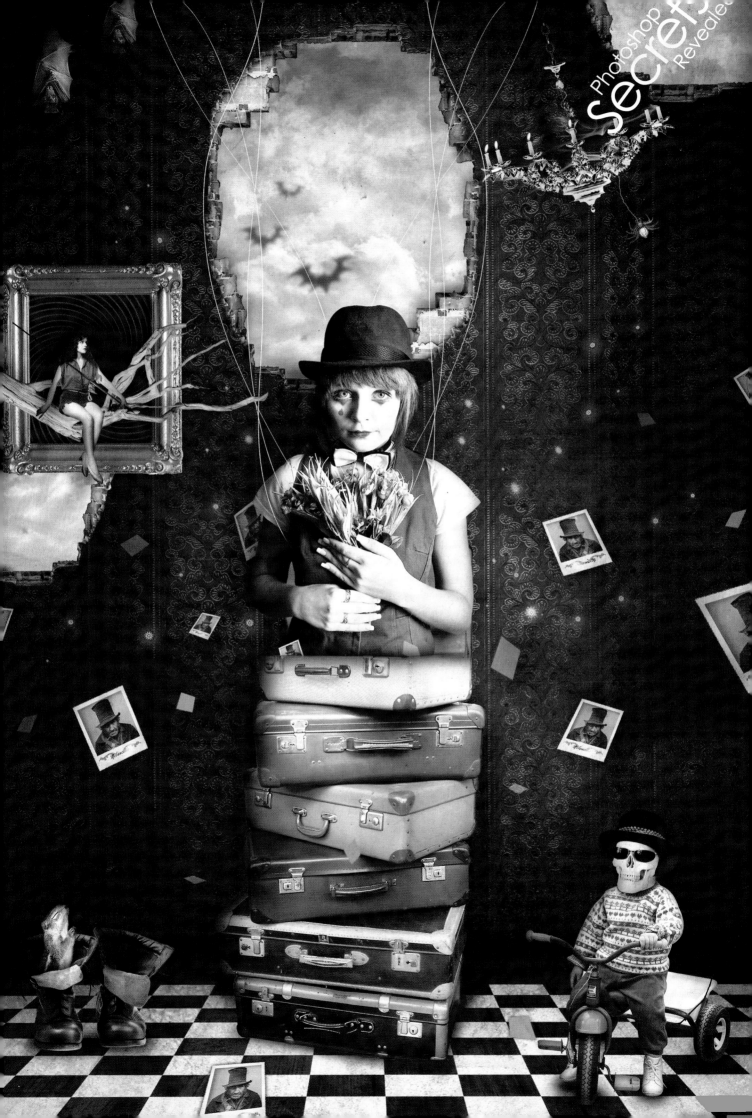

case study 4
The perfectionist

In his career as a montage artist, one event proved definitive for Rob Shields. "I watched a film, *How To Draw A Bunny*, about a 1960s collage artist called Ray Johnson," he explains. "He seemed really strange, and I thought, I'm really strange too; maybe I'm supposed to be an artist."

Based in Philadelphia, Rob studied psychology and philosophy, and also did a stint as a writer before teaching himself design a few years ago. Most of his time is now spent on creating artworks for a range of clients, particularly in the digital design realm – this magazine among them.

Rob believes collage enables budding artists to find their creative voice quickly, though he concedes that what was once liberating has become somewhat limiting. "If I have an idea now, I have to find a photograph," he says. "I'm trying to move away from that." But his creations are anything but limited. They are snapshots of Photoshop at its most powerful.

"I usually start off by sketching really loosely in Photoshop, just the basic shapes or composition," he says. "I use a tablet and I draw right into a layer."

Rob places great emphasis on the precision of his cut-outs. "If you see something that's poorly cut out, your expectations instantly go down. If you can tell the person's spent time on it and didn't just throw it together, I think that's really a big thing for making a good collage."

robshields.net

5 Top tips Rob Shields

1. Before you start a project, look for more elements than you think you will need. It will increase your options, just in case.

2. Research some of the old compositional tricks like the rule of thirds in order to have a more technically astute eye.

3. Look at each element in the work and ask yourself what it adds to the overall piece. If the answer is nothing, get rid of it.

4. Don't be afraid to stop, disassemble the work and start with a new approach: experimentation is a must.

5. Remember tip two? Now go ahead and break the rule of thirds.

Below Rob created this image around the theme 'what a mess'. His concept centres on the idea that subconsciously we all wear masks.

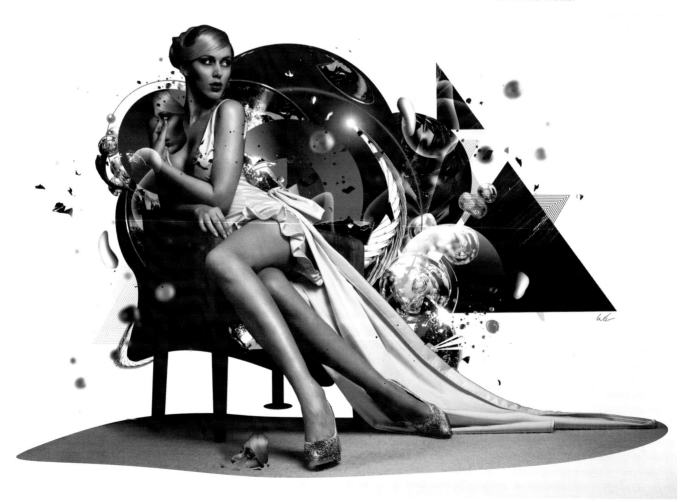

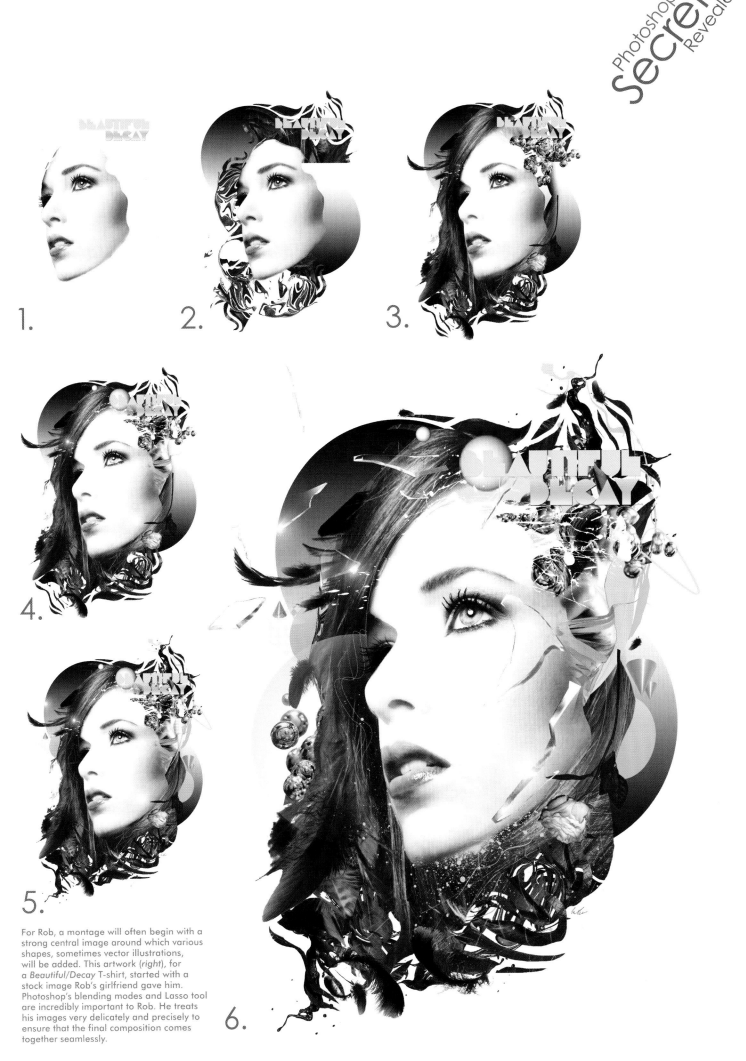

1.

2.

3.

4.

5.

6.

For Rob, a montage will often begin with a strong central image around which various shapes, sometimes vector illustrations, will be added. This artwork (right), for a *Beautiful/Decay* T-shirt, started with a stock image Rob's girlfriend gave him. Photoshop's blending modes and Lasso tool are incredibly important to Rob. He treats his images very delicately and precisely to ensure that the final composition comes together seamlessly.

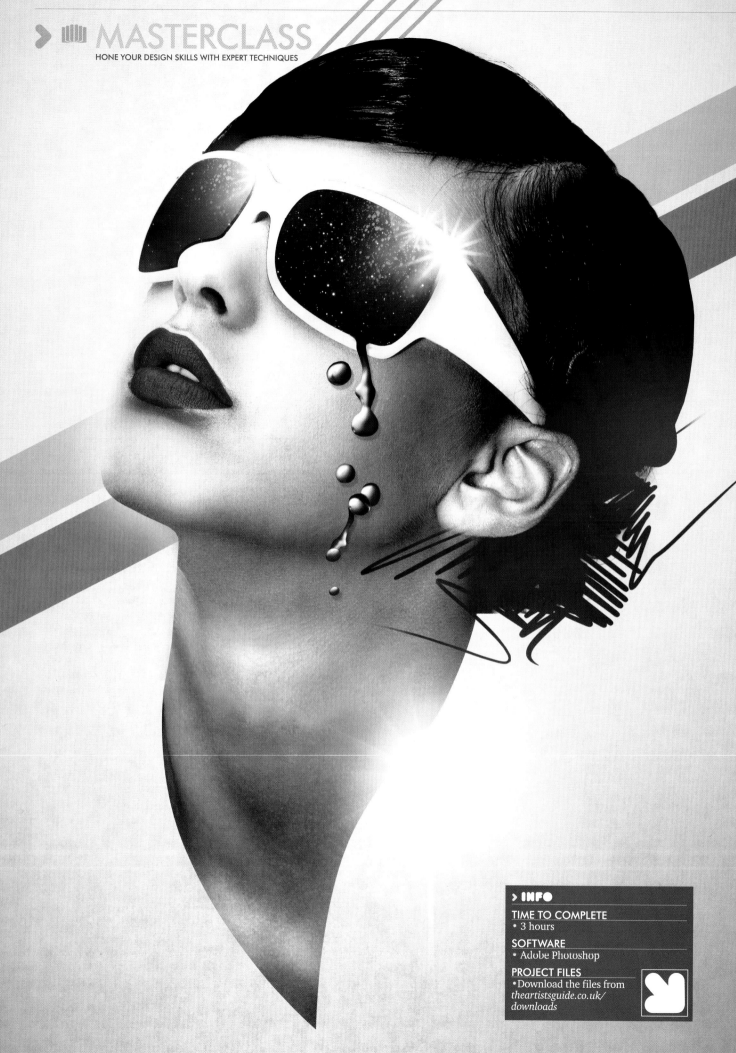

> INFO

TIME TO COMPLETE
• 3 hours

SOFTWARE
• Adobe Photoshop

PROJECT FILES
• Download the files from
*theartistsguide.co.uk/
downloads*

> **LEARN** 80S-STYLE GRAPHICS

Master Photoshop's layer effects

Give your images a boost with James White's slick pop style

Creating vibrant, eye-catching images like this one needn't be a complex or time-consuming affair. In this tutorial, James White shows how to add a vivid retro flair to a striking model shot kindly provided by *ThinkStock.com* (which you can download from project files).

You'll learn to hone your skills with the layers palette and useful tips in applying masking, Blending Modes and Hue/Saturation. You'll also learn how layers react with one another when overlayed in certain ways, and how selective colour can be added to enhance the overall design.

Don't be afraid to leave yourself open to experimentation. Try different things as you go along to see what results you may come up with.

SMOOTH OPERATOR

> The Polygonal Lasso Tool tends to leave tiny corners in your selection, visible when you zoom in. It's good practice to use the Brush tool after masking in order to smooth the selection.

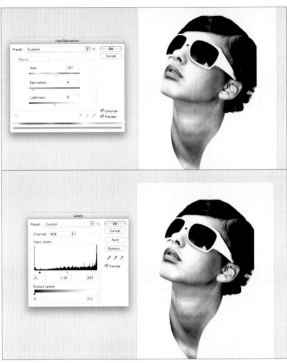

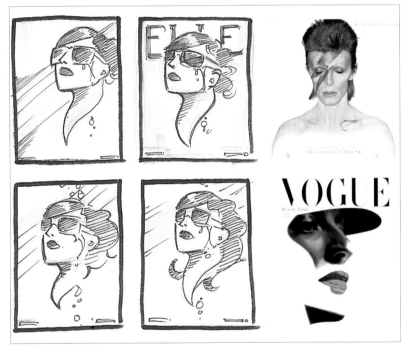

STEP 01 Start things off with a few sketches to get a general idea of what the final composition might look like. These make for useful guidelines when you start working on the elements in Photoshop. I've included some inspiration regarding form and style with the end two images.

STEP 02 Download and open the file *jw_lady.jpg*. Using the Clone Stamp tool with a soft brush, clone out the necklace and any other obvious blemishes or stray hairs. Try to keep the skin-tone even throughout and watch for shifts in highlights and shadows.

STEP 03 Next, cut out the head using the Polygonal Lasso tool. Click around the head and neck to select, then hit the Layer Mask button to knock out the background. You can then use the Brush tool to round off and fix the mask as needed.

STEP 04 With the headshot selected, open the Hue/Saturation palette and slide the Hue to 187 and the Saturation to 9. This will drop all natural color out and leave a hint of blue. Then, to add a bit of contrast, slide the shadow arrow in Levels to 21 and the highlight to 247.

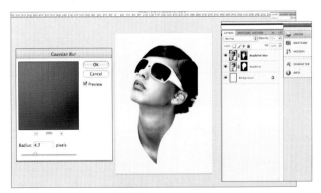

STEP 05 Now we need to add a bit of softness to that grainy skin. Duplicate the headshot layer, go to **Filters > Gaussian Blur** and apply a 4.7 blur to the new layer, then drop it's opacity to 51%. You may need to do some selective masking to retain sharpness in some areas, like the sunglasses.

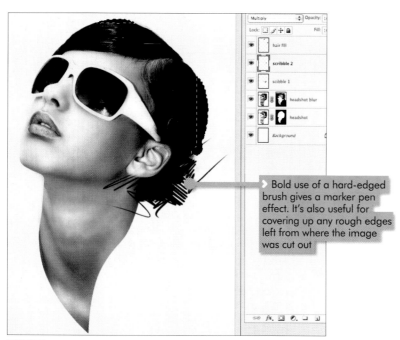

> Bold use of a hard-edged brush gives a marker pen effect. It's also useful for covering up any rough edges left from where the image was cut out

06 Create three new layers. In the first two new layers, select the Brush tool with a hard-edged brush and add some scribbles to the back portion of the model's head. Switch to the third layer, and with the Polygonal Lasso tool, round off and fill any flat areas where the photo was cut off.

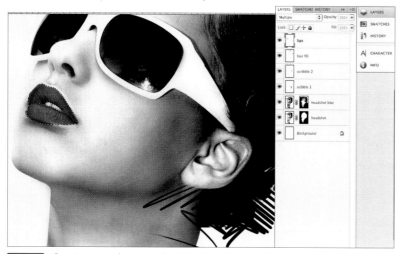

07 Create a new layer, and set the Blending Mode to Multiply. Select the Polygonal Lasso Tool and click to outline the lip area, ignoring the teeth. Then fill the selected area with a hot pink to really add a splash of colour to the face.

A BRIGHT IDEA

> If you feel your colour overlays aren't as bright as you'd like, try dropping the opacity of the colour layer and duplicating it. Having two or more colour layers will boost your saturation.

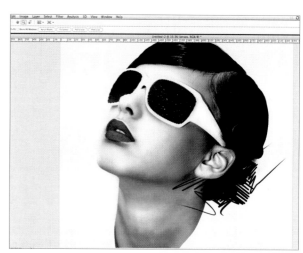

08 Create a new layer. Click around the edges of the lenses with the Polygonal Lasso tool until they are selected, and fill with black. I added a bit of a subtle star-field to mine for adde d interest. Apply the same effect to both lenses.

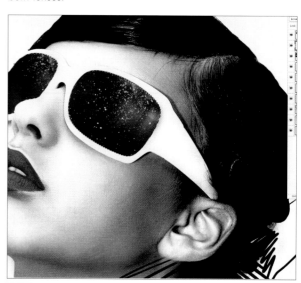

09 In order to add more detail to the lenses, I added a second layer of stars and shifted them to a blue hue using the Hue/Saturation palette. You can find plenty of star shots on the web for this effect.

10 For the mercury tears, I used a picture of water drops, turned them to greyscale using Hue/ Saturation, then used the Levels palette to amp up the contrast. Use the Polygonal Lasso Tool to select the drops and hit the Layer Mask button to drop out the background. Apply a subtle Drop Shadow layer style to add depth to your drops.

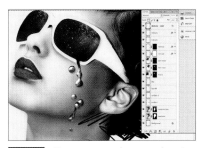

STEP 11 Create a new layer and, using the Brush tool, add some wild colours over the top of the drops. Once the colours are done, set the Blending Mode to Overlay and reduce the opacity to 60%.

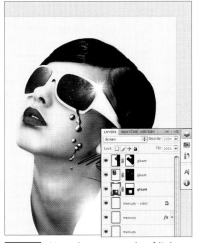

STEP 12 Hunt down a couple of light source images, I suggest streetlights or eclipse shots. Paste them into Photoshop, set the Blending Mode to Screen, adjust the levels in order to drop out the background and apply any masking that is necessary.

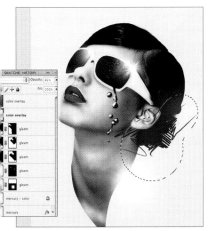

STEP 13 Create two new layers. On the first, set the Blending Mode to Screen and the opacity to 46%. Use the Brush tool to apply some soft colour to the back of the head – I suggest using pink and blue. Then on the second layer, use the Gradient tool to apply a full blue to pink gradient across the canvas. Set that layer to Overlay and the opacity to 22%.

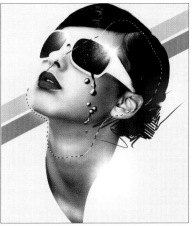

STEP 14 Create a new folder in the layers palette, and add a new layer inside it. Using the Rectangle tool with a de-saturated blue, draw a rectangle across the face. Duplicate that layer, hit the Lock Transparent Pixels button and fill the new rectangle with pink. Select both layers and angle them using the Transform controls. Add a layer mask to the folder in order to remove the stripes from the face.

STEP 15 Find a gritty texture with some nice contrast and paste it into your work to cover the entire design. Use Hue/Saturation to remove the colour and Levels to add a bit more contrast.

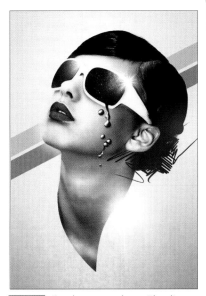

STEP 16 Set the texture layer Blending Mode to Overlay and reduce the opacity to 73%. Then drag that layer to the bottom of your layers palette, just above the background layer. ∎

PROFILE JAMES WHITE

> James White is a visual artist and designer based in Halifax, Nova Scotia, Canada. With 11 years of experience, James has worked on an array of personal art projects, and has worked with clients including Toyota, Nike, Google, VH1, Armada Skis and *Wired*. He owns and runs Signalnoise Studio, specializing in all things colourful.

CONTACT
• Signalnoise.com

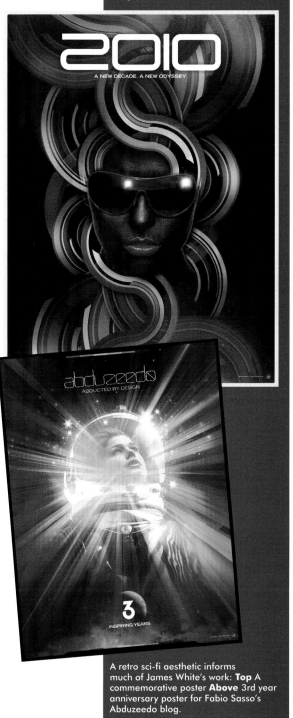

A retro sci-fi aesthetic informs much of James White's work: **Top** A commemorative poster **Above** 3rd year anniversary poster for Fabio Sasso's Abduzeedo blog.

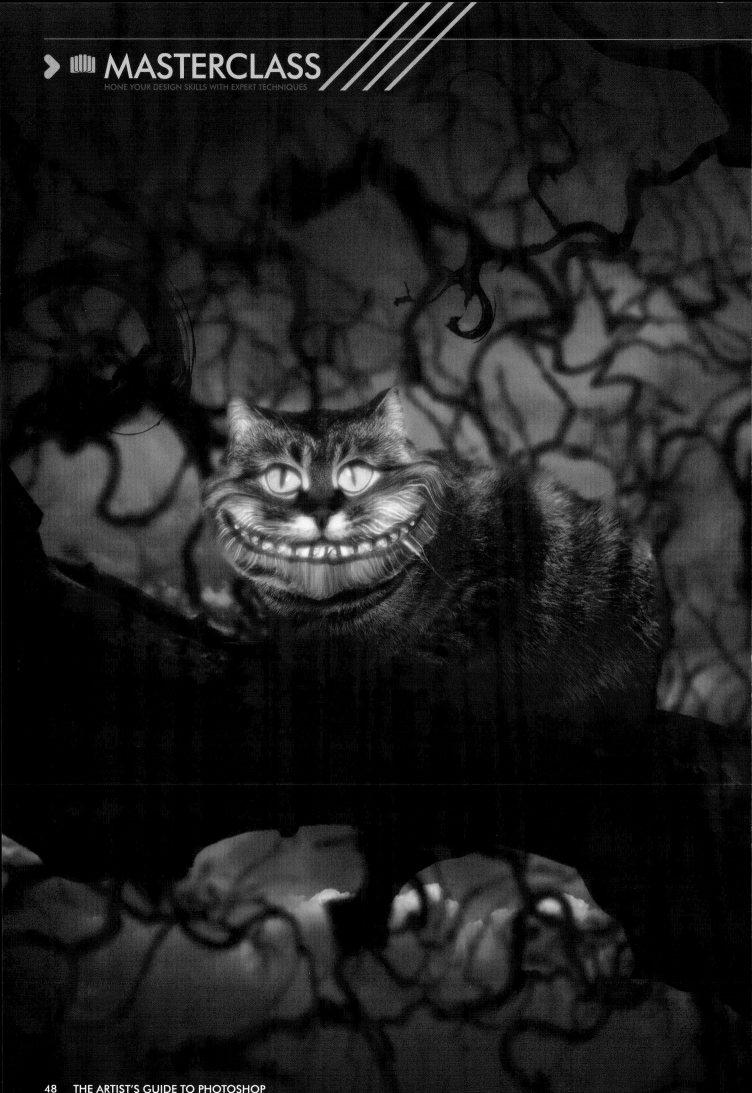

> **LEARN** CREATIVE IMAGE WARPING

Master the Liquify filter

Fabio Sasso dives down the rabbit hole to create *Alice in Wonderland* poster art

Tim Burton's retelling of *Alice in Wonderland* is full of dreamlike, grotesquely distorted characters. In this tutorial, Fabio Sasso shows you how to hone your use of the Liquify filter to make an image inspired by the film's sinister Cheshire Cat.

The Liquify palette offers all sorts of ways to distort an image: you can twist and pull specific sections through the Warp tool, expand them so that they look like they've been inflated using the Bloat tool, or squish up sections using Pucker.

As with all Photoshop filters, the Liquify tools are usually best used sparingly. However, for this tutorial Sasso whacks all the settings up high and gets stuck in with creating disturbing and distorted Liquify filter effects.

01 Create a new A4 document in Photoshop, then import a suitable photo of a cat – it's quite important that it's in a similar pose to this one and that the face is clear – and extract its background. The image I used was bought from Shutterstock; you can download it from *bit. ly/ayAR1J*.

> Use the Bloat tool to increase the size of the eyes

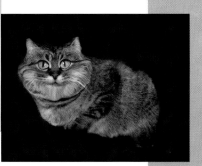

02 Now let's deform the cat to make it more cartoonish. To do that go to **Filter > Liquify**. In this palette, use the Bloat tool (**B**) to bloat the eyes, then the Forward tool (**W**) to move things around: push the ears down and stretch the mouth in preparation for the big teeth we'll put there later. Play with the brush sizes, density and pressure with these tools to get the best results.

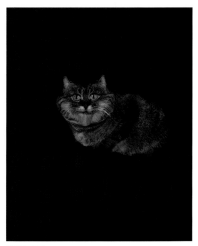

03 Go to **Layer > New Adjustment Layer > Hue and Saturation**. Place the new layer above the cat's in the Layers palette. Select **Layer > Create Clipping Mask**. When you create a clipping mask the layer is visible only over the area of the layer below, in this case the cat. So select Colorize then increase the Hue to 235, reduce the Saturation to 23 and the Lightness to -15.

04 Again select **Layer > New Adjustment Layer > Hue and Saturation**, then go to **Layer > Create Clipping Mask**. Place this adjustment layer on top of the previous one. Change the Hue to 85, the Saturation to 60 and the Lightness to -35. This gives the piece a green colour.

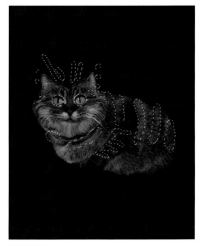

05 Using the Paint Bucket (**G**), select the mask of the Hue and Saturation layer over the Layers palette. It will be white, so fill it with black to hide the green. With the Brush tool (**B**), select a soft white brush and white, then paint over the eyes and also create green areas on the cat. ➤

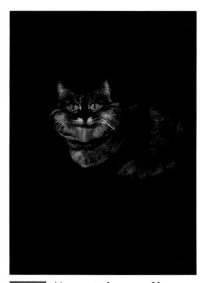

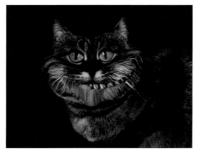

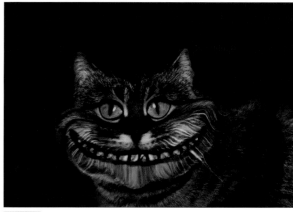

08 Paste the teeth onto the cat image and place them. To adjust the form of the teeth to follow the cat's mouth, once again use the Liquify filter with the Forward tool (**W**). After that duplicate and flip the teeth horizontally to create the mouth.

09 Add a layer on top of the teeth layers and with the Brush tool (**B**), using a soft black brush, paint on the edges of the mouth to create a shadow and give the impression of depth. Use Multiply for the blending mode.

06 Now go to **Layer > New Adjustment Layers > Gradient Map**. This layer is on top of the other adjustment layers, and once again create a clipping mask. Change the blending mode to Soft Light. Set the layer's blending mode to Soft Light too.

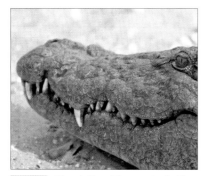

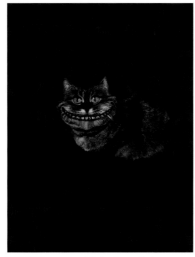

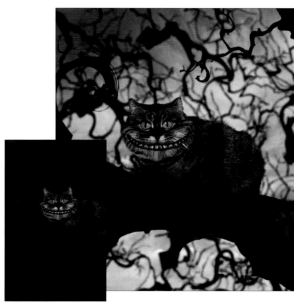

07 Now let's add some teeth. To get a suitably menacing set I used a crocodile image, again from Shutterstock (*bit.ly/cTpLUt*). Then with the Lasso tool (**L**) select a part of its mouth and copy it.

10 Now add the branch the cat is lying on. The image I used was from Shutterstock (*bit.ly/a0d58Q*). Rotate and try to find the best angle for the branches. Also use the Liquify filter with the Twirl Clockwise tool (**C**) to distort the tree's branches and create some swirls.

11 Add more branches in the background and apply a Gaussian Blur with a radius of 15 pixels, then import a photo of a sky. The one I used was from Shutterstock (*bit. ly/939V5X*).

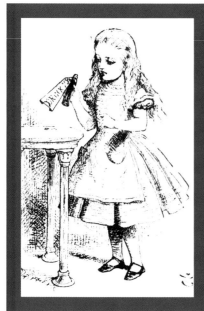

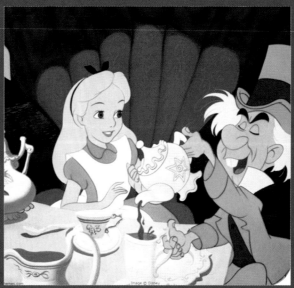

Alice through the ages

Lewis Carroll's *Alice's Adventures in Wonderland* has inspired artists, animators and filmmakers since it was first published in 1865. For decades, though, the book was firmly linked to the pen-and-ink illustrations of Sir John Tenniel (*far left*), which to modern eyes look stark and quite scary.

Since then *Alice* has often been used as a vehicle for psychedelic or creepy effect – notably for Disney's gaudy 1951 animated film (*left*).

These approaches have been mixed for Disney's latest live-action movie (*right*), which uses the neo-gothic signature style of director Tim Burton. *Alice in Wonderland* is available on DVD.

> When it's time to find some teeth for the cat, use a crocodile image to get a suitably menacing set

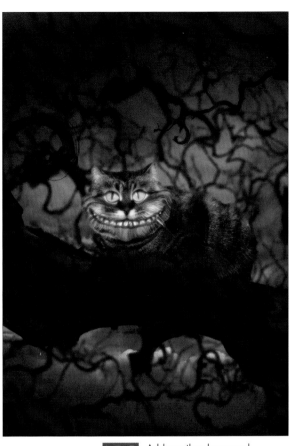

12 Select the sky image and move it below the others in the Layers palette. Still with the layer selected, go to **Image > Adjustments > Brightness and Contrast**. Reduce the Brightness to -135 and increase the Contrast to 100. After that go to **Image > Adjustment > Hue and Saturation**. Select Colorize, then increase the Hue to 262, change the Saturation to 43 and the Lightness to -15. This will give you a very purple background.

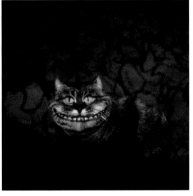

13 Select all layers and duplicate them, with the duplicated copies go to **Layer > Merge Layers (Cmd/Ctrl + Alt/Opt + Shift + E)**. Select the merged layer and go to **Filter > Blur > Gaussian Blur**. Set the radius to 20 pixels and change the blending mode to Screen. The whole image will get shinier. Then with the Eraser tool (**E**) delete pretty much the whole layer leaving only the face of the cat very well lit.

14 Add another layer and with the Brush tool (**B**) add a vignette to the design and you've practically finished. You can make the eyes brighter by duplicating the blurry layer and changing the blending mode to Screen. ■

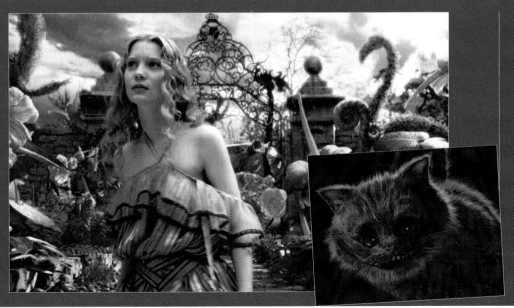

INFO FABIO SASSO

> Graphic and web designer Fabio Sasso is best-known for his Photoshop artworks and tutorials. He is also co-founder of Zee, a web-design studio, and he runs a hugely successful digital arts and creativity blog, Abduzeedo.

SOFTWARE
• Adobe Photoshop

TIME TO COMPLETE
• 2-3 hours

CONTACT
• *abduzeedo.com*

INFO

TIME TO COMPLETE
• 2-3 hours
SOFTWARE
• Adobe Photoshop

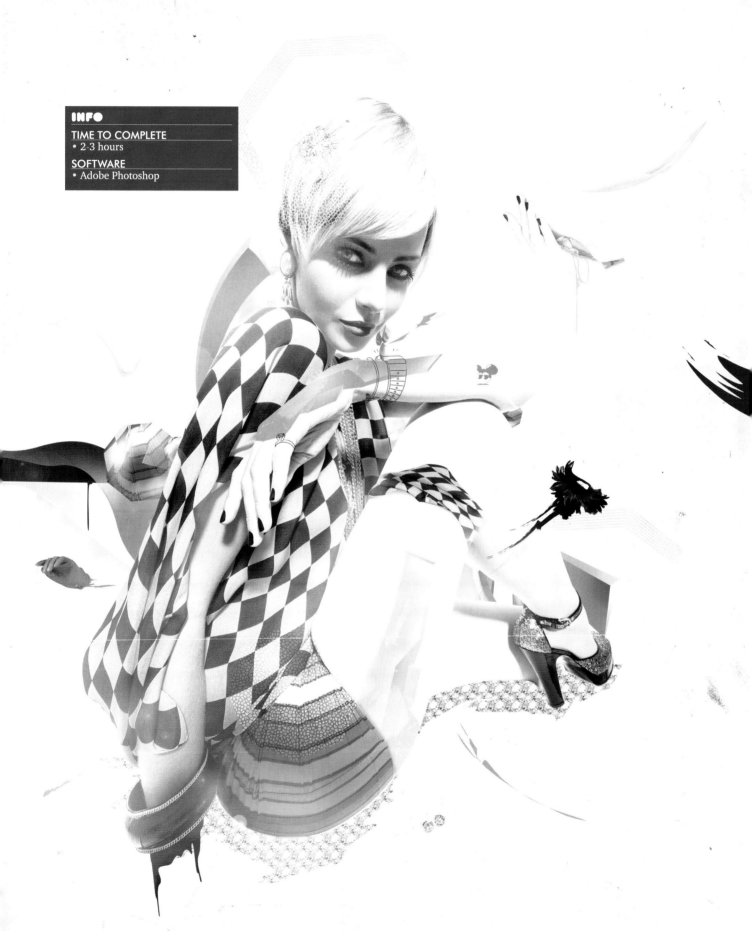

Fashion-inspired
illustrations

Keep things edgy with **Bram Vanhaeren**'s fresh, spontaneous style

Take one alluring fashion image – and add to its mystery using some clever photomontage techniques. In this tutorial, up-and-coming creative Bram Vanhaeren shows how you can transform fashion photography into edgy, enigmatic illustrations in just a few steps.

You'll create and layer textures, vector elements and little doodles to draw the viewer's attention and keep them noticing little details. Bram shows how to use the Warp tool to seamlessly blend elements, and to sample parts of your model's clothing.

You'll liven up your image's subtle colour palette with dynamic flashes. The effect is on-trend but distinctive – and the techniques you'll learn can be used for other photomontages.

The model shot was created by Katanaz-Stock and can be downloaded for free from DeviantArt at *bit.ly/ckWqaQ*. The paper texture is by bashcorpo and can be downloaded for free from DeviantArt at *bit.ly/cSqR43*.

04 At the moment the 3D shape doesn't fit in with the piece at all: to integrate it more smoothly we'll need to use the Warp tool. First merge the light and shadow layers, so that each 3D shape is a single layer.

Choose a particular shape and think of a place you want to blend it into – here I chose her upper legs. Now go to **Edit > Transform > Warp** and drag those parts into position.

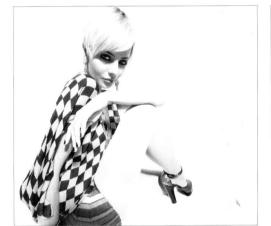

> "Fashion-related models tend to have good poses"

01 Choose a background and a model. I like to use a paper texture as a background as it gives you a lot of options to work with. Look out for fashion-related models, as they tend to have good poses with lots of attitude.

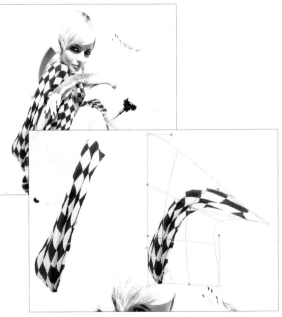

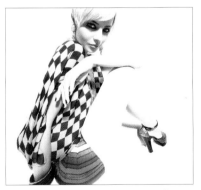

> Some clever use of gradients can help you fake the effect of 3D elements

02 Desaturate some parts of the model. Go to **Image > Adjustments > Brightness & Contrast** and set both Brightness and Contrast to +25. Duplicate the model layer (**Cmd/Ctrl + J**) and desaturate the duplicate (**Cmd/Ctrl + U**). With the Lasso tool set to a 100px feather, make a selection around the model's shoulder and delete this part from the desaturated layer.

03 Create some 3D shapes. Using the Polygonal Lasso tool and a soft round brush set to 20% opacity, create an abstract octagonal selection, and fill it. In a new layer, add depth with light and shadows.

05 We're going to use the interesting pattern from the model's clothing. First, take the coloured model layer and duplicate it again. Cut out the checked pattern from her shoulder and arms with the Lasso tool. Go to **Edit > Transform > Warp** again and place it around her leg or arm as an armband – or any other use you can think of.

06 Add some more coloured shapes in the background, and little elements that work well with the model – here, I've added some gold jewellery and a black abstract bird, as well as adding some drips to her wrist to conceal where her hand is cropped off.

Next, we need to create a pattern texture – in this case, I used a photo of a silver ring that I downloaded for free from stock.xchng (download it from *bit. ly/dikOH9*). Select a part of the jewelry, and select **Edit > Define Pattern**, and name your pattern.

07 To create this shadow beneath our model, make a quick selection from her with the Lasso tool and then **right click/Ctrl-click > Fill** and select your jewellery pattern. Don't forget to make a new layer under our model's layer.

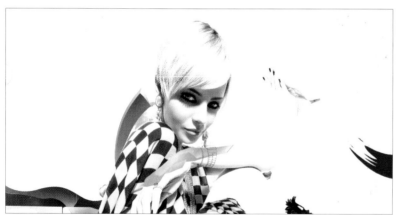

08 We're getting close to our finishing touches. As I mentioned in the beginning, I love to work with a paper texture in the background as it really adds to the depth of the piece without limiting you unduly. Here, I'm also going to highlight the model by adding white shapes – using the Lasso tool – behind her. I've created shapes that are similar to white abstract flames. On the paper texture this is subtle but highly effective.

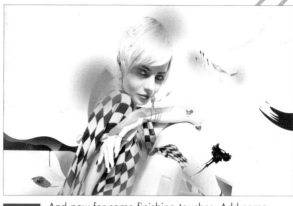

09 And now for some finishing touches. Add some abstract shapes and rough brush strokes. Now select a striking colour and highlight some parts of the model. Finally, take a round, soft brush at 60% opacity and paint some pink and blue over your model in a new layer. Change the layer's blending mode to Screen or Lighten. ■

PROFILE BRAM VANHAEREN

❯ At 19 years old, Belgian illustrator Bram Vanhaeren is already making a name for himself, forming the Into1 studio with his brother Tim.

Together they take on illustration and web-design commissions, while their desktop wallpapers and tutorials have appeared in a variety of high-profile blogs. Bram's style ranges from straight-up illustrations to typography projects and mixed-media artworks.

CONTACT
• *into1.be*

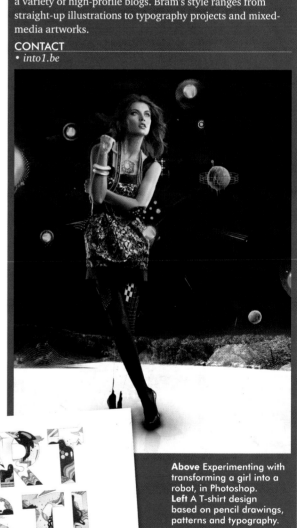

Above Experimenting with transforming a girl into a robot, in Photoshop.
Left A T-shirt design based on pencil drawings, patterns and typography.

PENDULUM
IMMERSION

> **LEARN** PHOTOMONTAGE TECHNIQUES

Immersion in an underwater world

Discover how Polish artist Valp composited this stunning artwork for the cover of the Pendulum's Number 1 album

T he Number 1 album *Immersion* by drum n' rockers Pendulum features a photo-illustrative cover by Polish artist Maciej Hajnrich (aka Valp), which was also used across the Collector's Box Set, including double vinyl, postcards and a bunch of merchandise.

Here, Hajnrich shows off the techniques for photo manipulation, retouching and editing he brought to

bear on the cover. It was created in collaboration with album cover guru Storm Thorgerson, best known for covers including Pink Floyd's *Dark Side of the Moon*.

The real creative challenge for *Immersion* was to achieve an original and natural-looking scenario merged with some hyper-real techniques. The more you look at the cover, the more you can see. It's designed to hypnotize and immerse the viewer.

01 The album's title *Immersion* brought a sinister, deep ocean to mind, with strange creatures, corals and suchlike. The original sketch was created in Photoshop at only 1400 x 1400 pixels.

One thing to remember here – and throughout the composition – is that while album covers are great to experiment with, the art needs to be viewable both as a 30cm sleeve for the vinyl and as a thumbnail at an online store.

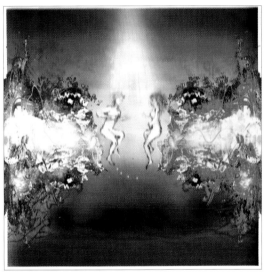

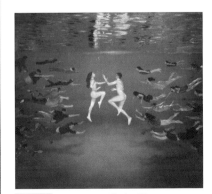

02 I was supplied with a composited photograph as a starting point. It was impossible to take a shot with so many swimmers, so many were taken and then combined. Bridge CS5 was very handy here for organizing all your resources. The nude figures in the middle are crucial to the artwork, so much time was taken selecting the right pose.

03 I began working with the shot of the two nude swimmers and added lighting coming down from the surface. I sketched light rays down and used the Screen blending mode to light the image.

I took an abstract shape, and converted it to a Smart Object (**Layer > Smart Objects > Convert to Smart Object**). I used the Warp tool (**Edit > Transform > Warp**) to pull it into an arch shape with the 'rays' coming down. The layer's Blending Mode was set to Overlay.

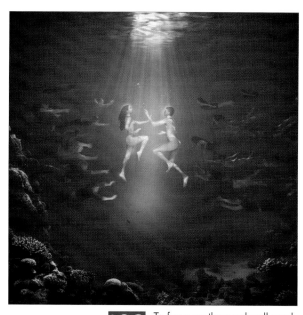

04 Next-up, colour correction. I prefer to work with several Hue and Saturation and Curves adjustment layers with different blending modes. Here, I desaturated and darkened the original image by moving the sliders to the left.

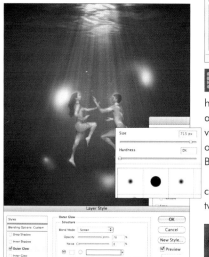

05 For the jellyfish, I chose a basic brush with soft edges and created a new layer with an Outer Glow effect (**Layer > Layer Style > Outer Glow**). Using a bright colour (#ffffbe), I set the Opacity to 64% screen and painted them with quite a large-sized brush.

I used the same tool for adding some water bubbles all around the place.

06 I added more water bubbles here, using a brush with hardness set to 100%. I tapped here and there using different opacities and various angles and roundness, all of which can be changed in the Brush panel.

I also added some more light in the centre, both behind and in front of the two main figures.

07 To bring the ghostly collective to life, I placed all elements on either side of the main image and performed a group merge (**Layer > Merge Group**) of these layers. I made a new layer and copied the outer glow effects.

To do this, I right-clicked on a layer and chose **Copy Layer Style**, then right-clicked on a newly added layer and chose **Paste Layer Style**. I used a small sized brush to paint ghosting on the edges – so it looks like the figures are crackling with electricity.

08 To focus on the coral walls and the bottom of the ocean, I turned off all of the glowing layers. This section was very time consuming but it was important to blend all the photos well. I used a very soft brush for careful masking and the Curves adjustment layers to darken images. The goal is to keep original underwater colours, so I focussed on blues and greens.

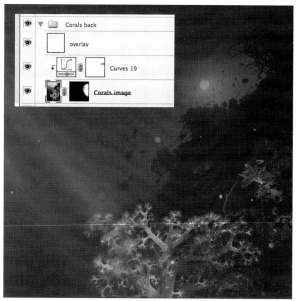

09 For the background details, I worked from a stock shot of some coral reefs. I masked the coral gently and set the Blending mode to Luminosity, so it would match the colour from layers below. These images needed to be rather dark silhouettes, so everything in front will stand out in contrast.

STEP 10 To really bring it to life, the underwater world needed some creatures. I placed them in various positions and at different sizes and dimensions for a sense of variety – like the whale in the foreground or the shark in the background as shown (right). Some of them can be really tiny, like the small fish below the couple, as they will add real depth to the vinyl artwork without detracting when the piece is viewed as a thumbnail in iTunes.

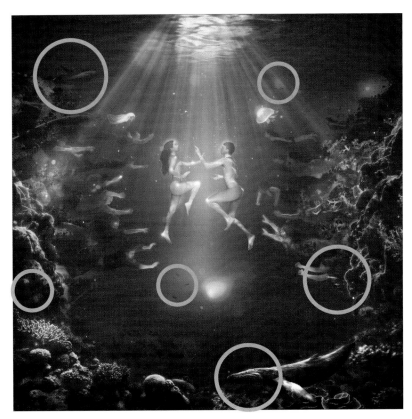

STEP 12 The end result was in sight. I just had to make sure that all the layers are treated similarly so that the whole artwork is coherent. I paid particular attention to make the edges glow in the same way as the ghosts and creatures.

STEP 13 The final step is typography. I created and placed the type as flat, single colour text. I created a path around it to paint within by selecting (**Layer > Create Clipping Mask**) and used a soft brush to paint above it. I created a selection from the text, create a mask on a new layer and copy the Outer Glow Layer Style to it. Now paint on that layer for a shining effect on the top edge of the title. ■

STEP 11 Additional elements, such as the dead fish and extra jellyfish, were created with black backgrounds and comped in. Using the Screen blending mode means no masking was necessary. For some more subtle details, I added some abstract shapes as well, placing them on a layer with the an Outer Glow Layer Style applied as before.

PROFILE VALP

❯ For Maciej 'Valp' Hajnrich, art and design has always been something more than just a profession. Based in Katowice, Poland, the self-taught freelance artist has five years of experience in print and web design.

After years of experimentation, Maciej has established himself as a considerable creative digital force; his imaginative style displays a high attention to detail, colours and textures.

Maciej has produced work for Warner Music, Odeon Film Studio, Platige Image and Armada Skis, as well as delivering illustrations for *Priscilla Queen of the Desert* musical.

CONTACT
• valpnow.com

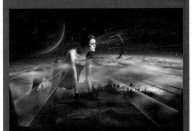

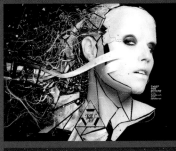

(**From top**) *Prototype 6, Trust The Future,* an illustration for London's West End production of the *Priscilla Queen Of The Desert* musical, and the piece on display.

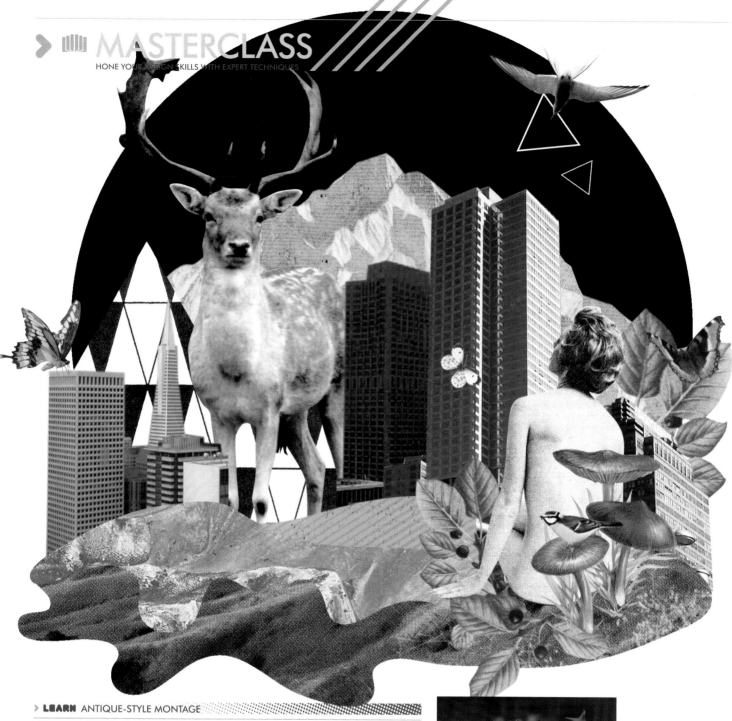

> **LEARN** ANTIQUE-STYLE MONTAGE

Vintage-look collage techniques

Achieve an aged look with very modern Photoshop techniques

here's lots to love about collage – the elements you select enable you to create whimsical contrasts. It's also currently very trendy, cropping up on posters, flyers and album covers.

Here, illustrator Ciara Phelan shows you how to hone your cut-out skills to prepare images for collaging. You'll also learn some handy tricks to give your images a vintage look.

You will learn how to adjust the contrast and colour levels as well as

shifting the channels to create a litho printed effect – a very useful technique to learn as it can be applied to imagery you have sourced yourself, making it appear to be from a 1950s journal.

This gives you flexibility with the images you can use, saving you hours of trawling through old magazines and encyclopedias. This tutorial focuses on transforming the photograph of the stag in the above example, but these techniques have been used on all elements in this artwork.

01 Open the image of the stag in Photoshop. As the stag will be used in a collage you need to isolate it from its surroundings – select the Pen tool, and on the toolbar along the top select Paths. Zoom into the image and use the Pen tool to draw a path around the stag.

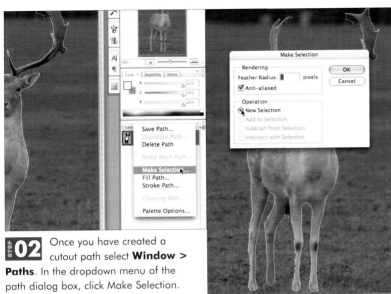

02 Once you have created a cutout path select **Window > Paths**. In the dropdown menu of the path dialog box, click Make Selection. In the box that appears, change the feather radius to 0 and tick New Selection; click OK to create a marquee selection around the image.

03 Now that just the stag is selected, copy and paste it into a new A4 CMYK document, with the resolution set to 300dpi. (**Edit > Copy**, then **File > New, then Edit > Paste**, or **Cmd/Ctrl + C, Cmd/Ctrl + N, Cmd/Ctrl + V**).

04 Vintage imagery tends to have a higher contrast than digital. To create this effect click **Image > Adjustments > Curves**. Change the curve line from straight to a slight S. This brings out the white and makes the shadows darker. To add more contrast you can also adjust the levels to bring out the black and whites. Select **Image > Adjustments > Levels**. Slide the arrows inwards to add more contrast.

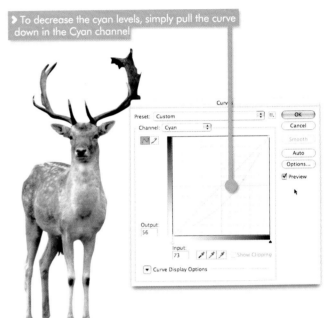

> To decrease the cyan levels, simply pull the curve down in the Cyan channel

05 Adding this amount of contrast has increased the cyan levels, which makes the image appear unnaturally blue. To adjust this, select to **Image > Adjustments > Curves**. Select Cyan in the Channel dropdown menu and decrease the cyan levels.

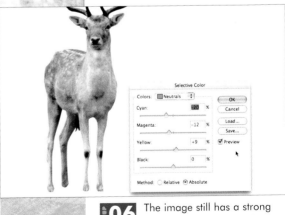

06 The image still has a strong cyan tint. To adjust this further go to **Image > Adjustments > Selective Color**. Select Neutral in the Colors dropdown menu and decrease the cyan percentage. In general, vintage imagery has a yellow tint due to age so use the Selective Color tool to add some yellow to the neutrals and take some cyan and magenta out of the whites.

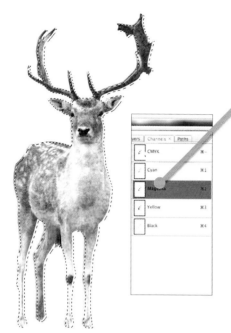

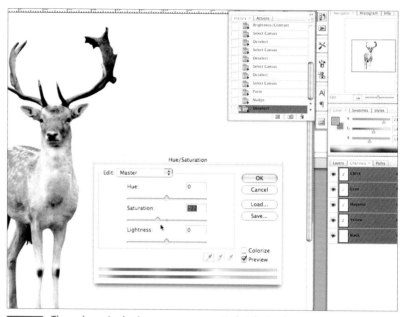

> Fake the effect of a litho printing process by nudging one of the colour channels so that it's slightly offset – this will mimic the imperfections of vintage photographs

07 The litho printing process layers up CMYK ink using plates. In vintage photographs it is common for these to misalign. To create this effect select **Window > Channels** then select a channel to misalign. Now go to **Select > Select All, Edit > Copy, Edit > Paste**. Using the arrow keys nudge the magenta layer so it's slightly misaligned. Deselect the channel, **Select > Deselect**, and in the channels dialogue box click CMYK to view the full image.

08 The colours in the image are now quite bright but in vintage imagery everything is slightly faded and less vivid. To correct this you need to desaturate the image. Click **Image > Adjustments > Hue/Saturation** and decrease the saturation levels. ∎

"I would describe my overall style as playful and whimsical. I nearly always include nature and organic shapes in my work," says Ciara. "Sometimes I feel like my artwork is my inner child expressing itself. I know that sounds clichéd but it's true. In general my favourite technique is to scan imagery and cut it out in Photoshop, which means I have more flexibility."

INFO CIARA PHELAN

> Based in London, Ciara Phelan is a freelance designer and illustrator. She studied graphic design at Brighton University, graduating in 2008. She says: "My work is predominantly collage-based – I like to combine a mixture of vector shapes, patterns and found imagery.

TIME TO COMPLETE
• 20 mins

SOFTWARE
• Adobe Photoshop

CONTACT
• *iamciara.co.uk*

> INFO

TIME TO COMPLETE
• 4 hours

SOFTWARE
• Adobe Illustrator & Photoshop

PROJECT FILES
• Download the files from
*theartistsguide.co.uk/
downloads*

> **LEARN** VECTOR EFFECTS

Composite photos and vectors

Give your images a dynamic twist with vector interventions

R ecreating colourful, 1980s-style graphics isn't hard – the tricky bit is updating them for the 21st century. In this tutorial, Karan Singh shows how to add a 1980s twist to stock or specially taken model shots, to jazz up your photos.

You'll master vector gradients, including useful tips for successfully working with gradients. You'll also use pre-prepared elements that you can scatter both in front of and behind

your model to integrate her fully into the image.

You'll learn to vary your vector elements using Layer Styles, adding glows, drop shadows and other variants. You'll also learn tips such as adding a vignette behind other layers to subtly direct the attention towards your model.

Karan Singh has provided a selection of vector elements for you to use; you can find these in our project files.

VECTOR LIBRARY

> Keep track of the vectors you make, as once they're made they're a great asset in any piece and have the potential to be used more than once. Have a file that you update often which documents new work.

01 Download and open the vector elements file in Illustrator; we're going to apply some colour schemes to the objects. I've included some of the colours I used here in the Swatches palette for you to use if you like. Open the Gradient panel (**Window > Gradient or Cmd/Ctrl + F9**).

02 You can add more sliders to the gradient by clicking anywhere along the track. Use the top and bottom sliders to create a combination that you like. You can adjust the gradient's colours by selecting them in the panel and then adjusting their values in the Color palette (**Window > Color**).

03 Fill a simple shape like a circle with the gradient you're adjusting colours on. This way you can see the results more clearly. Once you're satisfied with each gradient you create, save it to Swatches by dragging the gradient fill square on the Gradient panel into the Swatches palette.

04 Select one of the objects and apply your gradient by selecting it from the Swatches palette. You can control how the gradient looks on the shape by selecting the Gradient tool from the main panel (**G**). Click and drag on the artboard with the object selected and tweak until satisfied. Save a version of the Illustrator file when you have finished colouring the objects.

05 Open Photoshop and set up your document with a background colour and gradient to compliment the colours you applied to the vectors (I've used #F79D86 and #FCC081 in a radial gradient). Lock this layer by pressing the Lock All Icon in the Layers palette and save it. ➤

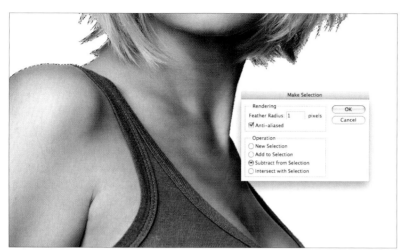

06 Next, open up your model shot. I've used an image from my photographer buddy Christian Hertel (*www.christianhertel.com*). Click the Create New Path icon at the bottom of the Paths panel (**Window > Paths**) and, using the Pen tool, carefully cut out the model from the background. Right-click on the path and select Make Selection. Feather the radius by 1px.

07 Copy and paste the model into your saved Photoshop document and adjust the Curves (**Image > Adjustments > Curves**) as well as the Color Balance (**Image > Adjustments > Color Balance**). This is so that the image doesn't look out of place in comparison to the background. Try to match the tones of the background colours you have chosen, then save the file.

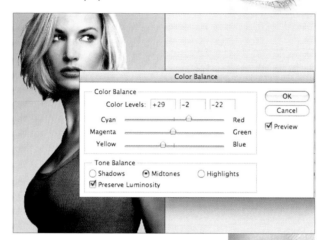

08 Before you start introducing vectors, it's a good idea to set your cursor to Auto-Select a layer. Click on the Move tool (**V**) and then in the top panel, tick Auto-Select and choose Layer from the drop-down menu. This makes working with multiple objects easier, as you can select them just by clicking them on the canvas, rather than locating their layer.

"Organising and arranging is time-consuming but important, so take your time transforming and positioning the objects"

09 Open your coloured objects in Illustrator. Copy them from Illustrator and paste them into your Photoshop document. You'll be asked how you'd like to import the object as; select Vector Smart Object. Import one of each object. You can always duplicate them once they're in the document.

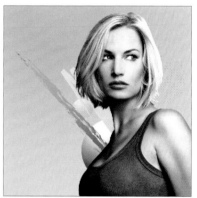

10 Name the Vector Smart Object layers as you go, as things can quickly get confusing. Organising and arranging is time-consuming but important, so take your time transforming and positioning the objects. Use alternative colours to draw attention to certain shapes.

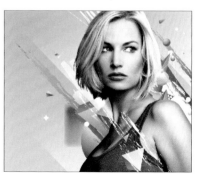

11 To add depth to the piece, bring some vectors of varying scale in front of the model too. Less is more for this piece, but adding a couple of elements in front of her is an effective way of adding a dimension to the piece.

12 Once you're satisfied with the arrangement you've created, you can add effects using the Layer Styles panel. I've chosen to add a glow to the specks and also to some of the brush strokes I've imported.

Double-click in the space next to the name of the layer you'd like to customise and the Layer Styles panel will appear. Tick the desired effect and adjust the settings accordingly.

16 Finally, add an adjustment layer to tighten up the overall look of the illustration. Select Create New Fill or Adjustment Layer (it's at the bottom of the Layers palette). You can add multiple adjustment layers if you feel you need them. Here, I've added a Brightness/Contrast adjustment layer, boosting the Brightness by 5 and Contrast by 25.

To further integrate the model with the background, add a shadow behind her. We've positioned this to match the studio lighting of the model shot. ∎

PROFILE KARAN SINGH

❯ Based in Sydney, Australia, Karan Singh has travelled extensively, working with everyone from small boutique studios to large international agencies and brands. A member of the international art collective Depthcore and the Keystone Design Union, he's constantly evolving his work believing that there is no style like freestyle.

CONTACT
• wakeupmrsingh.com

13 I've also used the Layer Styles panel to add drop shadows to some of the vector objects. In this case I'm using black for the shadow cast on the model's top but I recommend using different coloured shadows for the objects behind her. It's a subtle way of adding more colour.

14 Next, let's create some noise. Create a new layer at top of the layer stack and fill it with white. Click **Select > Filter > Add Noise**. I've added 5% monochromatic Noise on with the distribution set to Gaussian. Select OK, change the Noise layer's blending mode to Multiply, and set the opacity to 60%. Lock this layer as it's at the very top and if left unlocked, auto-select will keep choosing it.

15 Let's add a vignette. Reset your foreground and background colours to default (**D**). Click the Gradient tool (**G**) and set it to Radial. Set the white stop to 80% and the black stop to 100%. Set the white's opacity to 0% and black to 100%.

On a new layer create the gradient by clicking and dragging from the centre to the top edge of the canvas. Set the layer's blending mode to Vivid Light. Lock this layer too.

Crimson Premonition (**above**) and *Soft Surf* (**left**) demonstrate Karan Singh's skill in creating vibrant designs with a retro twist.

> INFO

TIME TO COMPLETE
• 7-8 hours

SOFTWARE
• Adobe Photoshop CS5

PROJECT FILES
• Download the files from
*theartistsguide.co.uk/
downloads*

Create a stunning pin-up collage

Use Photoshop CS5's new Puppet Warp and Repossé tools to give a fresh look to vintage-style images

On this tutorial, Malaysian design maven Ee Venn Soh shows you how to recreate this vibrant illustration that puts a modern spin on the classic pin-up style.

You'll discover how to make the most of Photoshop CS5's latest features, such as the Refine Mask, Puppet Warp and Repoussé tools.

You'll also learn how to sharpen your composition skills to create the perfect, detailed photomontage.

After following the steps here, you'll gain a valuable insight into the importance of creating balanced arrangements and paying more attention to detail; spending crucial time on those little finishing touches to a piece using simple filters is often the difference between good artwork and great artwork.

Most of the images you'll need to create this can be found on our project files. The anchor shot can be freely downloaded from stock.xchng at *bit.ly/bO2KSh*.

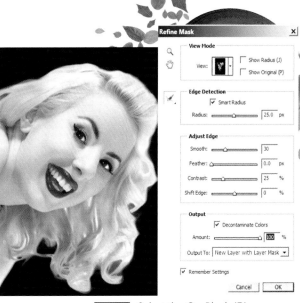

01 First, create a new A4 document in Photoshop at 300dpi and in RGB. Get the file *18885776.jpg* and then drag it into Photoshop. Notice with CS5, when you drag an image into Photoshop, it automatically becomes a smart object.

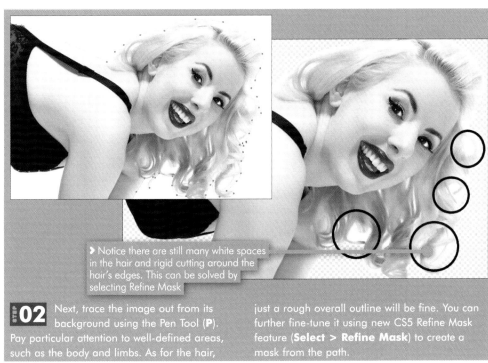

> Notice there are still many white spaces in the hair and rigid cutting around the hair's edges. This can be solved by selecting Refine Mask

02 Next, trace the image out from its background using the Pen Tool (**P**). Pay particular attention to well-defined areas, such as the body and limbs. As for the hair, just a rough overall outline will be fine. You can further fine-tune it using new CS5 Refine Mask feature (**Select > Refine Mask**) to create a mask from the path.

03 Select the On Black (**B**) option from the View Options menu. From the Edge Detection, change the radius to 25 and tick Smart Radius. Chose 30 for Smooth Radius, 0 for Feather, 25 for Contrast and 0 for Shift Edge. The edges of the hair will become more defined.

However, notice that the mask around the body and limbs gets blurry. Use the Erase Refinements tool (**E**) to paint around the parts you don't want the settings to interfere with your previous Pen Path.

To clear the halo, click on Decontaminate Colors and set the amount to 100%. Select Output to a New Layer with Layer Mask.

04 Now we will create the background. Fill it with a light grey (#F0F0F0) then add some Noise with the default Photoshop values (**Filter > Noise > Add Noise**). Next, add on a Fibre Filter on a new black-coloured layer. Set the opacity to 15% and the blending mode to Soft Light. ➤

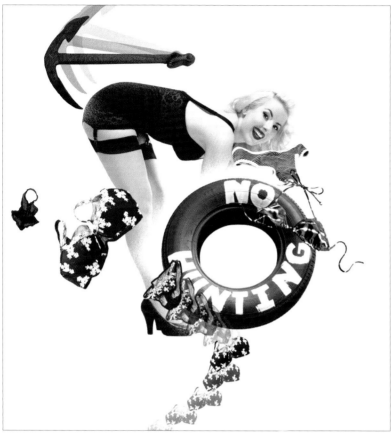

TOOL WARP

08 You can also create variations with an individual petal or leaf with the Warp Tool or CS5's new Puppet Warp. You can edit the Warp options from the Transform panel (**Edit > Transform > Warp**). Try changing the Reference Point instead of being centred all the time.

05 Using the Pen Tool (**P**) and Refine Mask (**Select > Refine Mask**), cut out the float and lingerie from files *19174483.jpg* and *24147211.jpg* and the anchor. Duplicate the anchor image and Free Transform the layer (**Edit > Free Transform** or **Ctrl + T**). Set the reference point to the far right and start rotating it clockwise and scale it down.

Layer Style

Styles

Blending Options: Default
☐ Drop Shadow
☐ Inner Shadow
☑ Outer Glow
☐ Inner Glow
☐ Bevel and Emboss
 ☐ Contour
 ☐ Texture
☐ Satin
☐ Color Overlay
☐ Gradient Overlay
☐ Pattern Overlay
☐ Stroke

Outer Glow
Structure
Blend Mode: Dissolve
Opacity: —————— 50 %
Noise: △———— 0 %
⊙ ☐ ○ [▼]

Elements
Technique: Softer ▼
Spread: △——— 20 %
Size: ———△ 250 px

Quality
Contour: [] ☐ Anti-aliased
Range: ————— 50 %
Jitter: △———— 0 %

Make Default | Reset to Default

OK
Cancel
New Style...
☑ Preview

TASK MANAGEMENT

> When you transform a bitmap image, the image becomes less sharp each time you apply a transformation. Therefore, performing multiple commands at once rather than applying each cumulative transformation is preferable.
> If you work with Smart Objects, you retain the image data and can perform non-destructive transforms without losing image quality.

06 Arrange the layers in order and set their opacity individually. I normally follow an even number order of 100% > 80% > 60% for the opacity and place the 100% layer on top.

Next, for the layers that are at full opacity, add an Outer Glow effect using a 50%-opacity white with a Dissolve blending mode. Then set the Spread to 20 and Size to 250.

07 After the main composition is done, we will start by adding the small details. This is the most painstaking part of the process and it takes time. Find some images of leaves (above) and petals (top) and trace around them with the Pen tool (**P**). Try and use images that have lots of different petals and leaves on them to generate a sense of randomness and variation.

TOOL PUPPET WARP

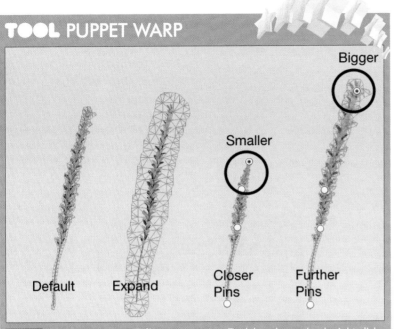

Bigger

Smaller

Default Expand Closer Pins Further Pins

STEP 09 The Puppet Warp (**Edit > Puppet Warp**) can precisely reposition or warp any image element. To edit images in Puppet Warp, convert the image to a Smart Object before applying. Click on the mesh to add pins. To delete them, simply right-click on the pin and select Delete Pin or hold **Alt** and click on them. Experiment with the mesh's Expansion values and the Mode adjustment to get different results.

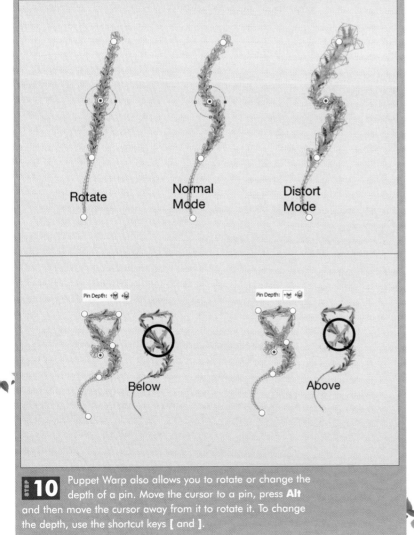

Rotate Normal Mode Distort Mode

Pin Depth: Below Pin Depth: Above

STEP 10 Puppet Warp also allows you to rotate or change the depth of a pin. Move the cursor to a pin, press **Alt** and then move the cursor away from it to rotate it. To change the depth, use the shortcut keys **[** and **]**.

> "The new CS5 Puppet Warp can precisely reposition or wrap any image element"

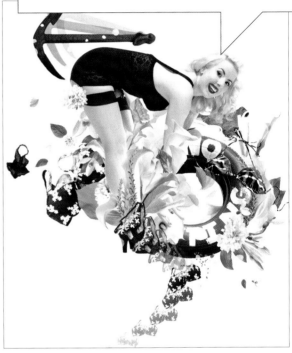

STEP 11 Now place all your completed objects onto the existing artwork. Use Levels (**Ctrl + L**) and Hue/Saturation (**Ctrl + U**) to adjust the lighting, shadow and colour of all the individual elements to make them blend as a whole.

TOOL REPOUSSÉ

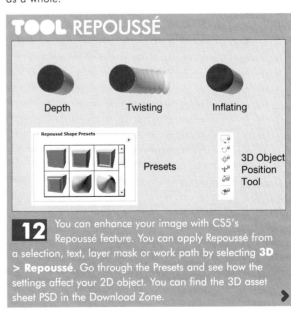

Depth Twisting Inflating

Repoussé Shape Presets

Presets 3D Object Position Tool

STEP 12 You can enhance your image with CS5's Repoussé feature. You can apply Repoussé from a selection, text, layer mask or work path by selecting **3D > Repoussé**. Go through the Presets and see how the settings affect your 2D object. You can find the 3D asset sheet PSD in the Download Zone.

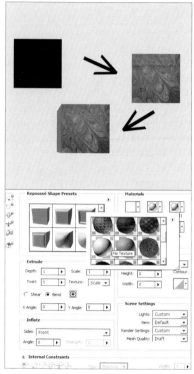

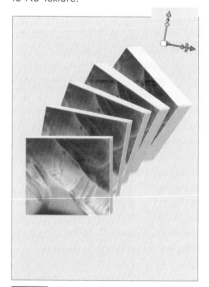

13 To make a dynamic transformation effect with Repoussé, start by creating a shape layer and add a texture to it. Next, apply Repoussé on the layer mask. Finally, change the layer's Materials to No Texture.

14 Then, position your object using the 3D Object Roll tool (**K**). Notice the depth gets thicker as it proceeds. This is done by using the 3D Object Rotate tool (**K**). You can also achieve a similar result by editing the Repoussé (**3D > Repoussé > Edit in Repoussé**) and changing the Depth value.

First Second

15 Create a solid colour layer and select a mid grey. Then select **Filter > Noise > Add Noise** and set the amount to 400 and the distribution to Uniform. Apply a Brush Strokes Spatter filter to the Noise layer with the default settings. Change the opacity to 15% and the blending mode to Overlay.

Now perform a Merge Visible everything on a new layer **(Shift + Ctrl + Alt + E)** and apply the Selective Color preset, *color.asv*, which you can find on our project files.

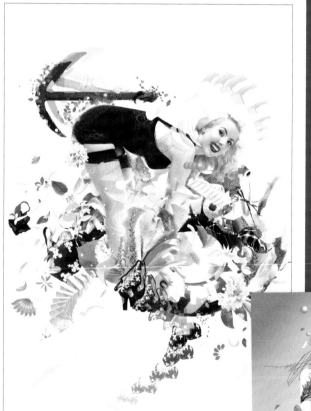

16 To finish your artwork, create random selections around the artwork with the Lasso tool (**L**) and apply **Filter > Pixelate > Color Halftone, Crystallize and Mosaic**. ■

THE BEAUTIFUL PEEPHOLE

The Beautiful Peephole (**above**) and *The Dino Club* (**below**) show Ee Venn Soh's skill with photomontage techniques.

DIGITAL PAINTING

BRUSH UP ON YOUR SKILLS AND PAINT LIKE A MASTER

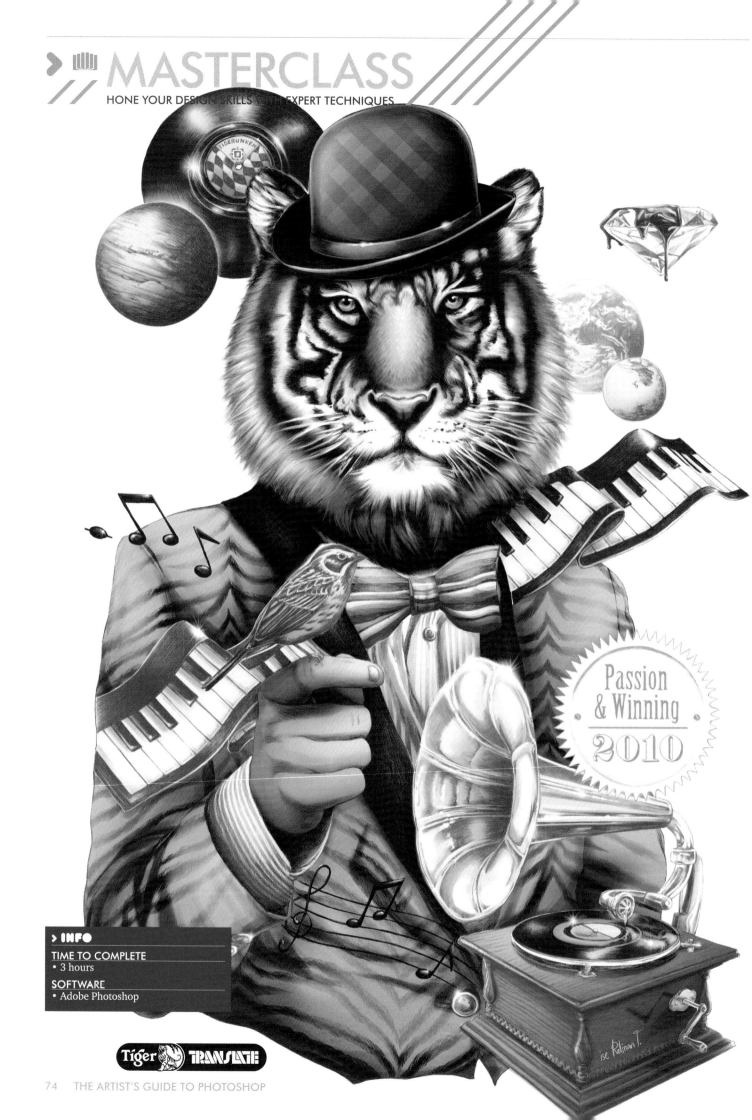

MASTERCLASS
HONE YOUR DESIGN SKILLS WITH EXPERT TECHNIQUES

Passion
& Winning
2010

> INFO
TIME TO COMPLETE
• 3 hours
SOFTWARE
• Adobe Photoshop

Tiger TRANSLATE

Elegant strokes

Ise details how she combines quirky elements with beautiful brushwork to produce groundbreaking artworks

s detailed in our feature on page 94, artists are pushing digital painting in innovative new directions inspired by a range of creative traditions. One artist who's leading the charge is Ratinan Thaijareorn – aka Ise – a Thai painter whose art draws on fine art and fashion, as well as symbolism.

Here she takes you through the process of how she creates her work,

first roughly comping the arrangement of elements using reference photos and then applying layers of brushwork above them to produce the final piece.

This artwork was created for a Tiger Translate event in Thailand, an exhibition and concert organised by the beer brand to showcase the work of up-and-coming musical and visual artists. Ise's work was displayed on banners in the event's chillout zone.

03 Before I begin painting, I always carefully select the right brush to use. For example, here I used the dry media brush set, because these brushes achieve a very similar effect to what you can get from a real, handmade brush. I use a Wacom tablet so that I can paint layer by layer as if I were painting oils or watercolours.

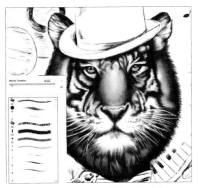

04 Using a set of brushes that I made myself at a Master Diameter of 12 pixels, I sketched the tiger's face with eyes, nose and mouth. I created these starting with dark layers, and building lighter layers on top.

01 First, I start by finding pictures, photos or images from a variety of sources. Then once I've found them, I roughy merge them into one picture so I can see what they'd look like combined and get a sense of the composition. I then used these elements to create a line drawing of a tiger.

> "Here I used the dry media brush set, because they achieve a similar effect to a real, handmade brush"

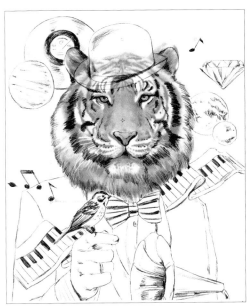

02 Once I finished the line sketch, I began the painting process, starting with the tiger's head. At every stage, I compared it with the photo of a real tiger to make sure I didn't create a poor representation of it.

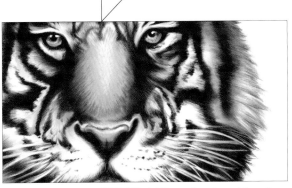

05 Adding a fine line of tiger fur between layers makes it look more realistic. I used a white-orange shade to give it a deeper colour tone.

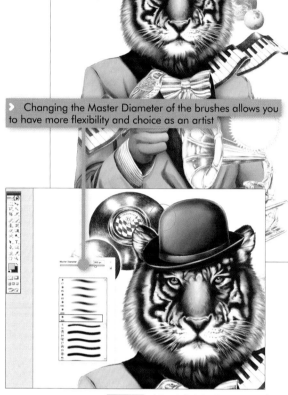

> Changing the Master Diameter of the brushes allows you to have more flexibility and choice as an artist

06 Once I finished painting the tiger face, for the next step I moved on to paint the hand. I chose a beige colour and painted a gradient of shades, using the Airbrush tool, following the contours of the hand and fingers. This tool is a great way to create tonal gradients between the light and dark colour areas, in a way that looks more appealing.

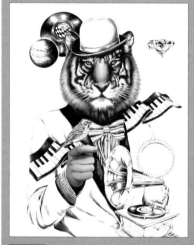

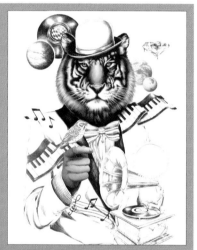

07 Here, I redrew all the strokes for the rest of the elements, over the top of the sketch using Photoshop's Pencil tool (*above left*). When I finished, I adjusted the stroke's colours to suit how each element should appear (*above right*).

08 I used the Airbrush again here – at a Master Diameter of 100 pixels – to apply a gradient to the coloured strokes to give them more tone and volume. Colour adjustments were easy to achieve using image adjustments such as Color Balance or Hue and Saturation.

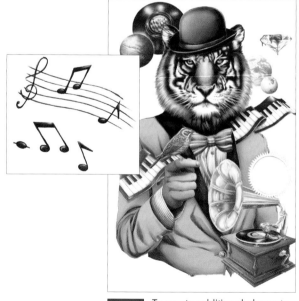

09 After I finished creating the line art elements, I began painting a base layer of each of the painted elements. I separated each object layer-by-layer to make painting them easier. Again I used the Airbrush to create tonal gradients.

10 To create additional elements such as the musical notes, I drew and airbrushed these in a separate document – before copying and pasting them into the main composition.

STEP 11 I made a new layer with a Color Burn blending mode, and used this to add more highlights and shadows. I used an auburn-coloured brush to add shadows that fitted with the colour scheme of the whole composition. As these are on a separate layer, if the effect is too strong, you can modify it using Photoshop's standard tools (**Image > Adjustments**, or through the Adjustments panel).

> "You can often further enhance compositions by adding more highlights and shadows"

STEP 14 You can often further enhance compositions by adding more highlights and shadows, and apply a light blur to the lowest layer (or layers, for more complex pieces). Here, I used a Gaussian Blur filter to make the planets and diamond appear less prominent.

STEP 12 I painted a new tiger-lined pattern, dragged it on an image as a new layer using the Darken blending mode to create a tiger cloth pattern on the jacket.

STEP 13 To create shiny highlights, I used a white brush to paint them on a new layer, and then applied the Gaussian Blur filter to this layer to make it seem more realistic.

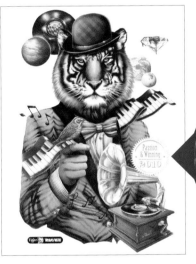

2010
2010
2010
2010
2010
2010

Passion & Winning
Passion & Winning
Passion & Winning

Passion & Winning
Passion & Winning
Passion & Winning 2010

Passion & Winning
Passion Winning
Passion & Winning 2010

STEP 15 The wording for the type was chosen by the client. Finding the right font for this was a matter of trial and error. The final stage was to add the client's logo. ∎

PROFILE RATINAN THAIJAROEN

> Ratinan is a 24-year-old artist (who illustrates under the moniker of Ise) who was born and raised in Bangkok, Thailand. She describes painting as her best friend, and she loves to draw the female form in a style drawn from the fashion industry. She has a degree in visual communication art and design from Rangsit University, and now works as a freelance illustrator.

CONTACT
• dieeis.wordpress.com

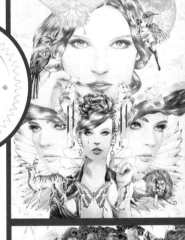

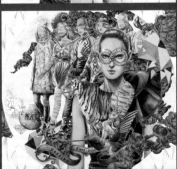

Ise enjoys getting her teeth into big multi-image projects like these (*The Moon* (top) and *The Seven Days* (bottom) which were created for the Tiger Translate event in Thailand.

> **INFO**

TIME TO COMPLETE
• 8-12 hours

SOFTWARE
• Adobe Photoshop

PROJECT FILES
• Download the files from
*theartistsguide.co.uk/
downloads*

80s airbrush effects

Combine multiple brush types for vibrant results

Want to create a beautiful, dreamlike painting full of subtle details but with a bold 80s colour scheme? Design duo KittoZutto show you how in this tutorial on creating an airbrushed portrait tapping the glory days of Athena posters.

You'll learn how to improve your brush skills, working with a variety of different brush heads for varying effects and you'll learn how to get the most out of colouring, masking and layer blending modes.

You'll also learn the benefit of working with lots of layers in a digital painting, as this allows you to work on elements separately and quickly adjust detail and colouring.

A layered version of the final composition, for reference, can be found on our project files.

01 You will need to sketch out a rough guide for the portrait. It can be really rough line work, just to give you enough indication on the overall composition of the elements, like the placement of the eyes and nose and the shape and movement of hair.

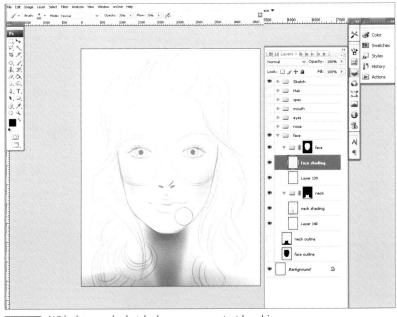

02 With the rough sketch done, we can start brushing in the shadings. Using the Pen tool (**P**), create a path around the face shape and use the shape as a mask for your shadings. Using a soft brush, start to brush out the dark areas of the face. Do the same for the rest of the sections.

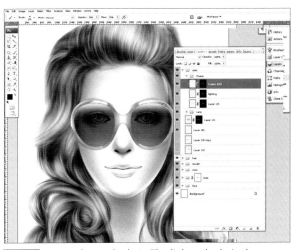

03 Proceed onto the hair. The lighter the hair, the smaller your brush needs to be. Create a path around the sunglasses using the Pen tool – make sure you include the frame as well as the lens. Using the shapes as masks, use a soft black brush to shade in the area. Similarly, use a white brush to apply the light reflections.

04 Now that we have a finished sketch, we can start colouring the image. By having a completed sketch, half the work is already done. Begin by creating a new canvas with a gradient background. Use a green to brown gradient as shown. Next, import the black and white shadings into the canvas.

05 Start converting the shadings to colour using the hue and saturation settings as shown. Set the dark shadings layers to Multiply to blend against the skin tone. Add tints to the face by brushing different colours near the edges of the face. They will be masked within the face shape. ▶

STICK TO THE RIGHT PATH

> After creating paths out of shapes using the Pen tool, make a selection from the shape and create a mask from it. If you find the edges of the path too sharp, you can apply a Gaussian blur to the mask itself to soften the edges

06 Now add some colour to the nose. With the black shadows' blending mode set to Multiply, apply a Gaussian blur with a Radius of 2 pixels to soften the nostrils path. Using a soft brush, add some shine on the tip of the nose as well as the bottom.

09 Using a soft brush, fill in the lips with a pinkish base colour. Build up details such as a lipgloss effect by brushing over white colour and carefully erasing lines using the Eraser tool. Set this layer to Overlay. Add some tints to the lips by experimenting with different coloured brushes and set their layers to Multiply, Soft Light or Overlay.

> The Airbrush setting can be turned on in either the toolbar (left) or in the Brushes panel (below left)

07 Block the eye with a light grey base colour. Apply shadins with a Multiply blending mode and highlights with Overlay. Fill in the pupil with details and light reflections. Add subtle details to the eye such as glittering shadows by using a white brush.

10 Add some subtle details to the face, such as skin textures, by using a white brush. Turn on the Airbrush setting and set the Opacity to 70% and the Flow to 70%. Select Scattering in the Brushes panel and set the Scatter to 393%. Set these layers to Soft Light with the Opacity at 60%.

08 Apply some makeup by brushing pink, grey and green on the side of the eye and set the layer mode to Overlay. Duplicate this whole group and flip it to form the right eye. Take note of details such as the direction of light reflection to avoid being too symmetrical.

11 Block out the hair with a base colour, then create shadows using a layer set to Overlay and highlights layer using Overlay and Soft Light. Add some tints to the outer hair by brushing in some orange and the inner hair with dark green. Set the blendings of these layers to Soft Light.

STEP 12 Create the earrings using the Pen tool (**P**). Enhance them by applying an Inner Shadow effect. Set the colour to white, the blending mode to Color Dodge, the Opacity to 100%, the Distance to 5px and the Size to 20. Mask off unwanted areas using a soft brush.

STEP 13 Next, create the sunglasses by blocking them with a base colour. Blend in the highlights and shadows using blending modes such as Overlay or Soft Light. Create the shadow of the sunglasses on the face by applying a Drop Shadow effect (right-click the layer and select **> Blending options > Drop Shadow**). Set the Blend mode to Overlay, the Opacity to 100%, the Distance to 2, the Size to 11 and mask off unwanted shadows.

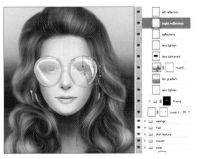

STEP 14 Now add some lenses to the sunglasses. Use a colour gradient as the lens colour. Set it to Pin Light, Opacity 85%. Darken the lens area slightly. Next, create rectangular-shaped reflections and blur them using the Gaussian Blur filter. Distort them slightly using the Warp tool. Experiment with layer modes to blend in the reflections.

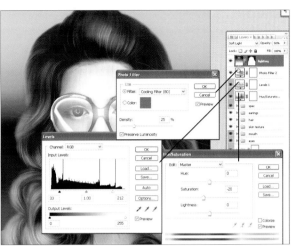

STEP 15 Apply some tint by overlaying magenta onto both the frame and lens. Adjust the overall colours of the portrait by using the following Layer Adjustments: Saturation -20, Levels 33, 1.00, 212. Add a Cooling Filter (80) on top. Create a gradient with the layer mode set to Soft Light and Opacity 50%.

Add subtle details to the eye such as glittering shadows by using a white brush

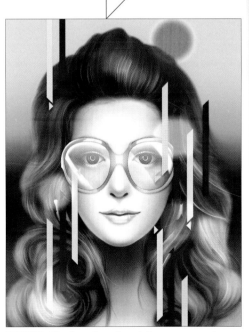

STEP 16 Finally, take a break from your work and revisit it later with fresh eyes. You'll begin to see some of the things that weren't visible to you before and other ways to improve your creation, for example, adding other elements like the bars to stylise the portrait. ∎

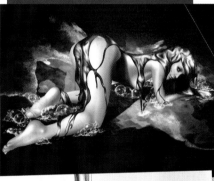

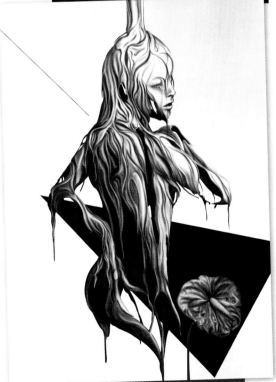

Kittozutto show their exquisite use of blend modes with *Bubbles* (**top**) and *Ephemeros 3* (**above**).

> **INFO**

TIME TO COMPLETE
• 13 hours

SOFTWARE
• Adobe Photoshop CS3/CS4/CS5

PROJECT FILES
• Download the files from
*theartistsguide.co.uk/
downloads*

> **LEARN** FLAME EFFECTS

Master Adjustment Layers and blending

Ignite your imagery with techniques that will create fiery forms

On this tutorial, we're going to take a simple model shot and transform it into a spitting, crackling beacon of fire.

Using some of the most common Photoshop tools (like Smudge, Dodge and Burn) Neville D'souza shows how to create a complicated artwork

without relying on third-party plug-ins. This lesson will also give you good practice with Photoshop's Levels and Adjustment Layers – which can be extremely powerful if used properly – as well as Layer Masks and Blend Modes to create stunning, and yet sometimes quite subtle, effects.

LENS FLARE EFFECT

> Using the same techniques as in the tutorial, you can come up with cool eye candy. Create a layer filled with a black colour, then go to **Filter > Render > Lens Flare**, select 50-300mm Zoom, position it where you want on the thumbnail and click OK. Then go to **Image > Adjustments > Hue/Saturation** and drag the hue slider to 180. Click OK and switch the layer's blending mode to Screen.

> The best way to judge for shadows and highlights is to switch the layer Blend Mode to Normal and then back to Color Dodge

01 First, open *24165569.jpg* from the project files and set its colour profile. Click **Edit > Assign Profile** and select Adobe RGB (1998) from the Profile drop-down list. This way, colours appear more vibrant and contrasting. Next, create the background. Fill a layer with colour, at R:127 G:53 B:41. Create a second layer with a Radial Gradient (**G**) then set its Blend Mode to Multiply.

04 Once that's done, set the Blend Mode of the stroke layer to Color Dodge. You can see how it takes effect, even in this initial stage. Next, use the Dodge and Burn tools (**O**) to tighten the effect.

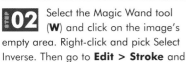
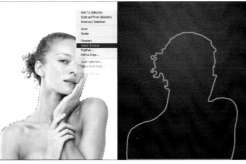

02 Select the Magic Wand tool (**W**) and click on the image's empty area. Right-click and pick Select Inverse. Then go to **Edit > Stroke** and select a Stroke Width of 50px, set the location to Inside and a Stroke Color of R:128 G:128 B:128. This stroke shape will be in a separate layer.

03 This is the interesting part – even if you make a mistake here, it can be turned into something artistic. On the 'Stroke' layer, use the Smudge tool with Hardness (on the Brush palette) set to 100%. Don't go too high in size, or it may take up too much memory. Smudge swirling wisps in an upward direction. Keep the reference image at an Opacity of 20% to help shape flames along the contours of the body.

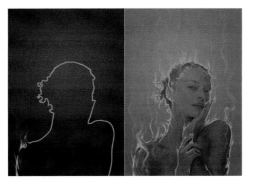

05 Right now, the flames aren't glowing. For that, I turn off the 'Gradient' layer, select the 'Color' layer and highlight a few areas with the Dodge tool, followed by duplicating the 'Color' layer. Go to **Image > Adjustments > Levels** and set the black slider to 115. Then, using the Hue/Saturation adjustment, shift Hue to 18. Finally, set the Opacity of the new colour layer to 50%, ensuring this layer is right under the 'Stroke' layer for the effect to be prominent. ❯

06 The flame effect needs to be enhanced even more. This is where the 'Stroke' layer comes in. Duplicate it three times and add a Gaussian Blur with a value of 80 to two of these. Next, add a Layer Mask with a Radial Gradient for the three newly duplicated layers. Look at the screenshot to see the layer order and what the image now looks like.

> This black background is temporary, just to show what the shapes look like

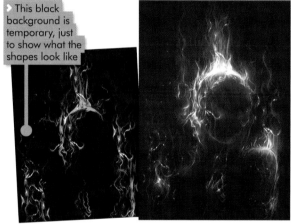

07 Using the same smudge technique as explained in Step 3, create more flame shapes in different layers – this is so you can have an extra level of control in case any of them need alteration. The Blend Mode of all the flame layers should be set to Color Dodge, followed by the Dodge and Burn treatment. It's best to keep these layers inside a layer group to avoid any complications.

08 Using a hard brush to create the sparks, paint blobs of different sizes on a separate layer. Dodge and Burn them and switch the Blend Mode to Color Dodge.

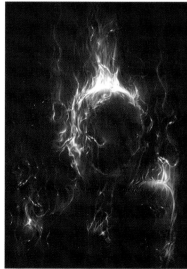

09 I felt the facial region needed more flames, so I painted and smudged an extra batch of flame shapes on to the image. These are slightly more stretchy and wavy, to follow the contours of the model's face.

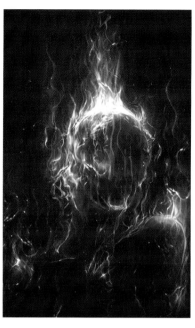

10 Next, using the stroke shape in Step 2 but this time without the flames, darken and highlight certain areas using the Dodge and Burn tools. This is for the subtle lining of the shoulders and neck area.

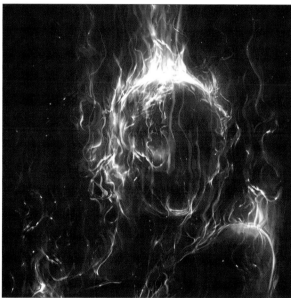

11 Now comes the tricky part: blending the model's face and a bit of her hands into the flames while keeping it subtle. On the reference image, use the Dodge tool to highlight areas of her face, hands, shoulders and so on. Next, keeping the layer selected, click the Create New Fill or Adjustment Layer button. Select Curves from the list then add points, adjusting the curve to get the desired look. You can see how the curve drastically alters the image.

STEP 12 Select the entire image, then Copy Merged (**Shift + Ctrl/Cmd + C**). Paste the image onto a new layer, then click **Image > Adjustments > Desaturate**. Again, click Create New Fill or Adjustment Layer, select Levels from the list and move the black point slider to 60.

STEP 13 Select the entire image again, click Copy Merged and paste the image onto a new layer. Then, using a soft brush, paint the white area with a black colour and finally, using the Burn tool, darken certain parts of her face and arms (the burn value can be experimented with). Next, use the same 'Curves' Adjustment Layer from Step 11 and place it on top of the 'Image' layer.

> This screenshot shows steps 11, 12 and 13 in layer groups. The 'Curves' layer from Step 11 was simply dragged on top of the image layer in Step 13

STEP 14 Now it's time to combine the model shot with the flames. Select the image from Step 13, copy the merged layers, and paste into your main artwork file under a new Layer Group called 'Color Edit', above the other layers. Apply Gaussian Blur to reduce facial detail. Duplicate it twice.

On the original picture, rename the image layer 'Blue A'. Switch on Colorize in Hue/Saturation and set the Hue to 235, Saturation to 100, the Blend Mode to Lighten and Opacity to 15%.

Copy 'Blue A' and rename it 'Blue B'. Change the Opacity to 35%. Rename the second desaturated image layer 'Yellow A'. Move it on top of 'Blue B'. Set the same options for this as 'Blue A' – except Opacity, which should be 25%. Copy this layer and call it 'Yellow B'. Click Create New Fill or Adjustment Layer, select Levels and move the grey slider to 0.88. Duplicate this adjustment layer, naming them 'Levels 1' and 'Levels 2'.

STEP 15 Duplicate the 'Yellow B' layer and rename it 'Yellow C'. Move it above the 'Levels 2' layer. Set the Blend Mode to Color Dodge and the opacity to 25%.

Rename the third desaturated image layer 'BW image' and move it on top of 'Yellow C'. Set the Blend Mode to Color Dodge and the Opacity to 75%.

Add Layer Masks for all layers except 'Yellow C'. Also add a Layer Mask to the Group 'Color Edit' to hide the eyeball section, so the eyes remain looking at the viewer.

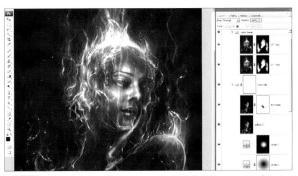

STEP 16 Select the entire image and click Copy Merged. Paste it into a new layer group called 'Color Tweak'. Rename the layer 'CT-hue' then click **Image > Adjustments > Hue/Saturation** and set the hue to 8. Click OK and set Opacity to 25%. Duplicate 'CT-hue' and name it 'CT-blur'. Make sure Blend Mode is set to Screen and Opacity is at 15%. Add Layer Masks to both layers. If you want to add any more sparks or flames, create extra layer groups. ∎

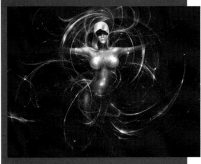

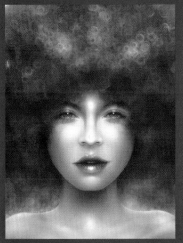

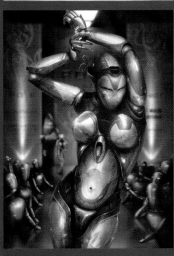

Top A State of Sublime Ecstasy makes much use of Blend Modes, as does The Showstopper (**above**)
Middle Adjustment Layers created the look and feel of Sweet As Candy

MASTERCLASS
HONE YOUR DESIGN SKILLS WITH EXPERT TECHNIQUES

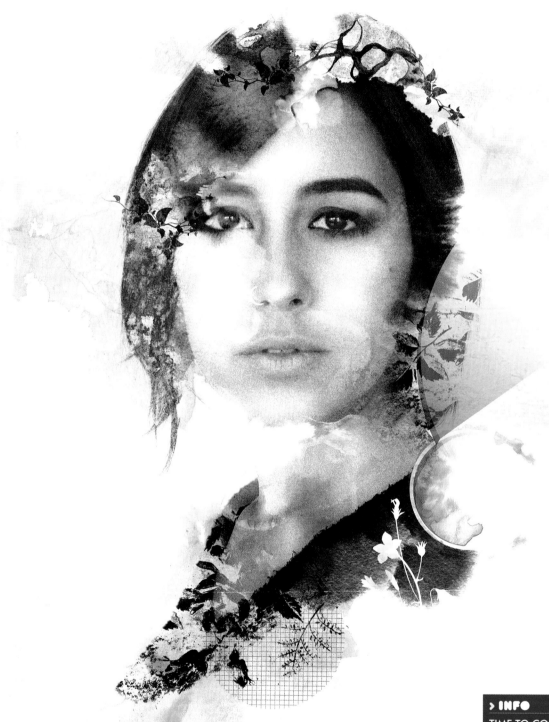

> **INFO**

TIME TO COMPLETE
• 2.5 hours

SOFTWARE
• Adobe Photoshop CS or later

PROJECT FILES
• Download the files from
*theartistsguide.co.uk/
downloads*
Please note: the files are for
educational purposes and cannot
be published or redistributed.

Paint and layer a distressed damsel

Blend watercolour and textures from old textiles and photos to create a mixed media artwork, explains Murilo Maciel

ixing media is a true art form. Brazilian illustrator Murilo Maciel demonstrates this in two new series of experimental artworks, *Distressed Beauty* and *Moon*. These mixed media pieces combine high-fashion photography with watercolours and tactile textile textures. The handmade feel is further emphasised by replicating the handmade look of screen printing.

In this tutorial, Murilo reveals how he composes these pieces. You'll learn not only how to mix watercolour with photos, and use blending modes effectively, but also how to marry them together, harmoniously.

The model shot and scanned watercolour washes can be found in our project files; these are Murilo's files for use in the tutorial only. They should not be used in other projects.

TIP THE POWER OF WHITE SPACE

> Think of white space as a design element. It can be as important as the illustration itself, and if well deployed, gives your artwork room to breathe. It will also guide the eye to the page's main elements.

04 Open *canvas.psd* and adjust the levels of the photo to increase the contrast. Select this layer, then **Image > Adjustments > Levels** (**Cmd/Ctrl + L**). Change the left-hand shadow input to 14 and the right-hand highlight input to 199.

Make a selection from the photo layer by holding down **Cmd/Ctrl** and clicking on the layer in the Layers panel.

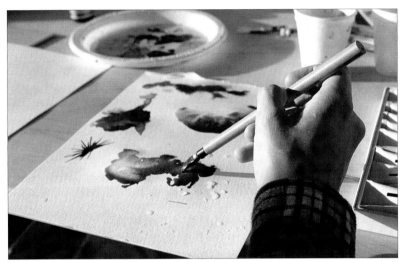

01 First, paint some black watercolour washes. Try to do as many as possible, so you'll have lots of variations to choose from. This is perhaps the most important part of the project, as the image will be overlaid on these washes. Hence, experiment with different papers and tools, in order to get nice textures and shapes.

> "Create mask by clicking on Vector Mask button. Set blending mode to Screen"

02 Let's paint some coloured washes. The key here is to keep experimenting, not only with tools and paper, but also with materials. Iodised table salt and Isopropyl alcohol give a really nice texture. Use different amounts; mix them up, or whatever you have in mind.

03 Now is a good time to paint some decorative elements, like ornaments and patterns. Once finished, wait until dry and scan in. If you don't want to get your hands dirty, use the images on the project files. I highly recommend you create your own as it's fun and you'll have more control over the final piece.

05 Create a layer group under the photo in the layer stack. Using the previous selection, create a mask by clicking the Vector Mask button at the bottom of the Layer panel. Select the photo again, and set the blending mode to Screen. You'll notice that the photo will disappear. >

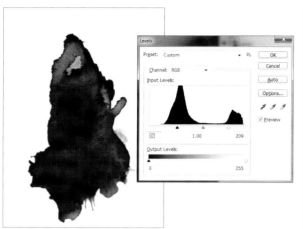

TIP DETAIL MATTERS

> Pay extra attention when adding detail to your image. This is as important as composition and colour — it's the difference between an amateur and professional image. Always make sure your elements blend well together and don't look like they've just been pasted over the image.

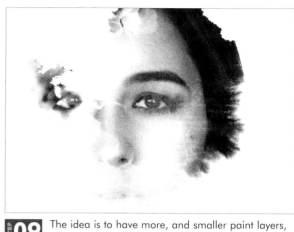

06 Open *blackwashes.jpg* and select each wash with the Lasso tool (**L**), then copy and paste them into our image. For each, hit **Cmd/Ctrl + L** to open the Levels dialog, and adjust the levels to 74, 1, 209 respectively to increase the contrast of each wash.

09 The idea is to have more, and smaller paint layers, instead of just larger ones, to give far greater control over our image. It will also look richer and more detailed, too. Copy a few more washes into the folder, but change the blending mode of each layer to Multiply.

07 Pick one of the washes and turn it into a black-and-white image by selecting **Image > Adjustments > Desaturate (Cmd/Ctrl + Shift + U)**.

Sharpening will emphasise texture, which is very important to get a great-looking image. Go to **Filter > Sharpen > Unsharp Mask** and set the amount to 106% and radius to 0.8. Repeat for each wash.

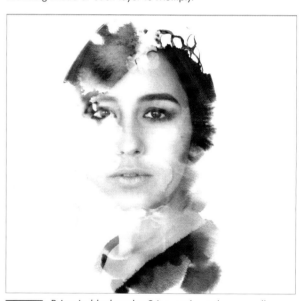

10 Bring in *blackwashes2.jpg* and use these smaller elements to add detail. Keep building the image, until you're happy with the results. Pay special attention to the borders of your image; try to leave a lot of white space, too. Incorporate some of the painted patterns you created before. This will make the image more interesting.

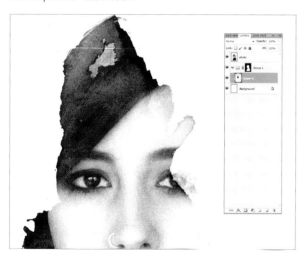

08 Move a wash into the layer group; you'll notice our image will begin to appear over the black areas of our paint. This is the main concept of this style, so it's important that you've mastered this creative process. Make this layer 60% smaller and place it where you wish.

11 Open *coloredpaint.jpg* and copy and paste it into the layer group. Resize it to 50% of its original size, and set the blending mode to Multiply. Move it to the left-hand side of the artwork. Duplicate it, then move this copy to the top of your image.

STEP 12 Open *oldwallpaper.jpg*. Go to **Image > Adjustments > Desaturate (Cmd/Ctrl + Shift + U)**, then select **Image > Adjustments > Threshold** and set the Level to 144. This will simulate a screen-print effect. Copy this into the layer group, setting the blending mode to Multiply, and duplicate it. Move one copy to the bottom-left part and the other to the right – as shown.

STEP 13 The image is pretty much done: It's time to work on the detail. Open *wc_circle.jpg* and make a rounded selection around it, using the Elliptical Marquee tool. Copy the layer above the photo and move it to her right shoulder.

Go to this layer's Layer Style by double-clicking it in the Layer panel. Select the Stroke box and set the Colour to white and the Size to 4.

STEP 14 Let's add some more decorative elements. Open the file *branch.jpg*. Copy it to the layer above the photo; set the blending mode to Multiply. Duplicate this a few times, and place the copies around the image, ensuring some sit next to the model's eye and hair.

Create a mask around each branch element. Soften the edges using a soft rounded brush with 40% opacity to better blend with and colour match the rest of the composition.

STEP 15 Keep working on the details. You could add more watercolour elements to the background – and over the image, too – to create a more appealing-looking composition. This also helps to blend the elements together better.

STEP 16 Create a new layer above the photo. Draw a circle with the Elliptical Marquee tool. Using the Gradient tool, fill it with colour values of c45 m90 y50 k40 and c15 m0 y60 k0 for the ends of the gradient, and set the blending mode to Hard Light.

For an abstract feel, use the Lasso tool (**L**) to delete parts of your circle. Add an additional lighting effect by duplicating the circle, rotating it about 45 degrees, and setting its blending mode to Screen. Now you're done. ■

PROFILE MURILO MACIEL

> Murilo Maciel is a Brazilian illustrator based in Vancouver, Canada, working under the name Grafikdust.

Murilo loves to experiment with different medias and techniques. His clients include Coca Cola, BBH/London, Ogilvy & Mather, JW Thompson, Vodafone, Leo Burnett Chicago, Philip Morris, Pizza Hut, Sony and many others.

CONTACT
• *grafikdust.com*

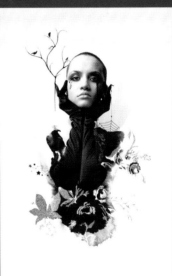

Top *Moon* was a fun, but also, rather challenging personal project as every group of elements had to work, both individually and together.
Above *Economic Review*: This series gave birth to the technique Murilo uses in this tutorial.
Below *Kyocera* is good example of how Murilo approaches paint in a very different way, to how he normally does.

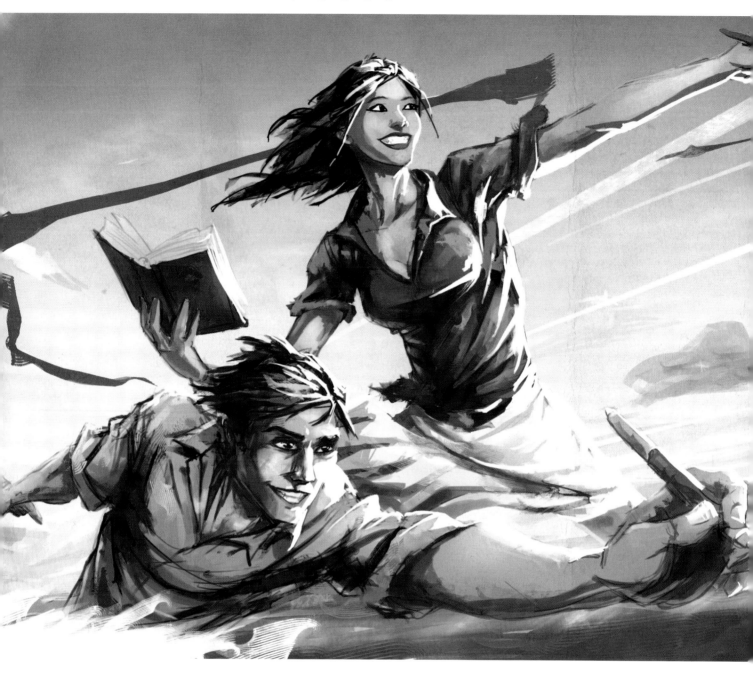

> **LEARN** CUSTOM BRUSHWORK

Draw inspiration from Chinese propaganda posters

David and Sarah Cousens give a guide to the techniques of the rousing political images from years past

here do you find your inspiration? Unlike a lot of Western propaganda posters which tended to be negative, Chinese propaganda posters of the 20th century depicted an overly positive amalgamation of fact and fiction, showing both life as it is and 'life as it ought to be' to inspire the Chinese population. Negative elements were ignored altogether, and the focus was on heroic 'everyman' characters looking forward to building a united utopian future (despite the reality being very far from this).

This tutorial takes you through how to make a subversive pastiche of Chinese propaganda posters using Photoshop. To emulate the motivational tone of these posters we'll be working on a theme of 'inspiration'. To help you make a successful pastiche we recommend collecting a lot of reference pieces and viewing them all in one place, side by side (whether on a table or in Photoshop) so that you can easily compare them to each other and identify recurring elements.

01 First off, find some images of original Chinese propaganda posters to use as inspiration. Create a new A4 landscape document. Select a colour of R 123, B 161, G 184. Press **Shift + Backspace** to bring up the Fill dialog box. In the Contents section, select Use: Foreground Color to fill the canvas with a pale blue.

02 Create a new layer called 'White Border', select a pure white colour and fill it using **Shift + Backspace**. Select the Square Marquee tool (**M**) and draw a widescreen/letterbox-style rectangle selection across your image, then add a layer mask (the circle-in-the-square button in the Layers panel). Press **Cmd/Ctrl + I** to invert the mask.

03 Select the Linear Gradient (from the Paint Bucket flyout menu), set opacity to 25%, click on the Foreground to Transparent option and pick a colour of R 222, G 212, B 211. Go to the background layer and drag the gradient from the bottom right towards the top left to create the light grey gradient transition of the sky.

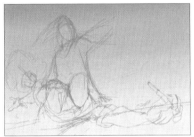

04 Create a new layer called 'Roughs' and sketch in your layout with a light blue brush. Your characters should be dynamic and optimistic-looking. Lock the layer's transparency (click on the padlock icon in the Layers panel) then press **Shift + Backspace** and fill the layer with black. Lower the layer's opacity to 64%.

05 Create a layer called 'Red Land' underneath the 'Roughs' layer. Use a hard-edged brush with Opacity Jitter set to Pen Pressure to paint in a red landscape. To simulate perspective, make the reds in the foreground darker and more saturated, with more muted colours for the distant land. The Opacity Jitter option can be found in the Brush panel, in the section named Transfer in Photoshop CS5, or Other Dynamics in older versions.

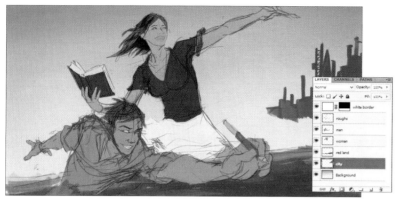

BRUSH WITH SUCCESS

> Making your own custom brushes is easy: select any brush, then click on the Brushes tab and start experimenting with the settings. For example, try altering the Texture, Scattering and Dual Brush options and see what happens.

06 Create two new layers called 'Man' and 'Woman' respectively. Position the 'Man' layer above the 'Woman' layer, and block the characters in with flat colours. Create a new layer, 'City', and paint in a retro-futuristic city skyline with a mixture of blues and greens. The Chinese posters we're referencing often focused on bright new futures, so include a rocket as part of the narrative.

09 Create a new 'Highlights' layer above 'Roughs'. Use a hard-edged brush to render in light yellow highlights on the characters. The human eye is drawn to contrast; using a bright colour will draw the viewer's eye to the focal points. Change the blending mode of the 'Roughs' layer to Overlay and erase any unneccessary construction lines.

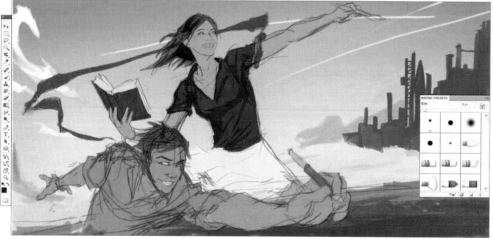

07 Create a 'Clouds' layer and paint some stylised clouds using various pinks and greys to keep with the colour scheme. Use the clouds as pointers; subtly angle them to lead your eyes back to the main focal points (the characters). Using the Magik custom brush, add a flowing red sash on the woman's arm; make sure it points back towards the characters.

10 Create a new layer: 'Man Overlay'. In the New Layer box tick 'Use previous layer to create Clipping Mask' and set the blending mode to Overlay. Create a 'Woman Overlay' layer with the same settings. Use the Radial Gradient with the yellow highlight colour to add highlights to the characters' skin, for example.

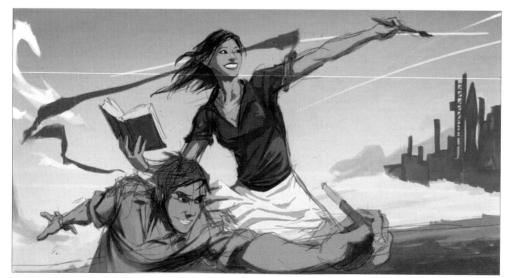

08 Start to add basic shading to the 'Woman' layer, using a light source coming from the right. When you've established the basic shading you can switch your attention to the 'Man' layer and do the same. Use local colours (colours from elsewhere in the image) in your shading as colours are always affected by their environment.

11 Lock the transparent pixels of the 'City' layer, then paint in some darker and lighter details. Just use simple brushstrokes to imply details. Open 'Cloud Texture' from *texturise.com* (tinyurl.com/2u4836p), press **Cmd/Ctrl + A**, **Cmd/Ctrl + C** to Select All and Copy the contents of the image.

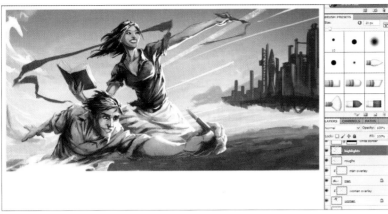

12 Press **Cmd/Ctrl + V** to paste in the cloud photo above the background layer. Free Transform (**Cmd/Ctrl + T**) the photo to fit your illustration, then set the blending mode to Soft Light at 92% opacity. Create a 'Sky Details' layer and use the Magik brush to add some more vapour trails soaring into the sky.

13 Return to the 'Highlights' layer and start painting over the linework using the Magik brush. When you've finished, hide the visibility of the white border layer. Now hit **Cmd/Ctrl + Alt + 2** to select the image's luminosity (it's **Cmd/Ctrl + Alt + Shift + ~** in older versions of Photoshop).

15 Go to *translate.google.com*, type in an inspirational phrase and translate it to Chinese (Traditional). Copy the translation, go back into Photoshop and select the Type tool (**T**) to paste in your Chinese translation. Free Transform it into place (**Cmd/Ctrl + T**) and change the text colour to red.

14 Press **Cmd/Ctrl + Shift + C** to copy from all of the visible layers and paste the contents into a new layer. Set it to Overlay at 67%, go to **Filter > Blur > Gaussian Blur** and apply a blur of 1.4 pixels. Make the 'White Border' layer visible again by clicking the eyeball in the layers palette.

16 You're almost done. Now head to *tinyurl.com/2vzm7m8* and copy and paste the paper texture there onto the top of the layer stack. Set the blending mode to Multiply at 36% opacity. Hit **Cmd/Ctrl + U** and desaturate by moving the Saturation slider all the way to the left. Finally, press **Cmd/Ctrl + L** and lighten the texture using the white Levels slider as shown in the screenshot. ■

David's back catalogue includes artwork for *Dazed & Confused* and an illustration to celebrate the release of *Monkey Island 2 Special Edition: LeChuck's Revenge (above)*.

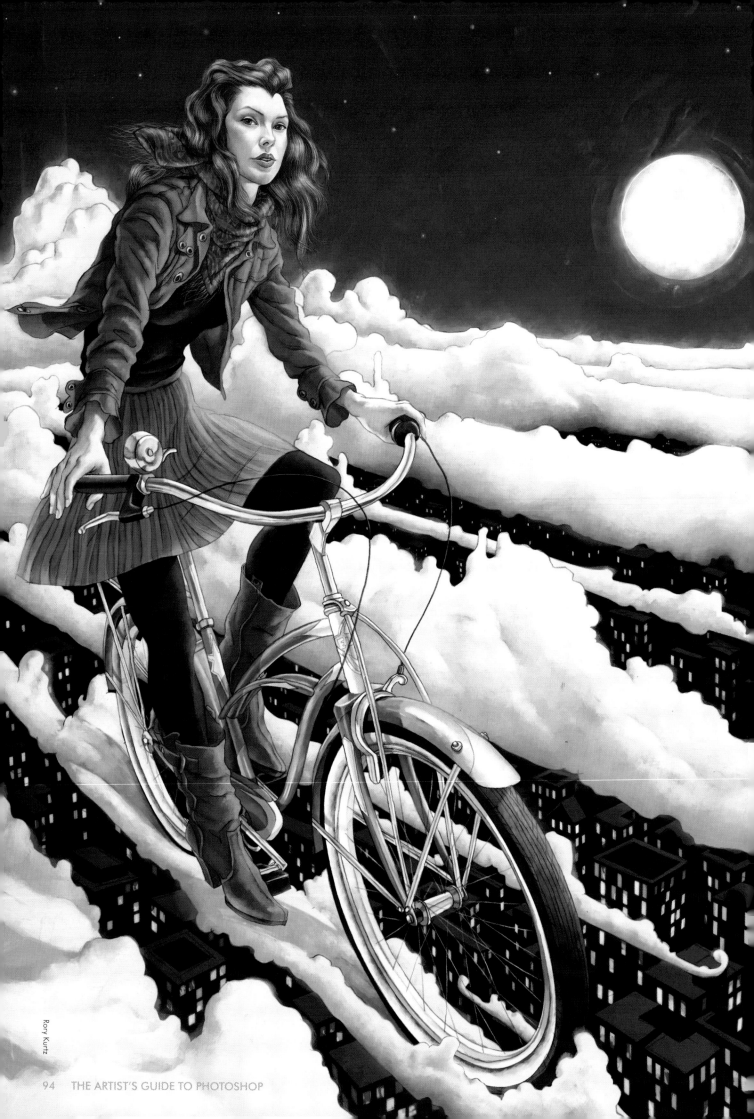

Brushes with Genius

Digital painting is stepping into the big leagues. **Alice Ross** meets the creatives poised to create a stir with their work

*I*f you thought digital painting was purely the preserve of dodgy fantasy art involving clichéd depictions of elves and dragons, think again. A wave of artists is harnessing technological improvements and frankly ridiculous levels of talent to transform the medium, creating works that combine the richness and human feel of painting with a slickness that could only be digital.

It's easy to see the appeal: "I like the flexibility," explains Sam Gilbey (*sam-gilbey.com*). "I can decide in a moment if I want to try a different technique, and if it works, great, but if it doesn't, I can go back to where I was without having to redo my artwork from scratch." He adds that digital painting is mess-free.

However, digital painting has long been a niche technique. The fact that Photoshop – the key package of most creatives – had only basic tools meant that many simply never got around to experimenting with it, while the clumsy efforts that crowd many fantasy art sites did nothing to aid digital painting's reputation.

All that is set to change. Over the years, painting packages such

as ArtRage and Corel Painter have developed into powerful tools and attracted a dedicated following.

Painter in particular offers incredibly sophisticated naturalistic painting tools and features such as pressure sensitivity, which allows creatives to use the styli of graphics tablets as though they were paintbrushes. Many traditional painters have crossed the fence to digital, lured by the increasing responsiveness of graphics tools.

Now, the new Photoshop CS5 boasts vastly improved painting capabilities, while the iPad is touted as a portable, tactile canvas, with a raft of high-end painting apps available. Prepare yourself for an explosion of work in the next couple of years as more digital artists start experimenting.

Digital painting is uniquely demanding, requiring advanced drawing, composition and colouring – essentially fine-art skills – as well as the technical savvy to get the effects right. Get it wrong and it can be really dire; get it right and it's totally sublime. We spoke to five artists who lead the field today – with not an elf or a dragon in sight. >

Master the art
Paintings tips by Sam Gilbey

● Stay focused: "You have so many options available to you that it can be tempting to introduce too many styles into a piece."

● Even within a style, limit yourself to a few techniques for each piece.

● "It's essential to work with a pen and tablet. A mouse click [provides] no pressure sensitivity to make more subtle marks," says Sam.

● Explore different software: "I use Painter because it offers convincing 'real media' effects, but all pieces are taken through Photoshop at the end."

Sam Gilbey's tribute to favourite programme *Flight Of The Conchords*.

Tom Bagshaw

Canvas to pixels

"I never touched a computer until about ten years ago," says Bath-based artist Tom Bagshaw. "Up until that point I was still very much a traditional artist – set in my ways with acrylic, pen, pencil and airbrush."

Then he encountered Painter and Wacom tablets. "That change my whole outlook on using computers in your workflow," he says. "It allowed me to create work in a familiar way while cutting out the mess, shortening the time-span and easing delivery to clients."

The graphics tablet is key, he says: "You can kind of get away with not using one for some types of work but for painting it's such an intuitive way of working that if it didn't exist, I just wouldn't be working digitally."

Tom divides his work into two categories: 'pure' digital paintings, created almost entirely in Painter and others with painted elements but more graphic elements. However, he'll also dip into ArtRage, Illustrator and 3D software "when the need arises".

In his pure digital paintings, the Gothic colour schemes and solemn poses of his exquisite, sensual portraits are undercut with wit. Flashes of colour and extremely contemporary character design sometimes make it seem as though toys have escaped from a Japanese toyshop and are hiding out in a collection of Victorian photographs.

"My favourite tool in Painter is the oil brushes," says Tom. "Painter's brushes are quite amazing and I have a lot of custom brushes that I employ, but I do come back to a small selection of oil brushes which I've saved with quite minimal custom settings and use them for pretty much everything I do."

His mastery of digital brushes is indisputable, but he's currently contemplating experimenting with older forms again. "I hadn't even touched a paintbrush since I started working digitally," he says, "but I created a traditional painting for my solo show recently and I'm looking at getting back into it again."
mostlywanted.com

Working from a base sketch, Tom blocked out the basic face in ArtRage and worked up the fine details using the oil brushes in Painter. Then he painstakingly painted in the hair using layer masks and brush strokes in Photoshop, before layering gossamer-fine textures and brush strokes, set within more layer masks, for the clothing, all still in Photoshop.

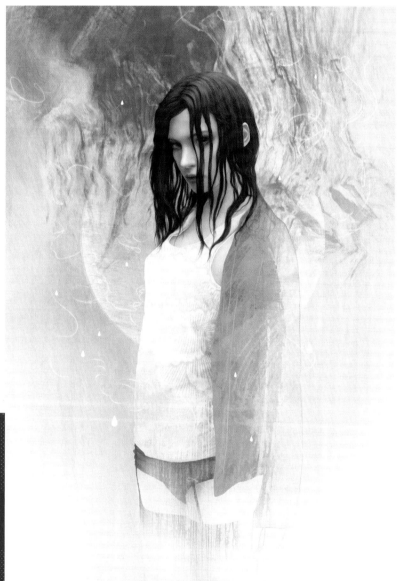

"Photoshop is massively powerful... but I feel that Painter is more intuitive for me coming from a traditional painting background"
Tom Bagshaw

The Red Dress
Beyond retro

<1. Ollie Bland and Olivia Chancellor were asked to create a poster for the Standon Calling festival. "Firstly we researched images of the era and took model photos. From this we produced the first drawing," says Olivia.

For inspiration, husband-and-wife team The Red Dress – Ollie Bland and Olivia Chancellor – plunder the past: "We find inspiration in pin-ups, trashy pulp-fiction covers and illustrated film posters," explains Olivia.

The artists who created these vintage images laboured in oils and acrylics, and Ollie and Olivia share a background in traditional painting – they met studying art at Central St Martins. However, they find digital painting has major advantages – especially for client work. "Being able to choose if paint is wet or dry is as great an asset as is rubbing out or undoing – especially for client changes," says Olivia. "Working on separate layers is a bonus too – as you can add extra elements, take them out or change its colour in an instant."

Working digitally allows them to overlay paper textures and distressed elements for a truly vintage feel. The results are vibrant, wittily kitsch oil paintings that have won them a portfolio of editorial and commercial commissions from a variety of clients.

Digital painting does pose challenges: "You have to try hard to make it look like real paint. It can be tricky to find the right brush effects and you don't get the 'happy accidents' with paint texture that you get with the real deal," explains Olivia. They make heavy use of the Bristle brushes in Photoshop CS5 – and Painter X's oil brushes and Blenders. For schlocky retro lettering, they turn to Illustrator. Olivia says that experimentation is the key, and the way they use their tools is "constantly evolving."

At the moment, a favourite technique uses Preserve Transparency on individual elements of images. "First block in the shape with a solid colour, then turn on Preserve Transparency in the layer. This allows you to quickly and easily fill in colours and tones without worrying about going over the edge," explains Olivia. ***thereddress.co.uk*** **>**

>2. Next they blocked in colour, tone and background, working on a layer underneath the original line drawing.

<3. On a layer above the line drawing, they refined details. "We experimented with the crop. At this point, the client requested a more modern look for the girl," explains Olivia.

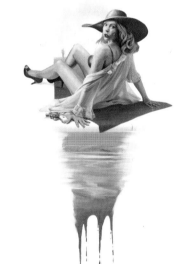

Right Another piece for the *Standon Calling* festival

Below A promotional poster for Bangkok Haunt, a spooky-themed tourism company. "We love the colours in this one," says Olivia.

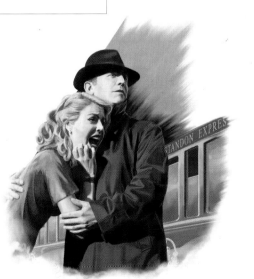

∧4. They took the crop off the bottom and added steam, then blended and refined the image, and returned to the previous girl. "Finally we overlaid a scan of some paper on a layer set to Multiply," concludes Olivia.

Rory Kurtz
The Digital frontiersman

1. Rory says of sketching: "I'm sparse with the lines, allowing for the colour to give it tones and dimension." He redraws images dozens of times to get the perspective and proportions right.

2. "I've got the drawing sitting on the very top of the Layers list in Multiply mode," explains Rory. "From this point on, all the digital paint will be done as a clipping mask to the isolated layers."

Rory Kurtz's images combine the delicacy of watercolour with rich hues that are closer to oils or acrylics, scuffed-up finishes and a precision that is purely digital.

"I painted a bit with watercolour – I loved how watercolour and ink washes let the lines of the drawing show through," says Rory. "However, watercolour doesn't allow for much reworking once it's dried, and it can't effectively be painted over either. Painting digitally allows me to endlessly make adjustments."

Rory recreates the feel of traditional painting alongside using effects that are hard to achieve by classical means. "There's a patina and texture to traditional paint that I bring into the work to keep it from looking too processed and soulless," he explains.

"At the same time, working digitally allows adjustments that you just can't get with paint. Depth of field, tonal shifts and layer masks are techniques that would be laborious with physical paint, and yield spotty results, [but] are a blast to experiment with digitally."

Basic artistry is key. "I still labour more than anything over the drawings that come before the paint. It's pretty difficult to badly paint a well thought-out drawing, but nearly impossible to save a terrible drawing with digital paints."

Working from these sketches, he uses Photoshop for colouring. "Along with the tools Photoshop offers for 'painting', its photographic tools offer solutions that give the art a mixed-media feel," he explains. "I've tried Corel Painter, but the results look... too generically digital. But that's just my knowledge of it."

Rory's trademark precision is the result of painstaking attention to detail: "You don't paint digitally by inches, but by pixels."

He says that digital painting is still in its infancy: "Right now, it's such a new medium with unlimited possibilities."

Looking at Rory's work, that's an exciting prospect.
rorykurtzillustration.com >

3. He created an underpainting using contrasting colours, staying deliberately loose to "see what happy accidents" crop up. He also decided on custom brushes for the finer detailing.

4. Rory's pencil drawing is still on the top layer, which is set to Multiply, while each element is still in its own masked layer, which allowed him to tweak them individually.

Rory used the Color Balance layers to tweak the overall hues, and added highlights, for example to the spokes, using a brush. The final artwork was used for the cover of the *New Bicycle Times* magazine.

> 5.

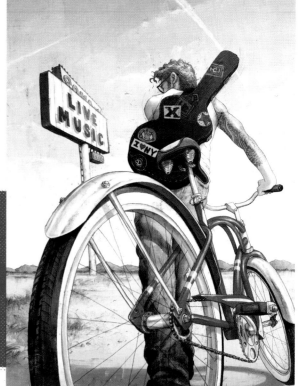

> *"There's a patina and texture to traditional paint that I bring into the work to keep it from looking too processed and soulless"* Rory Kurtz

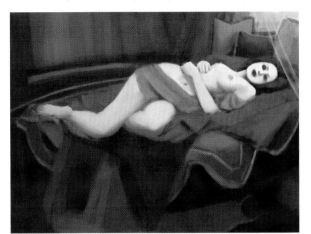

∧1. Marta started by blocking out shapes at a low opacity, building up the colour gradually as a traditional painter does.

∧2. Paying attention to the direction of light, Marta roughed out the face's contours and features with a round brush.

Marta Dahlig
Drama queen

Lush, playful and exaggeratedly detailed, Marta Dahlig's images are in a category of their own. "I think of my characters as real people, and therefore I never strive for perfect looks. I like my women to have bigger noses or stronger jawlines and so on," she says. This realism is enhanced by minutely detailed, almost photorealistic digital painting skills.

A self-taught artist, Marta has painted since early childhood. She discovered digital painting at 15: "Soon after, I got my first tablet. It didn't take long for me to get truly sucked in."

These days all her work is digital; she loves the freedom it gives her to experiment. "I have quite a messy workflow," she admits. "In traditional painting, experimenting can be very pricey – if you put a brushstroke wrong or use the wrong colour, it takes a lot of effort to make up for your mistakes. Digital painting is extremely forgiving."

Like many digital painters, Marta cherrypicks from Painter and Photoshop, appreciating Painter's traditional media feel and Photoshop's custom brushes. Her key tool is her Wacom Intuos4: "There are no substitutes for a tablet: a mouse does not offer pen-pressure sensitivity and a lack of any natural control. It's a necessity."

Marta admits digital painting isn't perfect: "It makes you hardware-dependent," she says, pointing to the cost of equipment. The other drawback is less tangible: "Digital art is less romantic than traditional art. Looking at the monitor simply does not offer you the same feeling as using real paints on a rough canvas."

But she flourishes in the medium, creating art for computer games and book covers; her work has even been featured in the Corel X bundle. She says the key to success is refusing to be pigeonholed. "Staying within your comfort zone will block your artistic development. It's important to always be aware of the box you are classified under and broaden your limits with new elements."

blackeri.deviantart.com >

∧3. Switching between the Ragged Hard Round brush and the Airbrush at low opacities, Martha applied shadows and highlights, and defined the eyes, nose and lips.

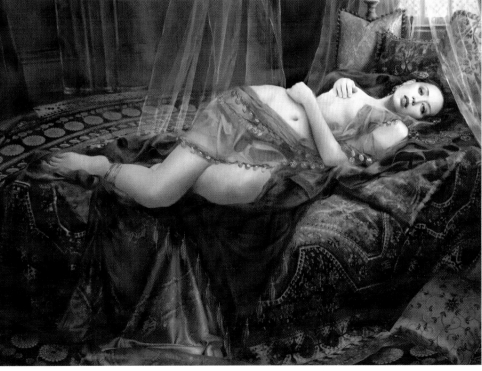

∧4. Using a fine brush, Marta created eyelashes and textures the lips; then added subtle pink and yellow hues to make the skin radiant. She worked up the hair using custom brushes.

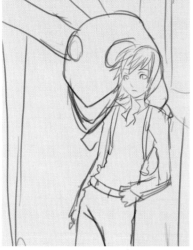

< **1.** Meisan started by roughly sketching the character in black and white on her computer, with a basic brush.

> **2.** Filling in more details as she went, Meisan also added layers of scanned-in watercolour blotches, setting each one to an Overlay bleeding mode.

< **3.** Meisan adjusted the colour until she was happy with the tone and painted in some highlights, such as the belt buckles.

> **4.** Meisan then flattened the layers and painted over the top, adding everything from creases on the shirt to details in the background.

Meisan Mui
Manga with a 'twist'

A degree in architecture isn't the most obvious qualification for a manga artist to have on her CV, but that's what Thai-Chinese artist Meisan Mui has. Actually, 'manga artist' isn't a fair description of Meisan's enigmatic works: as she puts it: "My style is watercolour-based illustrations, combining Japanese manga-like characters with motifs inspired by traditional Thai art."

It's an intriguing blend: wide-eyed, triangular-faced characters are surrounded by semi-abstract curlicues and striking, arabesque-shaped clouds, all rendered in jewel-bright colours straight from Thai art, or noisy candy shades sampled from manga. She often works by layering washes of watercolour for a splotchy, tactile backdrop, and then painting over the top.

"I was already using watercolours and markers as an architecture student, but I was looking at a lot of manga online, and saw that they used a Wacom to create their work," she says. This inspired her to try her hand at digital painting, which soon lured her away from architecture completely.

Now an established digital painter, Meisan can see both pros and cons to the medium: she points out that it makes it easy to knock off works that are samey – either to other pieces of your own art or, more dangerously, other people's: "I see a lot of artists getting trapped by style – including me sometimes," she cautions. "With some artists' work, you can tell who or what was inspiring them at that point, so the artist lacks a unique style of their own."

For her, the key is endless exploration: "I get bored easily and experiment a lot," she says. Her advice? Stay true to yourself: "Draw what you want to draw," she recommends. "Don't try to satisfy everybody in the world – because you can't."
meisanmui.com ●

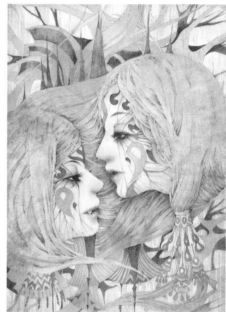

Right: Meisan Mui experiments with a Thai-style full profile – rather than the front-on faces typical of manga – for *Gemini*, a personal work.

Top gear

Gadgets and inspiration to create your digital masterpieces

● Pogo Sketch Stylus – If painting on the iPad feels more like finger-painting, this might help. It's basically a £10 stick. *tenonedesign.com*

● D'Artiste Digital Painting 2 – A glossy anthology of breathtaking digital paintings from the world's best with contributions from Marta Dahlig. *ballisticpublishing.com*

● *How to Paint like the Old Masters* by Joseph Sheppard – Aimed at traditional artists, the tips this book reveals are just as relevant to many serious digital painters. *randomhouse.com/crown*

● Cintiq 21UX – The £1,500-plus daddy of input devices, this graphics tablet has a built-in screen. *wacom.com/cintiq*

● Intuos4 – If your budget doesn't stretch to a Cintiq, the less flashy but respected Intuos4 starts at around £200.

CLASSIC EFFECTS REIMAGINED

TRADITIONAL TECHNIQUES GET A MODERN MAKEOVER

halftone

Halftone is the reprographic technique that simulates continuous tone imagery through the use of dots, varying either in size or in spacing. "Halftone" can also be used to refer specifically to the image that is produced by this process.

Where continuous tone imagery contains an infinite range of colors or greys, the halftone process reduces visual reproductions to a binary image that is printed with only one color of ink. This binary reproduction relies on a basic optical illusion—that these tiny halftone dots are blended into smooth tones by the human eye. At a microscopic level, developed black and white photographic film also consists of only two colors, and not an infinite range of continuous tones.

> INFO

TIME TO COMPLETE
• 3 hours

SOFTWARE
• Adobe Photoshop

Vintage halftones

Fabio Sasso shows you how you can put a stylish spin on one of Photoshop's most hackneyed effects, Color Halftones

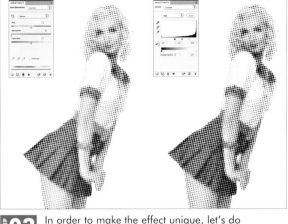

This chapter looks at how you can create stylish and innovative effects with some of Photoshop's most overused filters. In this tutorial, Fabio Sasso will show you how to put together an inspired vintage design playing with the Color Halftone filter.

Halftones are collections of dots that, from a distance, appear to merge into shades between the colour of the dots and the background. They were first used for printing in the 19th Century to allow newspapers to show shades of grey, and have been popular ever since. Currently, halftones are often used for creating screenprinted projects, T-shirts, stickers and posters to make the most of a small number of inks – but the dots used are often so small that its use isn't apparent.

In the past, larger dots were used that were more obvious to the reader, so the use of digital-created halftones can bring a retro feel that harks back to the newspapers and comics of your childhood. Applying the Color Halftone filters to a whole image could look cheesy, so here Fabio shows that by using it sparingly around a 50s-style photograph, you can achieve stylish results.

01 Open Photoshop and create a new A4 document at 300dpi. Then import a stock photo of a modern pinup, the one I used was courtesy of Shutterstock and you can get it at *bit.ly/b3vYP5*.

After that with the Magic Wand tool (**W**) select the white background, and with the new Refine tool in Photoshop CS5, extract it precisely. It wouldn't be exactly necessary to delete the background because that will be done late in the tutorial, but this will be necessary to create the masks we will use. Duplicate this layer, changing their names to 'Girl 1' and, below it, 'Girl 2' (imaginative, huh) because we will need extra copies to layer the effect over the model shot.

02 Select 'Girl 1' this and go to **Filter > Pixelate > Color Halftone**. Use a Max Radius of 12, and for a 100° Angle. Notice the Color Halftone filter works well for large images, if you are working with a small image I suggest you should try the **Image > Mode > Bitmap** with Halftone and Round for the settings. It has pretty much the same effect.

03 In order to make the effect unique, let's do something unusual to it. First desaturate the image so go to **Image > Adjustment > Hue and Saturation** and reduce the Saturation to 0. After that, go to **Image > Adjustments > Levels**. Change the Black Input triangle to 99 and the White Input to 205.

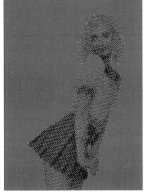
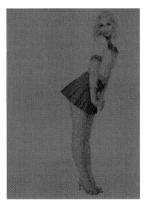

04 Add a new layer, change its name to 'Brown' and fill it with a dark brownish grey (#5a5855). Put this new layer behind 'Girl 1'. Select the white area of the 'Girl 1' layer and delete it. You will have just the black dots. Then go to **Image > Adjustments > Invert**. Now you will have only white dots on your image.

05 Group the 'Girl 1' layer (**Cmd/Ctrl + G**) to create a folder with one layer inside it and change the folder's blending mode to Color Dodge. You will now have a folder with one layer inside it. Select the 'Girl 1' layer and go to **Filter > Blur > Gaussian Blur**. Use a radius of 2.5 pixels here. Because of the Color Dodge, you will get a light effect.

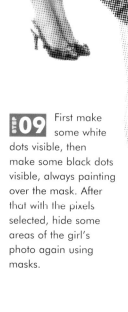

06 Select the 'Brown' layer and the folder with the 'Girl 1' layer and select **Layer > Merge Layers**. Now you will be left with just one layer. Go to **Image > Adjustment > Levels**. Increase the Black Input triangle to 140 and change the White Input to 215.

Why we did all of this? With the Blur and Color Dodge, we make the dots that were closest to one another get blended. Then with the levels here we make them solid again. These create a more organic effect, a little bit like molecules.

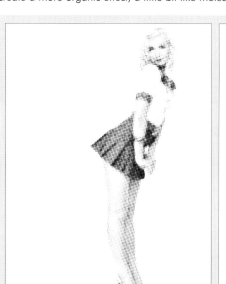

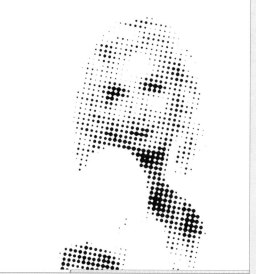

07 Go to **Image > Adjustment > Invert**. Then select the Magic Wand tool (**W**) and select the white area. To get all the whites go to **Select > Similar** and delete the white area. Duplicate this layer and go again to **Image > Adjustments > Invert**. You will have two layers, one with black dots and another one with white dots. Call these layers 'Black Dots' and 'White Dots'.

08 We'll now use masks so as to apply the effect sparingly. Order the layers as shown (*left*). For the 'Black Dots' and 'White Dots' layers, select the area of the girl using the 'Girl 2' layer for reference (as detailed in Step 1) and select **Layer > Layer Mask > Hide Selection**. Now every time you want to make a part of the layer visible, you can paint over the mask to reveal it.

I recommend that you make a pixel selection of the dots before painting the masks as well. To do this, right-click with the mouse over the thumbnail of the layer with the halftone girl and hit Select Pixels.

WORDS AND TEXT

> To make the Color Halftone filter work with text, you will have to merge it with a white background. If the background of the type is transparent, then the filter won't work. You can also apply a blur to increase the midtones to make the halftone filter even more stylish.

09 First make some white dots visible, then make some black dots visible, always painting over the mask. After that with the pixels selected, hide some areas of the girl's photo again using masks.

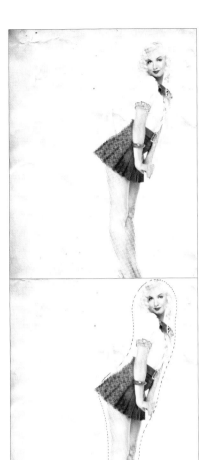

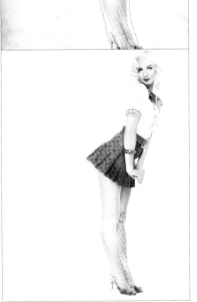

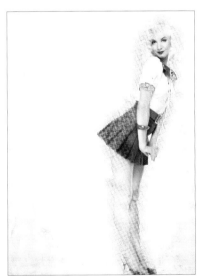

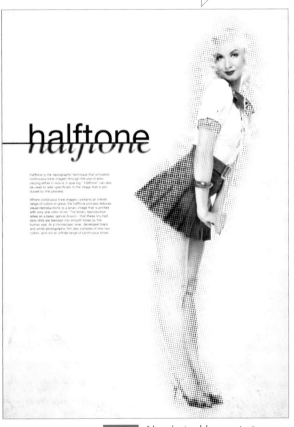

halftone

11 With the 'Texture 1' layer selected, go again to **Filter > Color Halftone**. Use a Max Radius of 12 pixels and an Angle of 100 for all channels. Then, go to **Image > Adjustments > Desaturate**, and **Image > Adjustments > Levels**. Increase the Black Input triangle and reduce the White Input to get rid of the midtones.

10 To complete the retro effects, I'm going to use a paper texture. The one I used can be found at *bit.ly/cUKkGz*. Import the texture, place it at the bottom of the layer stack and label it 'Texture 1'. With this layer selected, create a selection of the girl. It doesn't need to be perfect. Go to **Layer > Layer Mask > Reveal Selection**, and make just the area you selected visible. Select the mask of this layer and go to **Filter > Blur > Gaussian Blur**. Use a radius of 50 pixels.

12 Import another texture. The one I used can be found at *bit.ly/do9kSn*. Put this texture on top of all the other layers. Change the Blend mode to Multiply with 30% Opacity. After that go to **Image > Adjustments > Hue and Saturation**. Reduce the Saturation to -70, the go to **Image > Adjustments > Levels**. Change the Black input to 120 and the White to 212, and the Greys input to 1.18.

13 Now just add some text. In order to create a stylish composition, I placed the word Halftone with the top half using Helvetica for the font and the bottom half using Times, then I applied the Color Halftone to the bottom part. ■

> **LEARN** TRICKS FOR MODEL SHOTS

Stylish light effects in Photoshop

Lighting effects are often used cheesily, but here Fabio Sasso turns the spotlight on techniques to achieve an original look

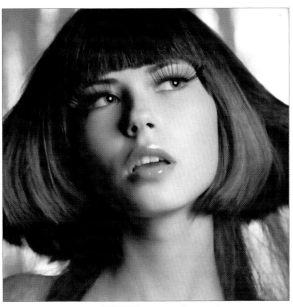

pplying lighting effects to model shots is a classic application of Photoshop, but through poor practice and overuse of the same tricks, it's become something of a cliché. In this tutorial, Fabio Sasso shows you how to put a fresh, stylish spin on lighting effects.

The secret here is to keep it simple and tap a 1980s look without overdoing it. You're aiming for a sophisticated feel, not retro pastiche. Of course, something that looks simple isn't necessarily easy to create, but here Fabio guides you step by step through the filters, gradients and blending modes that will bring a classy edge to your art.

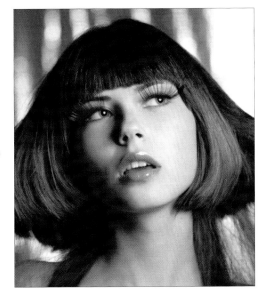

01 Open Photoshop and create a new A4 portrait document at 300dpi. Now import a photo that you will use for the tutorial onto a layer called 'Girl 1'. The one I'm using is courtesy of Shutterstock and is available at *bit.ly/c2rQOu*

04 Merge the two layers to create a new layer still called 'Girl 2', then duplicate to create a 'Girl 3' layer. Select it and go to **Image > Adjustment > Desaturate**. Set the blending mode to Hard Light and the opacity to 50%. Duplicate 'Girl 2' again to create a 'Girl 4' layer and place it at the top of the layer stack. Select **Filter > Other > High Pass** with a radius of 10 pixels. As before, set that layer's blending mode to Hard Light and the opacity to 50%.

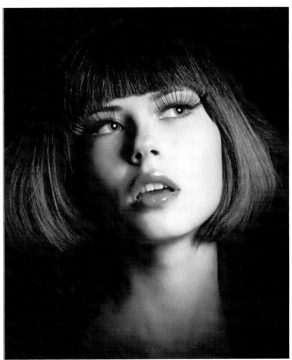

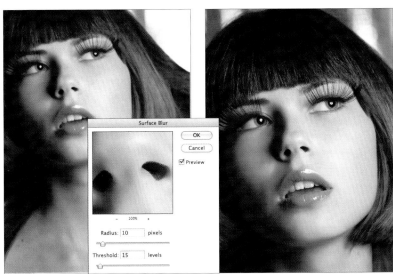

02 Duplicate the layer, calling the new layer 'Girl 2'. Select this layer and go to **Filter > Blur > Surface Blur**. Use 10 pixels for the Radius and 15 for the Threshold.

03 We're going to use this blurred layer to smooth the subject's skin without losing detail. With the Eraser tool (**E**), start hiding areas such as the eyes, mouth and hair, all of which contain important detail.

05 With the Eraser tool, delete the areas of the 'Girl 4' layer that show skin. Now add a layer called 'Paint 1' on top and with the Brush tool (**B**), use a soft brush with black to hide the background and the shoulders. Leave just a part of the neck. ➤

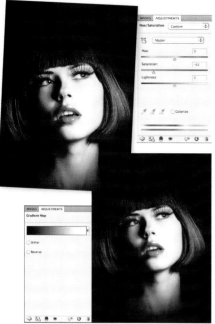

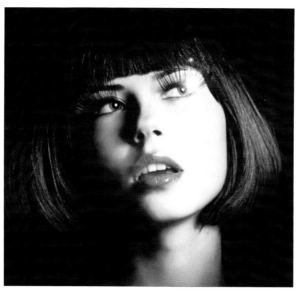

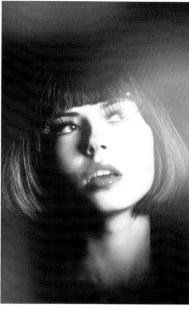

STEP 06 Go to **Layer > New Adjustments Layer > Gradient Map**. Use Black and White for the gradient colour, then change the blending mode of this adjustment layer to Soft Light. Call this layer 'GMap'.

Now go to **Layer > New Adjustment Layer > Hue/ Saturation**. Reduce the Saturation to 60 and call this layer 'HueSat'. Adjustment layers always have masks, so with the Brush tool (**B**), select a very soft brush and paint with black over the subject's mouth. This excludes that area from the Hue/Saturation effect.

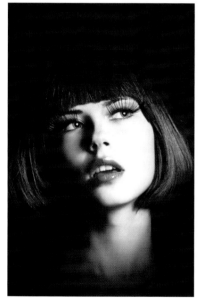

STEP 07 Duplicate the 'HueSat' layer to create 'HueSat 2'. Select the layer mask of this new layer and go to **Image > Adjustment > Invert**. Increase the Saturation to 55. That way you will apply the saturation to the mouth only, the idea being to make it really red.

STEP 08 Close to the subject's left eye, let's add a bit of lens flare, taken from an image at *bit.ly/dsJxpD*. Use Screen for the blending mode and go to **Image > Adjustments > Levels**, then increase the black input so you only get the lens flare.

> Adding a subtle orange spot to the left helps balance the lighting, softening the contrast between the bright pink and making the overall effect look more natural.

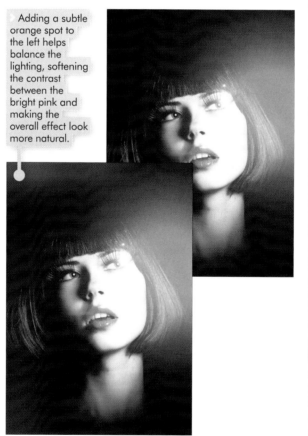

STEP 09 Now add a layer on top of the others called 'lights1' and fill it with black. Change its blending mode to Screen and then, with the Brush tool and a very soft brush, paint a big pink spot in the upper right of the image. Then select a dark orange and paint a very subtle orange spot at the top and bottom left.

STEP 10 Add another layer on top of the others called 'lights2' and fill it with black, then change its blending mode to Color Dodge. Paint over the orange areas with the same orange to create a sort of light leak in that area.

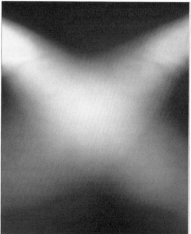

STEP 11 Time to import another image of a light effect. The one I'm using, of pink and blue spotlights, is from Shutterstock and can be found at *bit.ly/d8UuCk*. Put this image on a layer called 'lights3' on top of the rest and change the blending mode to Soft Light.

Add yet another layer, called 'bokeh', fill it with black and then, with the Brush Tool (**B**), select a rounded brush and create a few circles of different sizes in white. The idea is to create a simple bokeh-style background blur effect. Set the blending mode of the layer to Color Dodge.

12 Add another layer called 'Gradient1', then with the Gradient tool (**G**), click on the gradient sample to open the Gradient Editor. Change the Type to Noise, the Roughness to 100% and select Restrict Colors and Add Transparency.

Now choose the Angle Gradient style and create a ray of light effect coming from the mid/top right of the image. After that go to **Image > Adjustments > Desaturate** and then to **Filter > Blur > Gaussian Blur**. Use 15 pixels for the Radius.

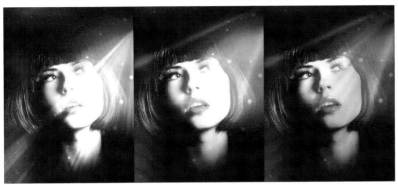

For a little extra style, add a paper texture on top or merge all layers and add some noise to the image

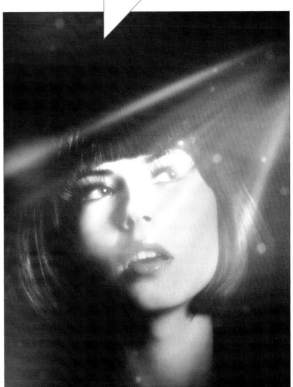

13 Change the blending mode of the 'Gradient' layer to Color Dodge, duplicate this layer to 'Gradient2' and move it down a little bit. Put it behind the 'Gradient2' layer, then change its blending mode to Linear Burn and the opacity to 50%.

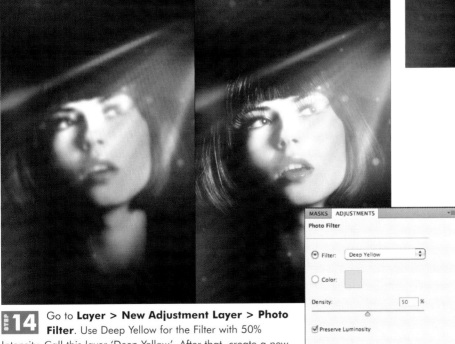

15 For a little extra style, you can either add a paper texture on top or simply merge all the layers and go to **Filter > Noise > Add Noise** to add some noise to the image. The whole effect is now complete, though it's up to you to keep experimenting with different combinations and colours. ∎

14 Go to **Layer > New Adjustment Layer > Photo Filter**. Use Deep Yellow for the Filter with 50% Intensity. Call this layer 'Deep Yellow'. After that, create a new layer with all the other layers merged into it (**Cmd/Ctrl + Alt + Shift + E**). Then use **Filter > Blur > Gaussian Blur**, with 15 pixels for the Radius. Change the blending mode of this layer to Screen and the opacity to 60%.

PROFILE FABIO SASSO

> Graphic and web designer Fabio Sasso is best-known for his Photoshop artworks and tutorials. He is also co-founder of Zee, a web-design studio, and runs a successful digital arts and creativity blog, Abduzeedo.

CONTACT
• *abduzeedo.com*

> INFO

TIME TO COMPLETE
• 1 hour

SOFTWARE
• Adobe Photoshop

Create an abstract cube mosaic

If you thought mosaics were another boring Photoshop cliché, think again, as Fabio Sasso presents a new spin on an old style

osiacs generally make you think of the Roman villas you visited on school trips, or those pictures-within-pictures that appeared on every student's bedroom wall after the craze for *Magic Eye* images died. They don't automatically conjure visions of stylish artwork, but Fabio Sasso has found a way to create truly striking visuals with a very simple, swift process.

In this tutorial, Fabio will show you how to create a deconstructed image using a pattern made out of cubes. The idea is try to simulate a mosaic but with a more abstract and up-to-date interpretation.

The technique is pretty simple and the whole tutorial can be done in less than one hour – though feel free to keep experimenting in order to create your own realisation.

01 Open Photoshop and create a new document. I'm using A4 for the document size.

02 Import a photo that you want to use for the abstract mosaic effect. The one I used is available from Shutterstock at *bit.ly/crQ7Eb*.

03 To create the base for our mosaic, open a new document in Photoshop and then with the Polygon tool (**U**) create a hexagon. Duplicate the hexagon and move it up so the base of it matches the top of the other hexagon. Then with the Direct Selection tool (**A**), delete vertices 1 and 2. Now move down vertex 3 to create the top part of the cube.

> 2D polygons grouped edge-to-edge are a perfect way to add depth and volume plus a high level of detail, depending on their size

04 Repeat the process to create the final side of the cube. As you can see, I've used different shades of grey to create the 3D effect.

05 Group the cube elements and duplicate them twice to start to create the pattern. Start duplicating them until you filled the screen with cubes.

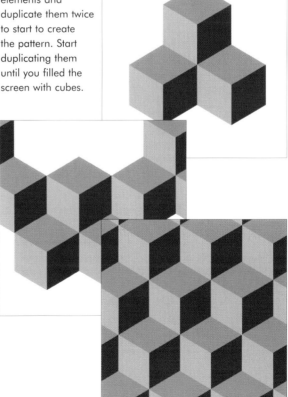

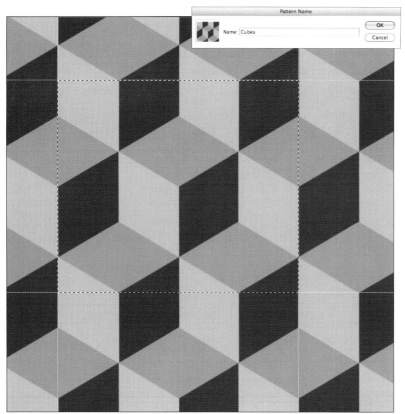

09 Repeat the process for the other side of the cube.

10 Raise the full photo of the girl up through the layer stack so it sits directly beneath the two layers you created in Steps 7 to 9. You'll have a pretty crazy effect, mixing mirrors and deconstruction.

06 Carefully select an area that will be used to define your pattern. Bear in mind that it has to be tileable, so use the image above for reference. Once you have selected the area, select **Edit > Define Pattern**. Name your pattern and go back to the design.

07 Add a new layer and fill it with the cube pattern you've just created. Duplicate the girl layer and apply **Edit > Transform > Skew** to this. Distort the image so it follows the angle of the cubes – for this image I used the left sides for reference. After that go to **Filter > Blur > Gaussian Blur**. Use 10px for the Radius.

08 For the next step, you'll want select the left sides of all the cubes. To do this, select one with the Magic Wand tool (**W**), and go to **Select > Similar**. With the marquee selection active, click on the distorted girl layer and go to **Layer > Layer Mask > Reveal Selection**.

11 Select all layers and duplicate them. Select the uppermost set of layers, and go to **Layer > Merge Layers**. With the merged layer selected, go to **Filter > Blur > Gaussian Blur**. Use a Radius of 20px.

Change this layer's blending mode to Screen, with at 80% opacity. After that go to **Layer > New Adjustment Layer > Gradient Map**. Use the default black and white gradient, but change the blending mode to Soft Light. Go to **Layer > New Adjustment Layer > Hue and Saturation**. Reduce the Saturation to -30.

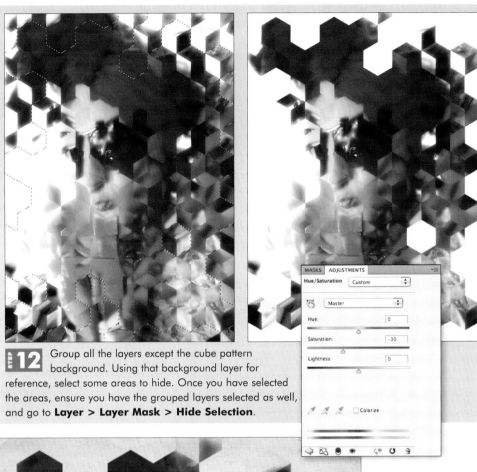

STEP 12 Group all the layers except the cube pattern background. Using that background layer for reference, select some areas to hide. Once you have selected the areas, ensure you have the grouped layers selected as well, and go to **Layer > Layer Mask > Hide Selection**.

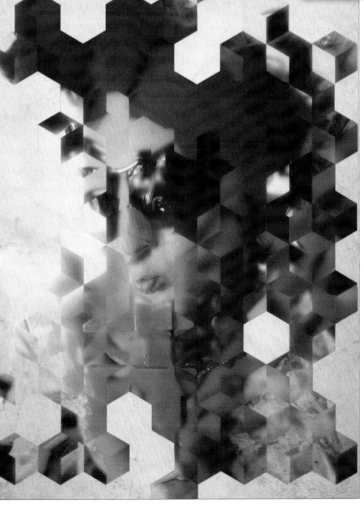

STEP 13 Now let's add a paper texture on top of everything to give a retro feel to the image. The image I'm using is from Shutterstock and you can get it from *bit.ly/b66njS*. Place the image on top of the others and change the blending mode to Multiply.

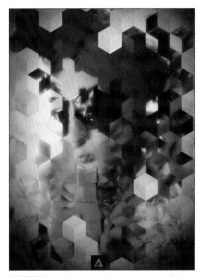

STEP 14 Duplicate the paper texture layer and rearrange it so that it's right on top of the cube pattern layer, and beneath all the other layers. Then change the blending mode of the cube pattern layer to Color Burn.

STEP 15 Add a new layer on top of the others and fill it with black. Change its blending mode to Multiply. With the Brush tool (**B**), select a very soft brush, and choose white for its colour. Start painting in the centre of the image so the white will be transparent. The aim is to create a vignette effect. ∎

PROFILE FABIO SASSO

> Graphic and web designer Fabio Sasso is best-known for his Photoshop artworks and tutorials. He is also co-founder of Zee, a web design studio, and he runs a hugely successful digital arts and creativity blog, *Abduzeedo*.

CONTACT
• *abduzeedo.com*

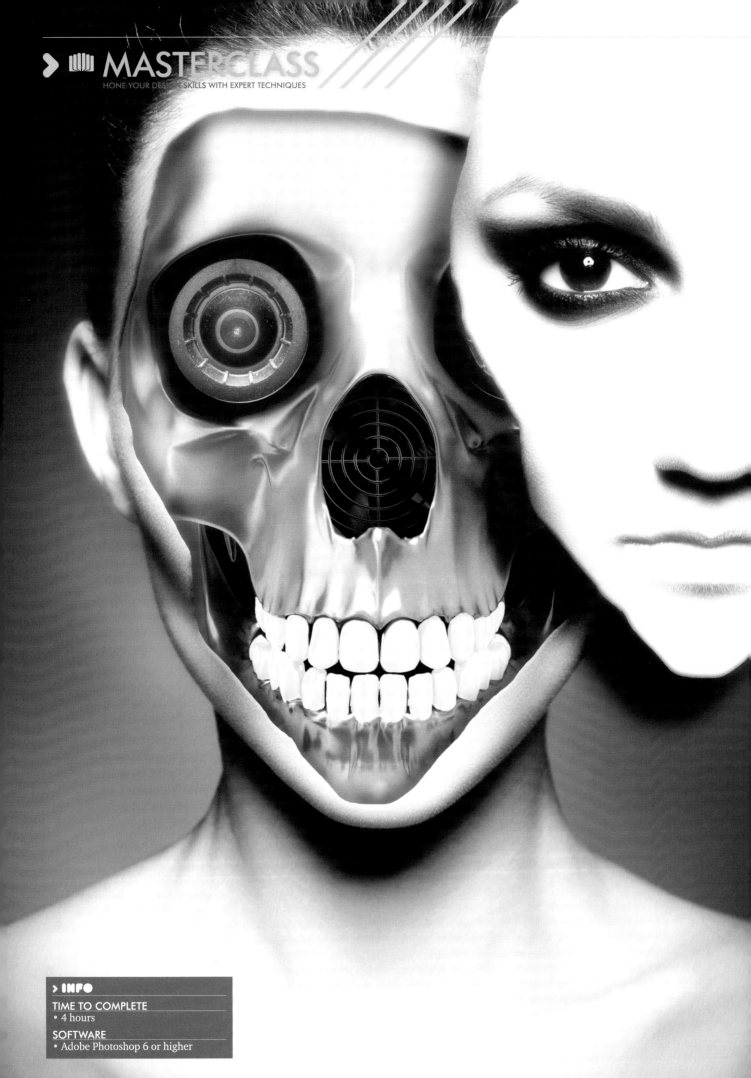

> **INFO**

TIME TO COMPLETE
• 4 hours

SOFTWARE
• Adobe Photoshop 6 or higher

> **LEARN** PHOTOMONTAGE

The cyborg revealed

Fabio Sasso injects some class into a frightening sci-fi image

The traditional cyborg, a mix of human and machine, has the ability to unsettle viewers in a way that robots or other synthetic humanoids can't possibly match. There's a visceral quality about the transplanting of flesh and metal in iconic figures such as *The Terminator* or *Star Trek*'s Borg. It conjures up visions of the horror of Victorian medical practices, and frightens us more than the completely synthetic

Replicants of *Blade Runner*, or the Cylons from *Battlestar Galactica*.

In this tutorial, Fabio Sasso shows you some techniques for creating a cyborg from photographic sources in Photoshop, tapping into the movie heritage of the cyborg, but mixing it with the glossy 'Bleach-Bypass' look of modern sci-fi TV shows such as *V* and *The Event*. You will use some stock photos and lots of adjustment layers, in order to achieve a convincing result.

01 Open Photoshop and create a new A4 portrait document. Import a photo of a person that will be your cyborg. You can call this layer 'HeadShoulders'. To obtain the slick look we're going for, choose an image with bright highlights and dark shadows, and with fashion stylings. The one I'm using is courtesy of Shutterstock and can be found at *bit.ly/aZe6wv*.

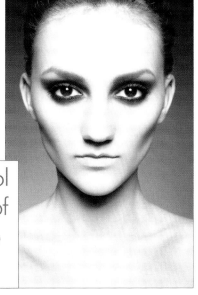

> "Using the Lasso tool (**L**), select the area of the face you want to cut out"

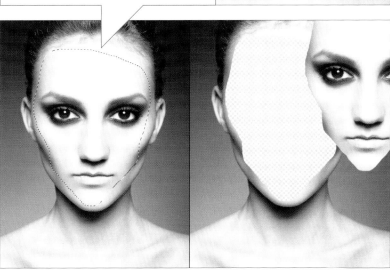

02 Using the Lasso tool (**L**), select the area of the face you want to cut out. Go to **Layer > New > Layer via Cut**. Call this layer 'Face'. Move the face to the top right. You can hide the 'Face' layer for now.

03 Select the 'HeadShoulders' layer and go to **Layer > Layer Styles > Drop Shadow**. Select a Multiply blending mode with 68% Opacity, 120° Angle, 0 Distance, 31% Spread and a Size of 114px.

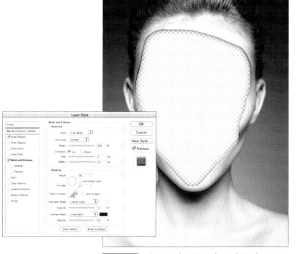

04 Go to the Bevel and Emboss tab and select a Style of Inner Bevel, a Technique of Smooth, 241% Depth, 10px Size, and 16px Soften. For the Shading use an Angle of 90% and an Altitude of 21%. Select Lighter Color for the Highlight Mode with a white, and a black at 60% Opacity with Linear Burn for the Shadow Mode.

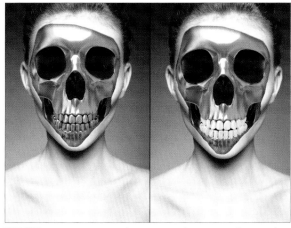

05 Let's import another image. This one is of a metalic skull I found at *bit.ly/bcjHxm*. Place it in your design in a layer called 'Skull', and move it so it's beneath the face. Add a new layer and fill it with black, then change the blending mode to Screen. With the Brush tool (**B**), start painting over the teeth, in order to make them white.

06 Select the 'Skull' layer and go to **Image > Adjustments > Levels**. Use 0, 1.40 and 255 for the Inputs. There's a huge highlight spot on the forehead that we want to remove. Add a new layer called 'Gray' and select a gray color of the skull with the Color Picker, then paint over the highlighted area with the Brush tool (**B**).

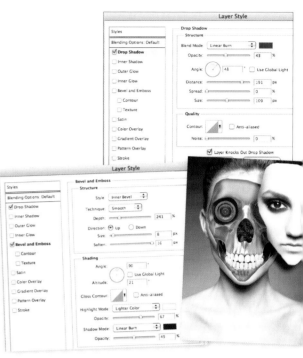

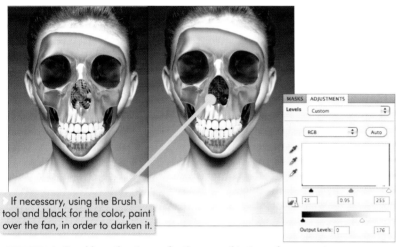

If necessary, using the Brush tool and black for the color, paint over the fan, in order to darken it.

07 Let's add another image for the nose, this time of a computer power supply fan. You can find it at *bit.ly/9UutQr*. Name the layer 'Fan', place it over the nose, and with the Polygonal Lasso tool (**L**), select the nose area and mask the 'Fan' layer.

With the 'Fan' layer selected, go to **Image > Adjustments > Levels**. Increase the black input to 25, change the grey input to .95, and for the white output, change this to 176.

10 Make the 'Face' layer visible once more, and go to **Layer > Layer Style > Drop Shadow**. On this tab and the Bevel and Emboss one, modify the settings to match those above. Please note that the blending mode colour for the drop shadow is a dark brown.

11 Go to **Layer > New Adjustment Layer > Photo Filter**. Use an orange for the color with 20% Density.

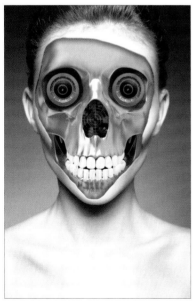

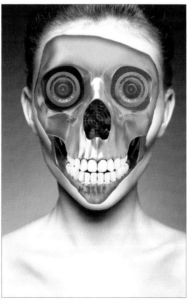

08 Let's use another image for the eyes, this time of a webcam. The one I used is from *bit.ly/d5I8yi*. Select just the central part of the webcam, and position it over the whole of the eyes.

09 Add a layer on top and fill it with black. Change its blending mode to Screen. With the Brush tool (**B**), select a very soft brush and red for the colour, then paint over the eyes to create a red glow effect.

12 Go to **Layer > New Adjustment Layer > Hue and Saturation**. Reduce the Saturation to -50. Next, go to **Layer > New Adjustment Layer > Gradient Map**. Use black and white for the colour and a blending mode of Soft Light.

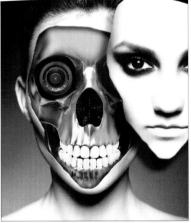

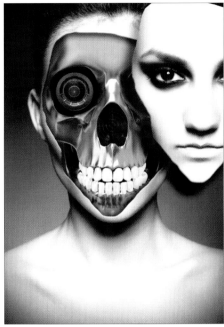

"If you want a more traditional sci-fi look, add a pattern of scanlines on top and a red light leak"

13 Add a new layer to the top of the layer stack and fill it with blue (#12497c). Change the opacity to 60% and the blend mode to Soft Light. Add another layer and fill it with green (#257940). Change its opacity to 60% and the blending mode to Soft Light.

14 We want to add a simple vignette effect. Add a layer on top. Fill it with black. Change the blending mode to Multiply. Select the Brush tool (**B**) and a very big soft brush, with white for the colour. Paint over the girl's face and other areas, leaving just the edges.

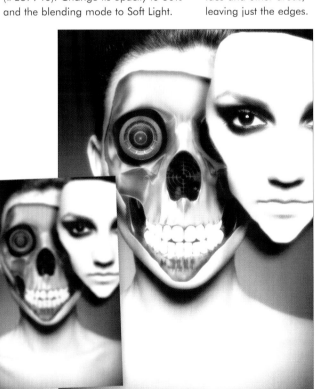

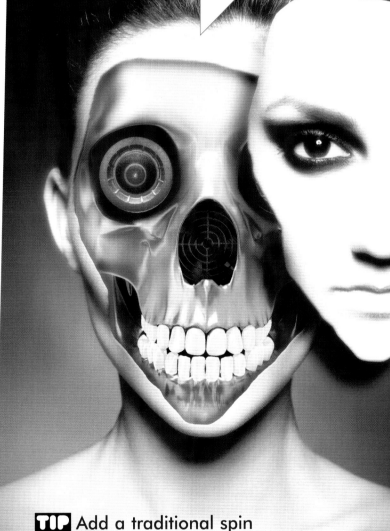

15 To add a glow effect, first select all the layers, and **right click > Duplicate Layers**. With the duplicated layers still selected, go to **Layer > Merge Layers** (**Cmd/Ctrl + Alt + Shift + E**). Next, go to **Filter > Blur > Gaussian Blur**. Use 20 pixels for the Radius. Change the blending mode to Screen and reduce the Opacity to 80%. ■

TIP Add a traditional spin

If you want to bring in a more traditional sci-fi look, add a pattern of scanlines on top and a red spot using the Color Dodge blending mode at the bottom right to create little light leak effect.

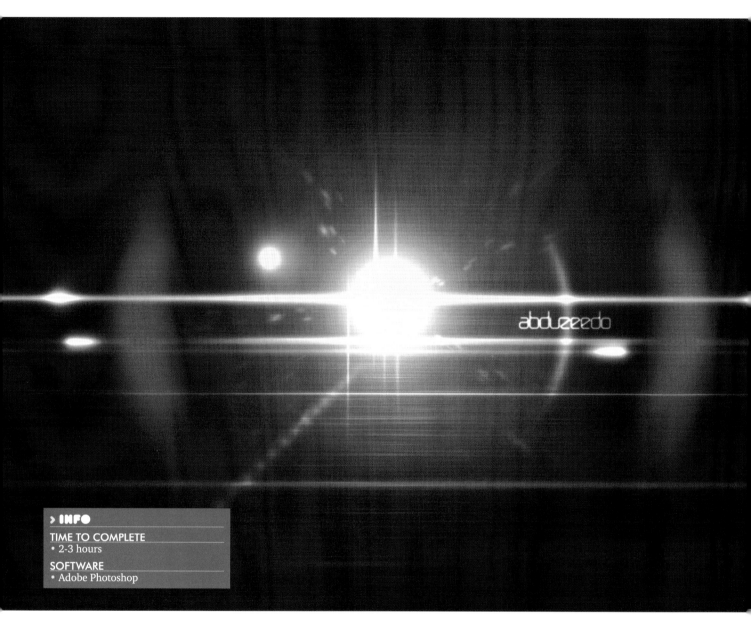

abduzeedo

> INFO

TIME TO COMPLETE
• 2-3 hours

SOFTWARE
• Adobe Photoshop

> **LEARN** LIGHTING EFFECTS

The lens flare **reborn**

Fabio Sasso shows you how to put a fresh spin on this much used (and abused) Photoshop effect

hotoshop's Lens Flare filter is an effect that's been so over used over the years, it's become something of a cliché in digital illustration. Which is a shame, since in the right situation, it can provide a powerful lighting enhancement to a piece. Luckily, Fabio Sasso has provided us with a tutorial that shows you that if you have a strong idea and unique execution, it doesn't matter if you

tap an effect that's been long over-exposed to achieve the result you want. You'll learn how to present exciting variations on an old theme through changing the position of the lens flares and creative use of the blending modes, brush tools and colour. So get ready to become reacquainted with one of digital imaging software's strongest effects. Just stay away from those default settings...

01 Open Photoshop and create a new document. Add a new layer and fill it with any colour. Label this layer as 'Blue gradient', then go to **Layer > Layer Style > Gradient Overlay**. For the gradient colours, use #0c0c36 for the dark blue and #25245e for the light purple.

02 Add a new layer and fill it with black. Next, go to **Filter > Render > Lens Flare** and select the 105mm Prime Lens Type with 100% Brightness. Then select **Filter > Blur > Gaussian Blur** and use 30 pixels for the Radius. The last thing to do with this layer is to change its blending mode to Color Dodge.

Combining multiple Lens Flare effects gives the most realistic results

03 Add another layer and again, fill it with black. Then go to **Filter > Render > Lens Flare** and choose the 50-300mm Zoom Lens Type with 100% Brightness. Repeat the same processes for the Gaussian Blur and blending mode as in Step 2.

04 With the Rectangle tool (**U**), add a white rectangle the width of the page and place it in the centre. Select this layer and go to **Layer > Group Layers**. The rectangle layer will be inside a folder. Change the blending mode of the folder to Color Dodge.

05 Select the rectangle layer and go to **Filter > Blur > Gaussian Blur**. Use 20 pixels for the Radius. As this layer is inside a folder with Color Dodge, the blurry edges will create a really interesting lighting effect.

06 Add a new layer inside the folder with the rectangle. Select the Brush tool (**B**) with a very soft brush and, using white for the colour, paint a second light source.

07 Repeat the same process with the Rectangle tool (**U**) and the Brush tool (**B**) to add more elements to your design. For the light in the centre, create a few vertical lines and then go to **Filter > Blur > Motion Blur**. Use 90° for the Angle and set the Distance to 90. This will create a stylish reflection effect.

08 Now go to **Window > Brush**. Select a basic rounded brush and set the Hardness to 0% and the Spacing to 80%. Then add another layer inside the folder with the other light effects. Click on an area close to the centre and, holding the Shift key, click on the bottom left to create a line of dots. If the effect is too strong, go to **Filter > Blur > Gaussian Blur** and soften it a little bit. Change the Opacity to 70%.

> "If you have a unique execution, it doesn't matter if you tap an over-familiar effect"

09 Add another layer and paint a few light spots with the Brush tool (**B**) using white for the colour near the big lens flare. Next, go to **Filter > Blur > Radial Blur**. Use 15 for the Amount, Zoom for the Blur Method and Best for the Quality.

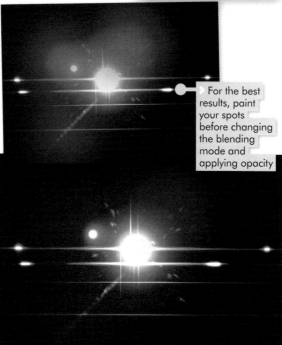

> For the best results, paint your spots before changing the blending mode and applying opacity

10 Add a layer on top of the others and then, using the Brush tool (**B**) with a big soft brush, paint a large pink spot and 2 large blue spots. Change the blending mode to Hard Light and the Opacity to 50%.

11 With the Ellipse tool (**U**) add a white ellipse. Go to **Layer > Layer Styles > Blending Options**. Change the Fill Opacity to 0, then select Inner Shadow. Use Pink for the colour and Linear Dodge for the blending mode. Set the Angle to 90°, the Distance to 0, the Choke to 14% and the Size to 250 pixels.

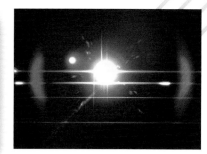

12 Group this layer into another folder and make it invisible (**Layer > Layer Mask > Hide All**). Select the Brush tool (**B**) and with a medium-sized rounded brush, paint with white over the layer mask just so a little bit of the left and right areas of the ellipse are visible. Repeat the same technique to create another lens reflection, but this time smaller.

13 Now we're going to put a yellow filter effect over the whole thing. Go to **Layer > New Adjustment Layer > Photo Filter**. Select Yellow for the Filter and 90% for the Density.

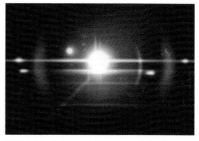

14 Select all layers and duplicate them, then merge all the duplicated layers into a single layer. You can also do this using a keyboard shortcut (**Cmd/Ctrl + Alt + Shift + E**). Next, go to **Filter > Blur > Gaussian Blur**. Move this layer so it will be beneath the Photo Filter layer, then change the blending mode to Screen with the Opacity set to 50%. ∎

PROFILE FABIO SASSO

> Graphic and web designer Fabio Sasso is best known for his Photoshop artworks and tutorials. He is also co-founder of Zee, a web-design studio and runs a hugely successful digital arts and creativity blog, Abduzeedo.

CONTACT
• abduzeedo.com

COMBINING PHOTOSHOP & ILLUSTRATOR

UNITE THESE TOOLS AND EXPAND YOUR HORIZONS

MASTERCLASS

> INFO

TIME TO COMPLETE
• 4-5 hours

SOFTWARE
• Adobe Illustrator & Photoshop

PROJECT FILES
•Download the files from
*theartistsguide.co.uk/
downloads*

> **LEARN** FASHION ILLUSTRATION

Back-to-basics photo illustration

Get sophisticated results from simple techniques in CS5

With the recent release of Adobe CS5, it's easy to get carried away with the new tools and presets. They might be designed to maximise workflow efficiency, but an over-reliance on these can give your work a generic feel To keep your style fresh, you need to get back to basics.

In this tutorial, Markie Darkie shows you how to create a stunning photomontage. You'll master repetition and layering of shapes, efficient use of simple colour palettes with the aid of Layer Style effects, or a file of vector elements.

The vector template for this tutorial is available from the projects files, but you'll also learn how to create your own design elements that you can use on future projects.

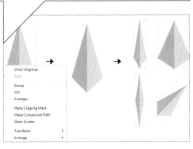

03 Connect the two paths to look like a pyramid, select both and hit **Cmd/Ctrl + G** to group the selection as one object. You now have a base design element that you can modify to create more variations. Use the Selection tool (**V**) to change the width, height and angle of the basic form.

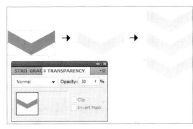

04 Next, we'll enhance the forms by adding a basic stripe pattern. Copy Shape 2 and change the colour to Swatch 3. Hit **Shift + Cmd/Ctrl + F10** to bring up the Transparency Window and change the Opacity to 30%. Create three copies of the path and stack them on top of each other to create the pattern.

01 Download and open the *Geometric Design Elements. ai* file in Illustrator. You can use it as a reference or resource file for this project.

Creating images from scratch is useful – not only does it save you searching for stock image files, you also build up a valuable archive for future projects.

02 Next, click the View tab and enable Smart Guides and Snap to Point. This will allow you to align paths and points with ease. Use the space inside the dashed box as your work area. Using the Selection tool (**V**), select Shape 1, create a copy and change it to Colour Swatch 2 using the Eyedropper tool (**I**). Right Click on the edited path and select **Transform > Reflect**. Then set the orientation to Vertical and angle to 90°.

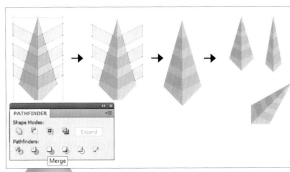

05 Place the stripe pattern on top of the form. Group the selection as one object, tap **Shift + Cmd/Ctrl + F9** for the Pathfinder window, then select the Merge option tab and use the Direct Selection tool (**A**) to delete excess paths. Use the Selection tool (**V**) to tweak the dimensions and angle of the new element.

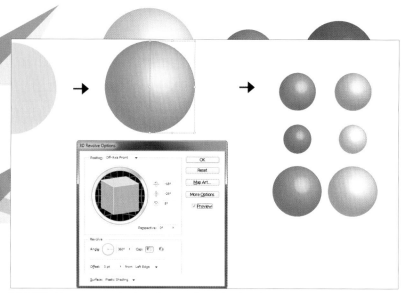

06 Now copy and select Shape 4 from the downloaded file. Click **Effect > 3D > Revolve** to bring up the 3D Revolve Options Window. Press OK and the default Off-Axis Front Position will give you an instant sphere. You can create various spheres by using the Eyedropper tool (**I**) and selecting different colour swatches.

THINK AHEAD

> Before starting design projects, it's always handy to prepare color swatches, design elements and stock images that you want to use. This will help you conceptualize and organize your thoughts prior to execution.

09 Create a folder by hitting the Create A New Group button on the bottom section of the Layers Panel. Rename it as 'Foreground Elements' and place it on top of the model shot layer. Create another folder and rename it as 'Background Elements' and place this under the model shot layer. This will help you classify layers when you start placing multiple design elements on your artboard.

07 Next, open Photoshop and hit **Cmd/Ctrl + N** to create a new Canvas. Specify the size and resolution of the file. I normally go with an A4 size and 300dpi for a lot of design projects. Press **F7** to bring up the Layers Panel and change the background colour to black using the Paint Bucket tool (**G**).

10 Now it's time to create an array of dynamic visual compositions using the design elements you made in Illustrator. This can be achieved by aligning and redistributing multiple design elements using the Align tool (**Shift+F7**) in Illustrator or just by randomly grouping them.

08 Place the model shot on the centre of your artboard. This image has been kindly provided by photographer Kate Frankfurt but you can use stock photos from our project files or use your own pictures. If your model is on a background, make sure you cut them out so you can wrap elements around them.

> Lock your main image in its own layer to ensure it doesn't get mixed up with the background and foreground layers

11 Create various repeating patterns in Illustrator and place them on your artboard in Photoshop. You can vary the sizes and orientation to make the patterns interesting, or change their colours to add some contrast between designs elements. ❯

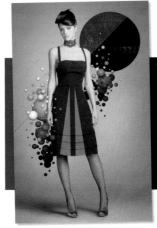

These layering techniques offer a lot of flexibility. Markie Darkie used them to create this variant that draws more attention to the model's dress.

STEP 12 Make individual layers for each pattern you've created. Place them inside the 'Foreground Elements' folder if you want them to appear on top of other design elements, or in the 'Background Elements' folder if you want them to appear on the background. This technique will create visual depth when you apply Layers Styles such as Drop Shadow and Outer Glow on selected design elements.

STEP 15 Masking is another method that you can use to enhance the relief and 3D qualities of your work. You can adjust opacity on certain areas by masking your layers. To apply a layer mask, click the Add Layer Mask tab on the bottom of the Layers Panel. Use The Brush tool (**B**) with a Black colour swatch to mask layers. Adjust the brush softness, size and opacity according to your preference.

STEP 13 To help define your foreground layers, apply Drop Shadow and Outer Glow in the Layer Styles palette. The default settings are good enough but feel free to experiment and change the opacity, angle, distance, spread and size of the layer styles you want to use.

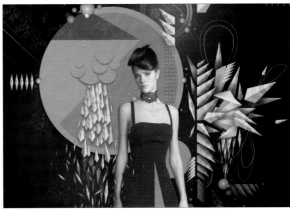

STEP 16 Finish up with more details, textures and visual elements using the same layering and styling techniques. Attention to detail is very important if you want to make your work stand out. It might be time-consuming but your patience will definitely pay off once you see the fruit of your artistic labour. ∎

STEP 14 Create more depth and volume by adjusting the opacity of the background layers to between 80-40% on the upper right section of the Layers Panel. This will fade the background layers a little, giving the entire visual composition a 3D-like quality.

PROFILE MARKIE DARKIE

> Markie Darkie, aka Ferdinand Mark Bsa, is based in Edmonton, Canada where he works as a full-time graphic designer. His clients include the World Wide Fund For Nature, Nestle, Coca-Cola and more.

CONTACT
• behance.net/markiedarkie

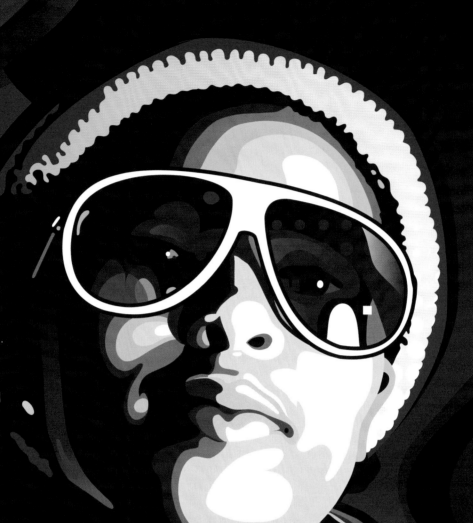

> **INFO**

TIME TO COMPLETE
• 3-4 hours

SOFTWARE
• Adobe Photoshop CS3 or higher,
Adobe Illustrator CS3 or higher

PROJECT FILES
•Download the files from
*theartistsguide.co.uk/
downloads*

Turn portraits into stylish vector art

Eelco van den Berg explains the secrets of his vectorised style through an easy step-by-step guide

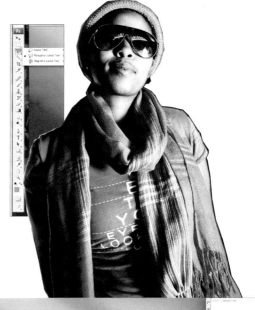

O n this tutorial, Eelco van den Berg lets you behind the curtain to see how he creates his incredible vector portraits by turning a photo into a 'poppy' vector illustration. You will learn quick and easy Photoshop adjustments that prepare artwork for translation into vector shapes. He shows you how to trace the basic shapes using the main tools in Illustrator, and how to use layers to organise the photos and your new vector artwork. You will discover how to create the feeling of light and shadow, build a simple brush to work with and use the Pen tool for more geometrical shapes. You'll also discover the possibilities of the Pathfinder tool, and how to draw with the brush to create a looser feel. We'll also show you how to play around with elements of the portrait to build up the background and how to use a simple raster to give it some texture.

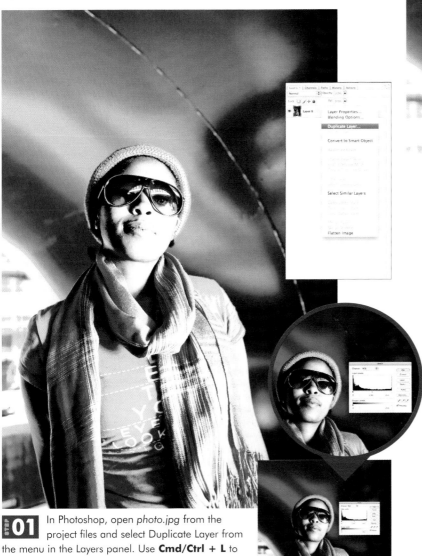

02 Use the Polygonal Lasso tool (**L**) to separate the subject from the background in the duplicated layer. This can be done quite roughly. Once the subject is selected, go back to the original layer, invert your selection (**Cmd/Ctrl + Shift + I**) and delete the background. Now you can delete the duplicated layer.

01 In Photoshop, open *photo.jpg* from the project files and select Duplicate Layer from the menu in the Layers panel. Use **Cmd/Ctrl + L** to bring up the Levels dialog, then use the middle slider to make the new layer a bit lighter, so the subject stands out better from the background.

03 Now choose the Crop tool (**C**) and select just the subject's face and a bit of her chest. Set the Crop Guide Overlay to None in the Options bar to help you see what you're doing. For now, we'll keep the image's resolution unchanged.

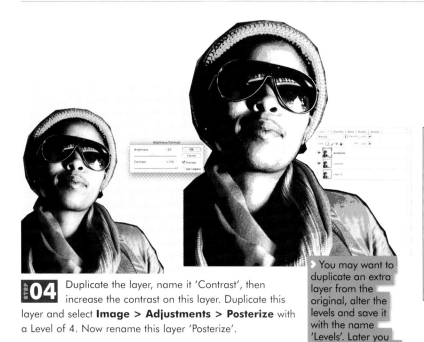

04 Duplicate the layer, name it 'Contrast', then increase the contrast on this layer. Duplicate this layer and select **Image > Adjustments > Posterize** with a Level of 4. Now rename this layer 'Posterize'.

> You may want to duplicate an extra layer from the original, alter the levels and save it with the name 'Levels'. Later you can use this to trace additional detail

Make a new layer and call it 'Front'. This is the layer we are going to work in. Put this layer on top of your other layers. Lock the other layers.

05 Now change the image resolution to 150dpi and the height to a maximum of 25cm; this will make the subsequent Illustrator file smaller. Save it as a PSD.

06 Open the PSD file in Illustrator and use the 'Convert Photoshop layers to objects' option. Now all your layers are in Illustrator's Layers panel.

07 Set the document up as a portrait A4 page, then save it as an Illustrator document. You can save it as a PDF instead to reduce the file size and stop your hard disk from overflowing.

08 Make a new layer and call it 'Front'. This is the layer we are going to work in. Put this layer on top of your other layers. Lock the other layers.

09 In the Brushes panel, select New Brush. Select New Calligraphic Brush and click OK. Rename it Basic Brush and set the Diameter to 1 and the angle to 0°. Choose **Cmd/Ctrl + B** to activate the brush, using black for the stroke colour and no fill.

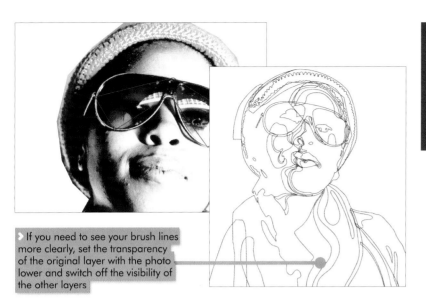

> If you need to see your brush lines more clearly, set the transparency of the original layer with the photo lower and switch off the visibility of the other layers

10 Now it's time to start tracing the photo. In general, use the brush for irregular shapes and the Pen tool for more geometrical shapes. Start off by mapping out the basic shapes. It will look a bit messy once you're finished, but trust me, that's fine for now. I start off by tracing from the 'Posterize' layer and turn to the other layers later if I want to add more detail.

11 Make sure the shapes are joined (using **Cmd/Ctrl + J**). Now you can start filling them, using the Eyedropper tool to pick colours from the 'Posterize' layer (you may also want to store them in the Swatches panel). If some shapes overlap, copy and select the shapes that need to be divided, then go to the Pathfinder panel (**Cmd/Ctrl + Shift + F9**) and hit the Divide button. Ungroup them (**Cmd/Ctrl + Shift + G**) and delete the parts you don't need. Remember to Group them again afterwards (**Cmd/Ctrl + G**).

12 Now return to the 'Contrast' layer (and the 'Levels' layer too, if you created this) – to pick out more details. After this, try playing around with the colours. Using gradients makes the results subtler and gives a pleasing painterly effect.

**POSTERIZE
A NEW PALETTE**

> Using Photoshop's Posterize command, you can create a nicely varied set of colours, each of which you can pick up with the Eyedropper tool.

13 Create a new layer called 'Background' and draw a rectangle the size of the document; I've made mine dark blue to make the face stand out more. Also draw some simple liquid shapes with the Basic Brush to make the composition more dynamic.

Open the *raster.eps* file and place the object over the green cap. Select both cap and raster element, duplicate them and drag the result beyond the document edge. Bring it to the front (**Cmd/Ctrl + Shift + }**) with the raster over the cap. Hit the Crop button in the Pathfinder panel. Align the result over the first raster element (use Smart Guides to help you), then delete the first element. Now you have a rasterised fill giving the cap more texture.

14 To assess your work, create a new layer called 'Mask' to use as a sort of picture frame. With the Rectangle tool, drag a selection over the artboard. Drag another rectangle bigger than your artboard. Select both and **right click > Compound Path**. Make this white and lock the layer.

Select **Object > Path > Offset Path** to accentuate the sunglasses – a value of 1mm should do. Choose Preview to see what works. To add an extra line inside, create another with an offset of -1mm. Note that it's not an outline, but an extra shape. Do the same for the scarf.

15 I want to add more detail to the scarf, which should make the rest more abstract. First, reduce the scarf area to just blue and black by deleting some things you've drawn. Now use the Basic Brush to create a stripe pattern using colours from the Swatches panel, then use the Pathfinder panel's Divide tool to fit the shape in the scarf. Next, draw a shape with your brush to suggest shadow. Open the Transparency panel (**Cmd/Ctrl + Shift + F10**) and select a Multiply blending mode with an opacity of 30%. Do the same for the background and clothing.

16 Copy the layer with the Multiply blending mode and paste it a number of times. Place them under the clothing to give it more depth.
Copy one part of the scarf pattern, group the elements (**Cmd/Ctrl + G**), scale them up slightly and place them in the background. Again use copy-and-paste versions of the layers with Multiply blending modes to add more depth to the composition.

17 Delete the 'Mask' layer and the layers you brought in from Photoshop. In the Layers panel menu, select Flatten Artwork. Select all your elements (**Cmd/Ctrl + A**) and group them (**Cmd/Ctrl + G**). Drag a rectangle precisely over your artboard and make sure it is on top of your grouped artwork. Select all again (**Cmd/Ctrl + A**) and hit **Cmd/Ctrl + 7**. Now you've made a clipping mask of your work, showing only what is within the artboard. Your vector portrait is now complete. ∎

PROFILE EELCO VAN DEN BERG

❯ Eelco van den Berg is an illustrator, painter and graffiti artist based in Rotterdam, the Netherlands. He can often be found freaking out in the studio with Adobe Illustrator or outdoors with spraypaint and latex. Eelco's work stands out in its strong use of colours and outlines, combined with highly decorative elements. His portfolio illustrates the diversity of his work and clientele, ranging from Bacardi to the fashion trade show Bread and Butter.

CONTACT
• eelcovandenberg.com

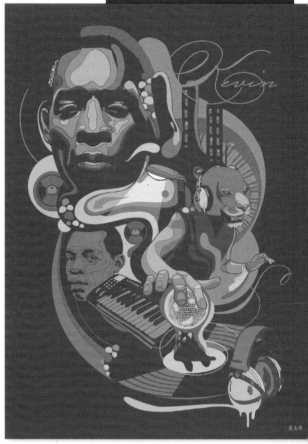

Above This portrait of legendary Detroit DJ Kevin Saunderson was created for the online gallery Heroes On Canvas.

Below A Vlieger & Vandam bag bearing one of Eelco's prints.

GET IN TOUCH WITH THE TABLET REVOLUTION

160 PAGES OF ESSENTIAL INFORMATION FOR JUST **£9.99**

TabletWorld
The Complete Guide To Tablets

EVERY TABLET TESTED
IN-DEPTH REVIEWS, TESTS AND TUTORIALS FOR ALL UK DEVICES

40 must-have apps to install today
50 ways to get the most from your tablet
100s of essential tricks, tips & secrets

iPad 2 | BlackBerry PlayBook | Galaxy Tab | Motorola Xoom | HP TouchPad

£9.99

ISBN-13: 978-0956539021

9 780956 539021

> **LEARN** PHOTOSHOP COLLAGE

Retro poster style

Update the styles of the 1950s and 1960s with artist **Middle Boop**

The retro aesthetic of the 1950s and 1960s is currently back in vogue, with the trend expected to gather pace over the course of the year.

It's not hard to see why retro design is so enduringly popular: the bold, blocky colours, simple imagery and vivid typography make this a striking era of design.

In this tutorial, Gordon Reid – who works under the creative handle Middle Boop – shows how he blended retro imagery and colour schemes with digital technology to create this month's stunning cover image.

He walks you step-by-step through the process of preparing stock images for compositing, lighting, colouring and texturing the design – as well as providing a few sneaky keyboard shortcuts to speed things up.

The stock images that Reid has used are all available from iStock. You can buy them from *bit.ly/4V2JvR*, *bit.ly/7rdMRZ*, and *bit.ly/4P2kj9* – or if you prefer, you can substitute similar images of your own.

03 Let's take the aged effect further by adding a slight texture to the three images. In the computer layer, go to **Filter > Noise > Add Noise**, set the amount to anywhere between 6 and 8 for the computer and set the distribution to Gaussian. Do the same process for both of the other layers but use the filter a lot more lightly.

04 Now that we have the focal point to work from, it's time to work out some vibrant colours to make the design really eye-catching. I want to use colours that emphasise the old-school feel but can also be combined to look contemporary. Put a cream coloured layer such as #fdf9d1 over the top of the image and set the blending mode to Multiply, then play about with colour swatches to find some great colour combinations.

01 To start off, download the images mentioned in the introduction, or find suitable ones of your own. Then cut out the images – there are many ways of doing this but the cleanest and most efficient by far is the Pen tool (**P**). Once they're cut out, add a more aged effect by holding down **Shift + Cmd/Ctrl + U** and desaturating the images.

02 Now let's merge the two images of the women together giving the impression that one is presenting the computer. Hit **Cmd/Ctrl + L** to match the levels of the images, go to **Image > Adjustments > Brightness/Contrast**, adjust these, and add a warming photo filter with a density of around 15% (**Image > Adjustments > Photo Filter**).

05 Next, create some solid geometric shapes. A great way to get interesting results from shapes is to create your own custom grid. Open Illustrator and line up some diagonal lines with some vertical, and while holding down **Alt/Opt**, drag the cursor across. Continue until you have a grid. ❯

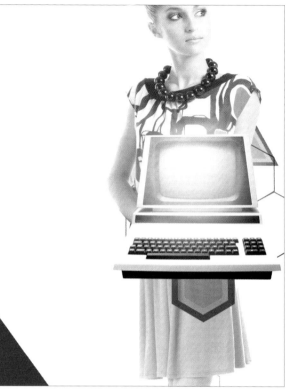

06 One way of achieving interesting effects is by creating your own brushes in Illustrator. Play about with some ideas that might work well as a brush – such as a dotted line – then go to **Brushes > New Brush > New Art Brush**.

07 Back in Photoshop, we want to give the impression that light is exploding from the computer screen. Take a large soft-edged brush with the hardness set at 0, then using a bright white colour click over the screen. Double-click on the layer in the Layer Palette to open up the blending options and select Outer Glow, setting the size to 51%, range to 55% and opacity to 61%. Repeat this on a new layer, changing the contour's preset to Cove – Deep and the opacity to 70%. Add some vibrant shapes underneath the blurred layers.

09 Let's add some depth to the image. Grab a large, soft-edged brush, pick one of the colours, and in a new layer behind the main image, click a few times to create some coloured patches. Take the opacity down to 40% and set the layer's blending mode to Pin Light. In a new layer, select another colour and paint some more blotches, this time setting the layer's blending mode to Satin, the distance to 33, size to 250, and the contour to Gaussian. Set the opacity to 63%.

10 One tool that can be really useful if used well is the Blend tool. Return to Illustrator and import your image from Photoshop to use as a guide. On a new layer use the Pen tool and create two separate wavy lines, then go to **Object > Blend > Blend Options**, select the specified steps and select around 70, hold **Cmd/Ctrl + Alt/Opt + B** and see the results.

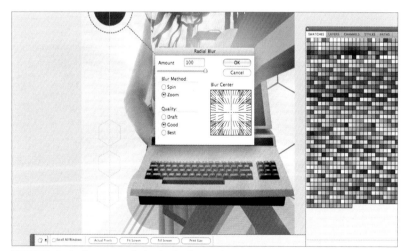

08 To further intensify the look of something exploding from the computer screen, take a textured stock image such as the one I downloaded from Photos To Go at *bit.ly/6571Ec*. Press **Shift + Cmd/Ctrl + U** to desaturate the image. Next, select **Filter > Blur > Radial Blur**, setting the method to Zoom, the amount to 100 and the quality to Best. Erase the edges with a large soft brush, set the opacity to 47% and set the image in the centre of the screen.

11 This technique can be also be applied to shapes as well, such as the triangles. You use the same process but play about with the amount to get the desired effect. Don't be afraid to experiment; if you need to alter anything hold **Shift > Cmd/Ctrl + Alt/ Opt + B** to release the blend.

15 Now use a black brush to add some shading around the top and sides of the image. Go to **Filter > Noise > Add Noise**, setting the distribution to Uniform and the amount anywhere from 50% to 60%. As this is only for background texture, set the opacity and fill right down to 20-35%. As with step 14, set this layer over the top of the image.

12 The illustration at this point still looks a little empty and could do with a spruce-up. Choose a few more vibrant colours from your swatches and bring a few simple shapes to life using techniques such as gradient overlays. Select the Gradient tool and customise your gradient by clicking the Gradient editor in the top left hand corner.

16 For the final addition of texture set a new layer on top of the rest. Change the background and foreground colours to the cream and yellow already used, go to **Filter > Render > Clouds**, then **Filter > Blur > Gaussian Blur** and set the radius to 20 pixels. Change the opacity to 9% and the fill to 70%. ∎

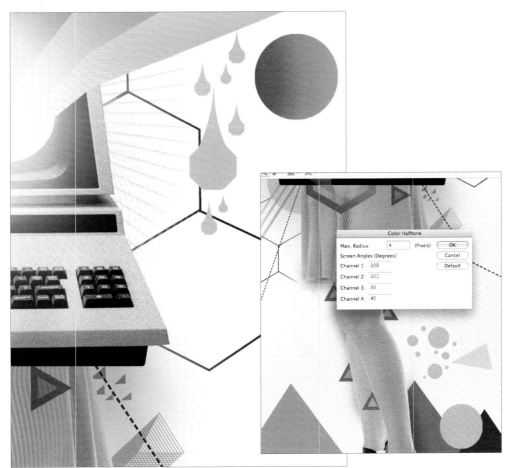

INFO MIDDLE BOOP
> Middle Boop is the moniker of designer, illustrator and blogger Gordon Reid. As well as working for record labels 4AD, Warp and Bella Union and bands such as Deerhunter, Prefuse 73 and Of Montreal, he has shown animations shown at the BFI. Reid also runs the Middle Boop blog and fanzine.

CONTACT
• middleboop.com

SOFTWARE
• Adobe Photoshop and Illustrator

TIME TO COMPLETE
• 2-3 hours

13 Tweaking simple geometric shapes can really bring the design out. To create these green shapes, for example, I've simply used the Pen tool to create a teardrop effect and merged the two layers. Then while holding **Alt/Opt** I've duplicated the image a number of times and lined them up.

14 Now it's time to add some more texture to the background. Use a yellow soft-edged brush at 500-600 pixels and go nuts! Once you're happy go to **Filter > Pixelate > Colour Halftone**, and set the maximum radius to four. Set the opacity to 32% and the fill to 71%. Place this layer over the top of the image.

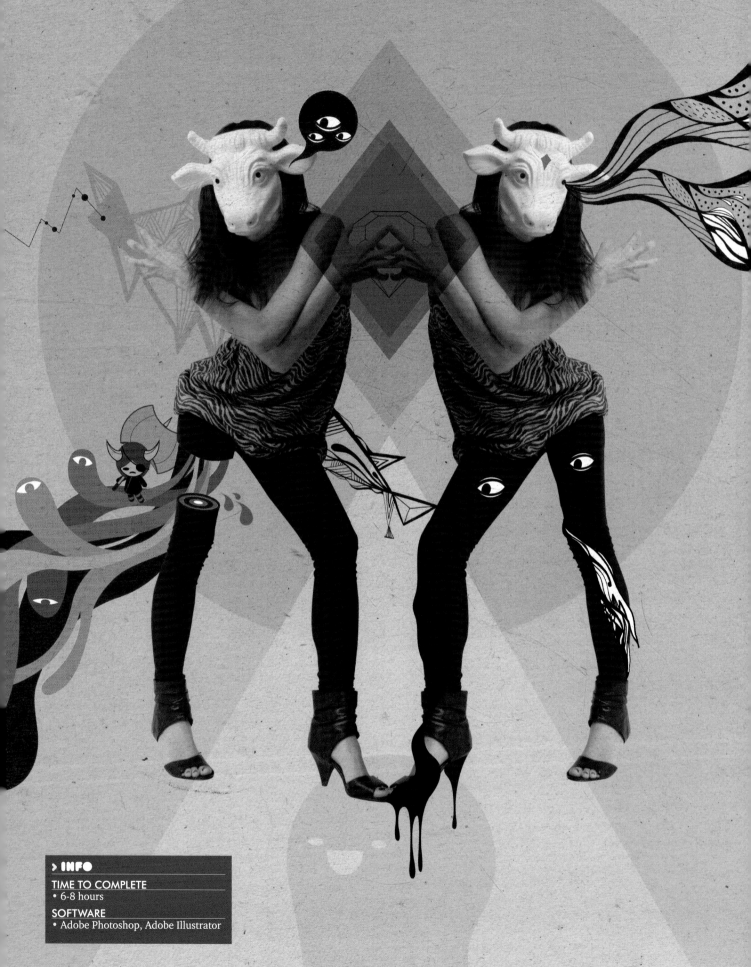

MASTERCLASS
HONE YOUR DESIGN SKILLS WITH EXPERT TECHNIQUES

> INFO

TIME TO COMPLETE
• 6-8 hours

SOFTWARE
• Adobe Photoshop, Adobe Illustrator

> **LEARN** COLLABORATION

Digital art remixed

Discover how **Stephen Chan** and **Andriana Katsiki** combined their skills to create something that was a synthesis of their styles

airytale Asylum is a collaboration that has been waiting to happen since artists Stephen Chan and Andriana Katsiki (AKA Wundercloud) met in 2007. They instantly loved each other's work and soon realised that they share a lot of the same inspirations, even though their styles are quite different.

Eventually they decided to properly join forces and start experimenting by combining their styles into something new and unique. Both love working with characters, especially ones that have some weird or twisted aspects to

their personalities, and that became one of the main themes in their collaborations.

"When creating a new piece, we give the freedom to each other to express themselves how they like," says Andriana. "The harmony of a finished piece comes naturally from the love and respect we have for each other's work."

The piece that Andriana and Stephen have created is a journey into the world of Fairytale Asylum – where characters live, play and kill together. They hope you enjoy the trip.

04 Once she was happy with the sketches, Andriana scanned the image back into Photoshop and, using Levels, she removed the guide character, leaving just the drawing. She then cleaned them up and placed them over the original image.

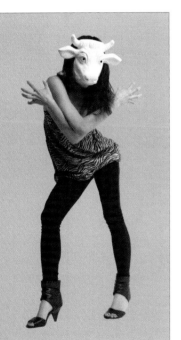

01 Andriana began by first selecting an image from her personal library of characters, from which all of the Fairytale Asylum project's illustrations will take inspiration from.

"The image I chose is from a series of anthropomorphic characters that combine fashion photography with surreal animal heads," she says.

To begin the project, Andriana cut out the image in Photoshop and placed it on a background colour of #a3948d.

02 Andriana started to build up the character by doing a colour correction pass using Hue/Saturation. She shifted the skintones down to an unnatural blue colour as the artist wanted to accentuate the dynamic pose of the character. These colours further added to the surreal, almost otherworldly feel of it. A slight gradient fill introduced more depth to the image.

03 Andriana began to introduce some hand-drawn elements. She printed out the character at around 15-20% opacity and began sketching over the top. She hand-draws a lot of elements in her work, using them to extend other parts of the image in organic ways – in this case, the photography.

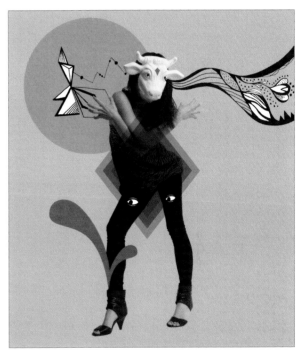

05 She then added some geometric shapes into the composition to contrast with the sketched elements. Stephen could use these additional shapes as starting points for his own illustrations. At this stage, Andriana looked at the image as it stood and, after a few tweaks to the composition, she passed it over to Stephen to start experimenting.

Her fellow artist wasted no time putting his own mark on the work. Stephen roughly established a way of working having collaborated on a few illustrations before (one of them would find a nice photo and add some graphical elements before passing it to the next person). Stephen opened up the file and saw the imagery, the strange pose of the model and the sketches – and loved it.

> "When creating a new piece, we give the freedom to each other to express themselves"

ANDRIANA KATSIKI

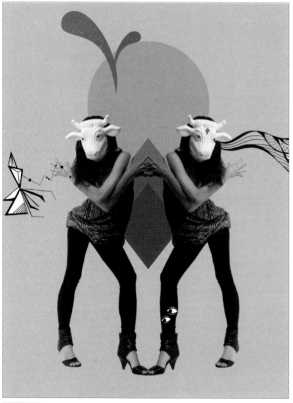

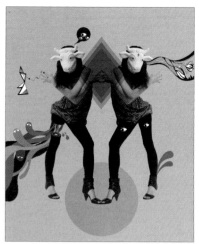

07 Stephen started with his usual technique for approaching a piece of work – stared at it for about half a day until something suddenly sparked in his brain. He decided to amputate the leg, firstly masking off the section in Photoshop, and then saving a low-resolution version to take in to Adobe Illustrator. "Cutting off limbs is all the rage," he quips.

09 When Andriana received the work back, she had to spend a lot of time considering her next move, as Stephen's duplication of the central figure had changed the dynamic of the artwork a lot.

"I really liked how it gave a completely fresh feel to the piece, so it inspired me to think about the story that was forming between these characters. My challenge now was to develop the relationship between the new elements and continue to build the story."

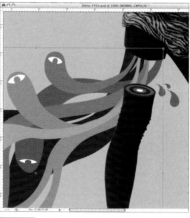

06 "Everything in the piece was great, but I just wasn't too happy with the composition, the positioning of the main focal point," says Stephen.

He moved things round until they seemed right, and making adjustments to the composition after a few quick emails with Andriana. Stephen ended up duplicating the model for more impact.

08 With Stephen being quite heavily influenced by surreal and weird artists, Manga and Asian culture, massive worm creatures spewing from the thigh seemed quite perfect. He quickly vectored up some new worms and found some old worms, then quite conveniently copied and pasted them in to Photoshop.

10 Stephen received the piece back, with a few elements moved and a texture background added. The pink circle that was at the top was now at the bottom. The heavy shape at the bottom seemed like it wanted to drag itself off the page, which lead him to create the drippy character (even the slightest change in composition can spark off inspiration).

Animated idents for for Self Similar, a minimal techno and electronic club held at The Magnet in Liverpool.

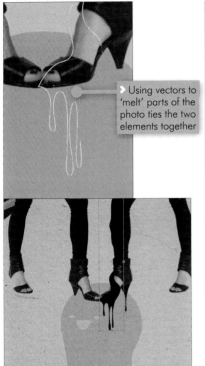

> Using vectors to 'melt' parts of the photo ties the two elements together

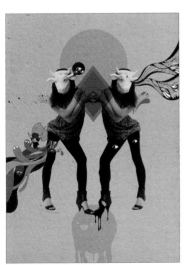

11 Stephen wanted to blend the photographic elements and the vectors a little more, and after staring at the drippy character for a while, it lead to the creation of the melting leg. He drew it up in Illustrator again, using a bright colour, which he found helps when tracing or drawing on top of dark objects. This could easily have been done in Photoshop, too.

13 Andriana's response to Stephen's work was, "Wow! The new characters and vectors really begin to make the piece look solid now, and I was inspired to do some more drawing. I feel like the little narrative had developed nicely, and my new drawings would pull the whole thing together."

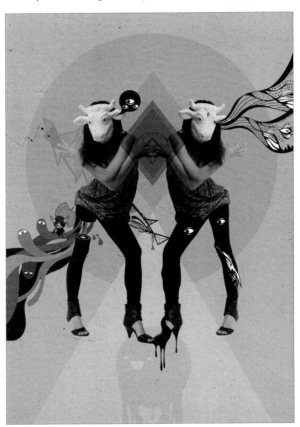

12 "The illustration is now starting to near completion, needing just a few more elements to tighten it," says Stephen. "Looking around again I thought maybe an image of a diamond being grasped on to by those claws (in the middle of the diamond shapes) would be fitting. And no illustration would be finished without my axe-wielding little girl."

14 Andriana then toned down the illustration, taking out the pinks so that the other elements were stronger, and so it wasn't too busy. She and Stephen decided the composition was looking a little dull, so bringing back some of the pink would draw the viewer in to the piece nicely. This finished the piece to both artists' satisfaction.

"There were some compromises to be had along the way," says Andriana, "with tweaks to the composition and individual elements being sent back and forth. But in the end the overall look was achieved by working close together, and fine-tuning the composition until we were both happy."

PROFILE STEPHEN CHAN

> Stephen's illustration style is unique. "I try to implement as much detail and make the illustration as fun and interesting as possible," he says. "It's character-driven, and often involves large, isometric detailed landscapes and scenes." He is also one of the founding members of design portal Thunder Chunky, and part of the Blood Sweat Vector Collective with J3 Concepts, 123Klan and Niark1. His work has been exhibited internationally.

CONTACT
• stephen-chan.co.uk

Chan has become well-known for prints like *Power In Numbers* (top), *King Kong vs Godzilla* (middle) and *Great Battle of 1211* (bottom).

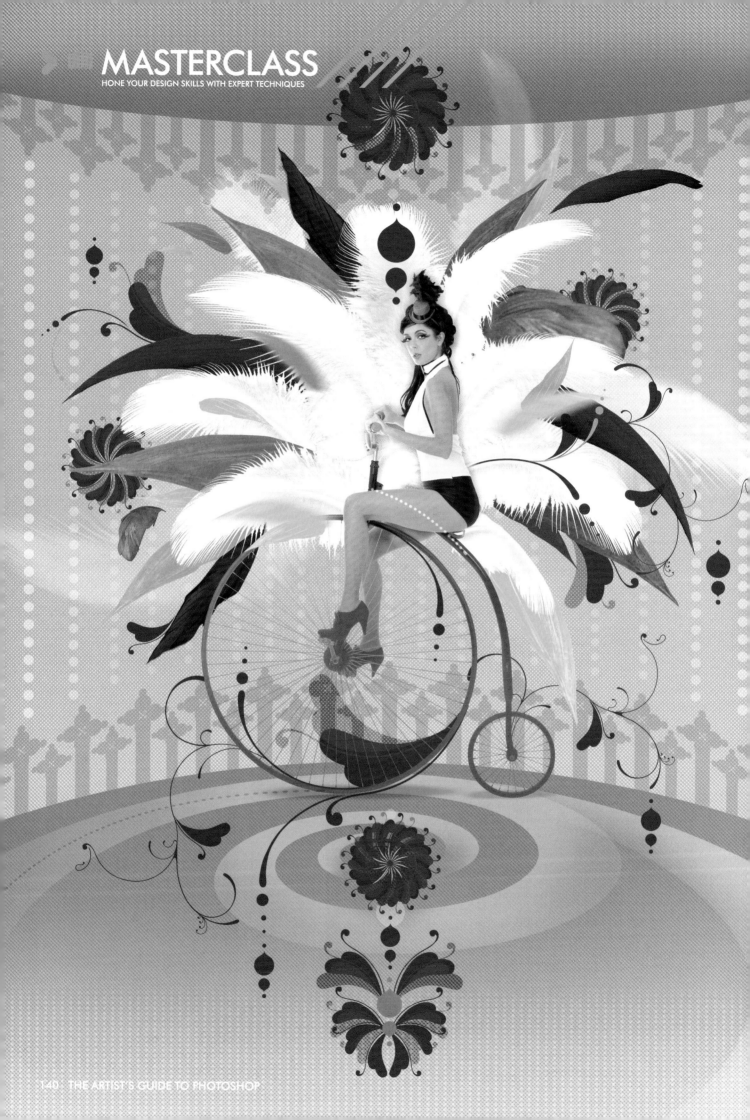

Learn pro-level masking skills

Put your masking and colouring talents to the test creating this sumptuous image with **Radim Malinic**

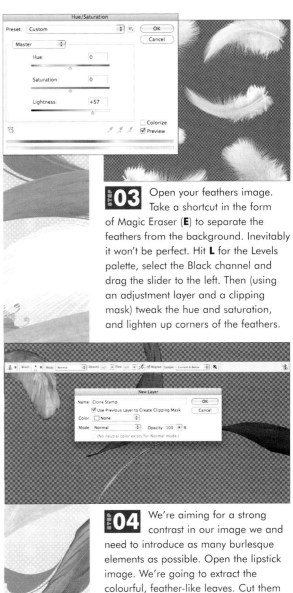

lirty, fancy, and defiantly old-school: burlesque is big news at the moment. It relies on teasing and subtle details for its sexiness, rather than resorting to acres of exposed flesh – meaning that you can be seductive without having to go all-out raunchy.

In this tutorial, Radim Malinic lets his imagination go for a wander, creating a unique image by blending a burlesque-style central figure with other exuberant, whimsical elements – including a dream catcher and a merry-go-round.

Malinic says: "It's imperative that you learn how to make your workflow as intuitive as possible. The software should be an extension of your thoughts, rather than making you into a slave and telling you to use this or that filter. We will explore simple techniques that emphasise colour shifts, quick masking, and adjustment layers."

The images that Radim has used can be bought for a small cost from *iStockphoto.com*, or you can use similar images of your own. Download the images from: *bit.ly/cxAvcv* (the model), *bit.ly/9JNckm* (the feathers) and *bit.ly/cl4l4C* (the lipstick).

01 You've been here before and you may not like this part at all. Separating an image from its background can be a chore, but it's worth doing properly – and you'll always find new ways to improve your cut-outs. For some quick tips see steps 1-3 of Ciara Phelan's tutorial (page 60).

Open your model shot – we need to get rid of the bike stand and lose the white reflections on the model's body and bike frame. Add a new layer with a clipping mask, sample and brush colour around the edges. It will make the final layer look more 'natural' in the final composition.

02 The spokes will be far too fiddly to cut out – it will be quicker to ignore them and then draw new spokes on the bike. When your cut-out is complete, hit **U** and set the line thickness to 3px. Using the model image as a reference, draw from the outside in. Group all the spokes (**Cmd/Ctrl + G**) to save space in the Layers palette.

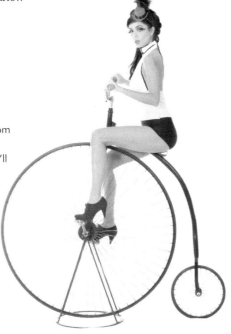

03 Open your feathers image. Take a shortcut in the form of Magic Eraser (**E**) to separate the feathers from the background. Inevitably it won't be perfect. Hit **L** for the Levels palette, select the Black channel and drag the slider to the left. Then (using an adjustment layer and a clipping mask) tweak the hue and saturation, and lighten up corners of the feathers.

04 We're aiming for a strong contrast in our image we and need to introduce as many burlesque elements as possible. Open the lipstick image. We're going to extract the colourful, feather-like leaves. Cut them out with the Pen tool (**P**) and put on separate layers. Create a new layer with a clipping mask and use the Clone Stamp (hold down **Alt/Opt** to copy an area, then click to stamp it) to build up a nice, smooth and even texture – as if they had never overlapped.

05 Although the previous few steps may feel tedious and time-consuming, getting them right is crucial to the success of the piece. Now, the fun part begins. Create a new document, setting the background colour to C – 32, M – 29, Y – 29, K – 0. Hit **G** and build up a gradient colour by setting the blending mode to Multiply.

06 Bring your burlesque cyclist into the main document as a flattened single layer, with a Levels adjustment layer attached using a clipping mask. Place it in the middle of your document, add an orange gradient from the bottom of the bike, and draw simple shadows to give the right perspective. Scale the girl down to about a third of the size of the canvas.

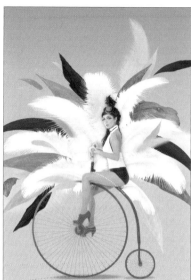

TIP

> When you're working on a multi-layered image with lots of photographic elements, it's always useful to keep hidden groups of original layers as a back-up for quick workflow. Make your time spent enjoyable with extra ideas and not dipping in and out of extra documents.

07 Bring in the feathers, placing each on a separate layer with its Hue/Saturation adjustment layer. You'll be able to tweak any dark edges by brushing on an extra white mask. For easy navigation, create a group for each layer, then group all the groups together, copy them for back-up and flatten each feather when you're happy with the colour and white balance.

09 Now group the original leaves to make them quicker to work with, flattening each individual group (**Shift +E**). Distribute them around the model and between the feathers. To make colour tweaks, hit **Cmd/Ctrl + U** to bring up the Hue/Saturation palette, then adjust the colour as you like.

08 Drag over the leaves from the lipstick image. You can flatten the extra retouch layers in the original document for an easier workflow. To change the leaves' colour, use a Solid Colour adjustment layer set to Hard Light. Select a leaf, hold down **Alt/Opt** and click New Adjustment Layer icon at the bottom of our Layers palette. Select Solid Colour and sample a basic orange from the Swatches. Set it to Hard Light and you will see how all of the original texture remains with vibrant result. Repeat for all the separate leaf layers.

10 Now let's add some vectors. Many creatives store a bank of vector elements they've previously created – or you might prefer to draw new vectors for each image, as I do. I've worked up some simple shapes that will add extra depth to the image, and give it a more intriguing look – the images are on the project files, saved as *Shapes.ai*.

> "Many creatives store a bank of vector elements they've previously created – or you might prefer to draw new vectors for each image."

ADJUSTMENT LAYERS EXPLAINED

> Adjustment layers in Photoshop enable you to drastically change your image without disrupting your workflow: they non-destructively alter the layer that you've clipped the adjustment layer to, so that you can change them later on without having to backtrack or otherwise mess around. To create an adjustment layer, click the black-and-white circle at the bottom of the Layers palette, or go to **Layer > New Adjustment Layer** and selecting the type of adjustment you're looking to make.

11 Although the vectors have nice gradient colours in Illustrator, here we'll use them as basic shapes in single colours in the main Photoshop window. Paste each object onto the canvas as a Shape Layer and fill with red or maroon. Setting some objects' blending modes to Multiply and Overlay builds up vibrancy in your image.

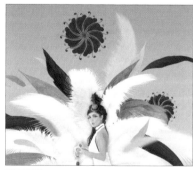

12 Add a Hue/Saturation adjustment layer above your Background layer. You can move sliders to get the right tone, which is more brown, more in line with our other elements – I've set the Hue to -180, the Saturation to -25 and the Lightness to -3.

13 Depending on the size of your monitor, zoom out (**Cmd/Ctrl + 0**) to see the whole image and to figure out what it's lacking. Add simple shapes to the top and bottom of the image (drawn with a U set to Ellipse) to give the piece a carousel-type look.

Add extra vector elements for each edge and quickly mask out the excess by selecting from the round layers.

14 Sometimes it's nice to give an illustration an overall texture. You could find an image and overlay it on the top of your Background layer, but we'll do it a different way. Open a new document the same size as the main canvas, but in Grayscale mode. Set a gradient (**G**) so that the colour builds up nicely at the top and bottom. Go to **Edit > Mode > Bitmap** and select Halftone screen (Diamond 25 / 42).

The outcome will be an uneven dotty texture, which seems just ideal for the piece. **Cmd/Ctrl + A > Cmd/Ctrl + C > Cmd/Ctrl + V** to copy-and-paste it into the main piece, setting the blending mode to Overlay.

15 Your piece is pretty much done. Feel free to copy some more vector elements and use them more around the cycling model, to give the eye more to devour. One last tweak would be to add Levels (again as an adjustment layer) on the very top of our layers stack to get the colour just right. ■

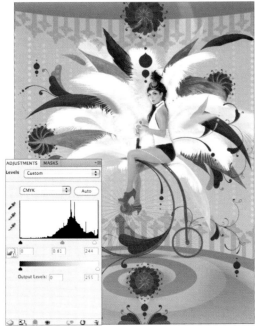

INFO RADIM MALINIC

> In the past few years, Radim Malinic has established himself as a sought-after commercial illustrator. His recent projects have included digital illustrations and photo-based images for clients including Blossom Hill, the London Film Museum, PlayStation, and Penguin Books. His illustrations have also appeared on album covers and in a range of magazines.

CONTACT
• brandnu.co.uk

SOFTWARE
• Adobe Illustrator & Photoshop

TIME TO COMPLETE
• 4 hours

PROJECT FILES
•Download the files from theartistsguide.co.uk/ downloads

Left "A personal experiment where I found that less is definitely more."

Below Radim says: "David Ogilvy is a hero to me... It was my pleasure to work up one of his quotes for *Format* magazine."

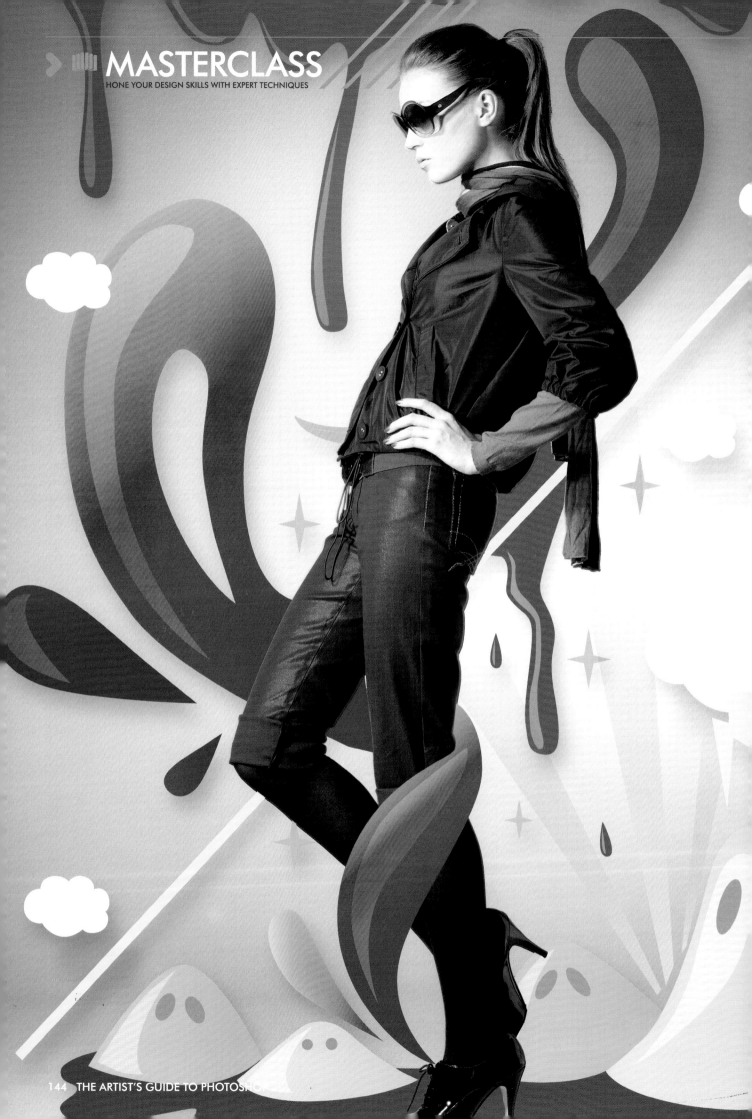

> **LEARN** SHAPE EFFECTS

Add vector flair to model shots

Recreate this brilliant image with tips from **Camilo Bejarano**

There's something about the rounded, gentle textures of vectors that makes them a playful and very tactile contrast to an elegant model shot.

In this tutorial, Camilo Bejarano shows you how to ramp up this juxtaposition, hand-drawing elements before scanning them in and transforming them into dramatic, colourful designs that interact neatly with the photograph.

This technique offers many opportunities to creatives: you can use it to add or accentuate colour, to alter the feel of a photo, or to suggest moods and thoughts that aren't immediately apparent from the photo itself. Best of all, it's a lot of fun and offers you the chance to let your creativity run riot.

> **INFO**

TIME TO COMPLETE
• 4-6 hours

SOFTWARE
• Adobe Illustrator & Photoshop

GET THE HABIT

> Sketching is essential: whether you're at home watching TV, commuting or simply relaxing, try to open up a pad and start sketching whatever comes to mind. Any idea can lead to a great final composition. Be open to problem-solving — plenty of great ideas often first arise as mistakes. Save all of your sketches — they always come in handy.

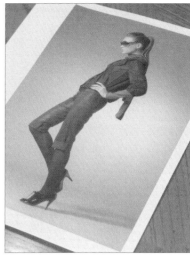

02 Before drawing over the print-out, do some practice sketches, to give you a clearer idea of the end result. Once you have a good idea in place, begin sketching it around and over the photograph. Try to create the shapes and forms that communicate well with the object or objects.

01 First, we'll need to find the right image – this is key to the whole piece. It can be a photo you've taken yourself, or a stock image. If you want to use the same image I've used here, you can download it for a small cost from Shutterstock at *bit.ly/9P42mk*. I recommend seeking out images with little or no background.

Once you have found the right image, open it in Photoshop and print it onto A4 paper. The reason we print the image so small is so it's a manageable size for sketching on.

03 Once you have a composition that really clicks, make sure the line quality is consistent and that it's dark enough to scan clearly. You may need to retrace your shapes if the lines are too light. Scan in your work or photograph it to import to your computer. If you're using a camera, make sure that the image is completely straight-on to the camera. ➤

04 Depending on the quality of your scanned image, you may need to open it in Photoshop to retouch it, such as darkening lines. I usually do this to make sure I'm confident that the trace is going to line up.

Back up the original photo and open the duplicate. Make sure the dimensions are correct for your final output. Now create a new layer with the drawing you created over the original. Take the drawing layer, set it to a 50% opacity and resize it so the photos match with each other in height and width – it should be exact.

05 Once the images line up, export a flattened version of the image to Illustrator. This may take some time so it's a good opportunity to put some music on or make a cuppa.

Adjust the canvas to the size of image and begin tracing each of the shapes you've created on new layers. I usually use a red outline and no fill to trace all the shapes first, so I don't have to worry about colours and gradients. Put each set of objects on a new layer.

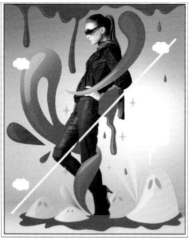

06 Now that all the shapes are vectors, we need to create a colour palette to work with. Pay close attention to the lighting of the image you're working with because this will work as a guide for your gradients and colours. Start filling in all the shapes with colour, gradients and highlights.

07 Now that you've finished adding colours and gradients, delete the layer that contains the photo, and export your vectors to Photoshop. Use the Export as PSD option it helps keeping the layers you have created. Open your file in Photoshop, and import the original model shot into the file, placing it in a layer behind all the layers. Ensure that everything lines up correctly and that the relationship between the photo and vector elements is as smooth as possible.

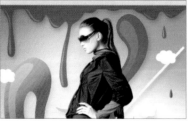

08 Almost done. Since we're using this artwork for print, now that everything lines up, ensure you convert the file to CMYK. If you like you can adjust or add some extra colour, overlays and textures to the artwork. Since all the layers are separated you can easily add shadows and finishing touches to your artwork. ∎

INFO CAMILO BEJARANO

> Colombian-born multidisciplinary designer Camilo Bejarano is based in the US, where he works under the name Ph7labs. His work has appeared in titles including *The New York Times*, *New York* magazine, *Revista Colectiva*, and *IdN*.

He says: "Since I was very young, I've always enjoyed drawing and building things – passions which later led me to become an illustrator."

CONTACT
• *ph7labs.com*

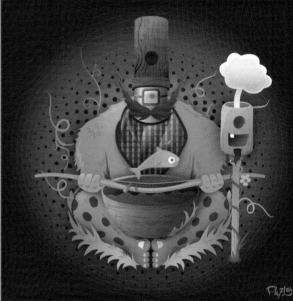

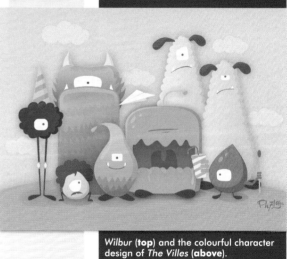

Wilbur (**top**) and the colourful character design of *The Villes* (**above**).

> ◧▥▥ PHOTOSHOP SECRETS

GLEAN INSIDER TIPS FROM OUR TEAM OF EXPERTS

secrets

of the world's best designers

words Craig Grannell

Leading creatives of all stripes share their favourite tricks and tips.

Meet your deadlines, treat clients well, don't use the Photoshop Lens Flare filter unless you want to be ostracised by the entire creative community. Yeah, yeah – we get it. And you've read about it. Tips for artists tend to follow a set formula – and they can be both practical and useful, but they don't always provide much of an insight into the more hidden, intangible parts of the creative process.

For this feature, we turned to the best of the best, and the brightest up-and-comers across the creative industries, and asked them to tell us a secret – a tip that helps them do their best work, sparks ideas, or gets them through the day.

What we got is a glorious mix of practical information, instinctive and personal working methods, wise words, and amusing quips, and a hint that hula-hooping might cure the creative industry's ills.

We hope you'll find these glimpses into the innermost thoughts of the designers, illustrators and filmmakers we spoke to as exciting as we do. Whether it's a Photoshop tip for making images sing, or a tea selection that's guaranteed to inspire, there's something in here that will help you work better and be more creative. Enjoy!

1 "Developing, building and stubbornly maintaining a successful visual style will ultimately kill your creativity – and your career. Change constantly or die."

Bob Staake, illustrator, winner: *Time* Best Magazine Cover 2008
bobstaake.com

2 "Keep your desk tidy – not like mine. I spent an hour this morning looking for a DVD of images for a book cover, and finally had to ask the client to upload them again to our FTP. It turned out they'd mistakenly sent the DVD to a 'Ryan Hughes' in California, but with all that mess, I assumed it was under there somewhere."

Rian Hughes, font designer, illustrator and occasional comic-book artist
devicefonts.co.uk

3 "Think before you start to work. Something should be in your head or your sketchbook before you switch on your Mac. I never let my Mac control me – he knows his place; he is only a tool that helps me execute my thoughts."

Noma Bar, illustrator, creator of the new book *Negative Space*
tinyurl.com/nomabar

4 "When stuck for material, think back to some terrible childhood trauma and draw it. Works every time."

Gemma Correll, illustrator and fan of "drawing, pugs and coffee"
gemmacorrell.com

5 "Brainstorm and rapidly prototype – force yourself to come up with as many ideas as you can, but spend no more than five minutes on each one. It's surprising how quickly this can expose ideas that work and those that don't. Often, ideas you least expect work best."

Simon Crab, co-founder, digital agency Lateral
lateral.net

6 "For video, storyboards and animatics are crucial, but they needn't look beautiful – mostly, they're just a guide.
 "Carry a notebook and pencil for sketching out ideas, and use basic storyboards to test out ideas as a sequence, and to make important storytelling, timing and editing decisions."

Chris Sayer, animation director at Wyld Stallyons
wyldstallyons.com

1

2

3

4

Your Family Friendly Feature Presentation

Nature!

**Always available
in glorious Technicolor!**
Super Stereophonic Sound Guaranteed!

7

11

7 "Create seminal pieces that tell the world about what you love, where you draw inspiration from and where your enthusiasm peaks. This could attract a dream client or collaborators you share a common bond with.

"I love nature, so I create pieces to attract clients needing something nature-themed, to work together promoting, recreating or enthusing over nature."

Ben O'Brien, illustrator and creator
of Speakerdog
bentheillustrator.com

8 "Take photos of anything that tickles your fancy to use as inspiration later on. Don't worry about quality or reflections – the pictures are just reminders. I love a badly stuffed weasel at the Bristol Museum. Its unnaturally arched spine and placid face are beautiful.

"I never got a good picture, but found something on my camera recently, and turned it into a character illustration."

Phil Corbett, illustrator and creator of the
Kitten Parasites clothing label and book
philcorbett.com

9 "Take advantage of software integration. I create artwork in Illustrator and develop it in Photoshop. Vector elements pasted into Photoshop become Smart Objects, that can be subjected to treatments like adjustment layers, masks and smart filters – great for creating subtleties of texture and colour that are lacking in designs made purely in Illustrator."

Matt Lyon, designer and artworker
c8six.com

10 "Work without distractions such as 'new email' alerts, and play your favourite music – that which affects you – to do your best work."

David Carson, designer, and author
of bestselling book *The End of Print*
davidcarsondesign.com

11 "Aim to spend a day entirely focused on creating one particularly special piece of work. Do everything you can to make this possible – avoid distractions in your schedule, and ensure you've had a good night's rest and have a clear desk."

Alex Mathers, illustrator and admirer
of bold, simple, smooth forms
alexmathers.net

12 "Breaking your routine encourages your powers of observation and critical judgment, enabling you to view work from a wider perspective.
"Tunnel vision is the enemy of the single-minded worker, so take a side-step and look at something you don't expect. Go for a walk, head in a new direction, to a place you've never been."

Holly Wales, art director, illustrator and lecturer
eatjapanesefood.co.uk

12

13 "I got this Twinings tea multipack recently. It's made up of Assam, Earl Grey, Lady Grey, Breakfast and Ceylon, and I find dipping into it perfect to spark that bit of creativity."

Matt Dent, D&AD Black Pencil winner for UK coinage redesign
mattdent.com

13

14

14 "To work as an illustrator, don't think you need to be 'born talented' – it's not about holding the best cards, but playing the ones you have well.
"Know yourself, work hard, and understand your weaknesses but also what you're good at."

Murilo Maciel, illustrator and designer for clients such as Pizza Hut and Sony
grafikdust.com

15

15 "Paste flat shapes from Illustrator to Photoshop as Shape Layers. Smart Vector Objects are great to maintain vector information in complex art, for choosing spot colours, and for rescaling. When working on murals or billboards, you can start at a third of the finished size and later upsize without losing quality."

Radim Malinic, art director and designer, for clients including Mini and MTV
brandnu.co.uk

16

16 "When creating complex layered compositions, stroke thickness needs a lot of attention. Use a smaller stroke thickness in a lighter colour to make background items subtler, and a thicker, slightly darker stroke for foreground items, so they appear more clearly. For the focal point, use the thickest stroke and darkest fill colour."

Stephen Chan, vector designer and illustrator
stephen-chan.co.uk

17 "Save time creating digital artwork by learning keyboard shortcuts. In Photoshop, use Actions to record specific tasks, such as changing the resolution of a batch of images rather than amending each one manually."

Yee Ting Kuit, pattern-obsessed illustrator who regularly exhibits
yeeillustration.co.uk

18 "Interesting compositions help retain interest in a drawing – for example, mathematically dividing a page and balancing black and white equally. Working with rules like this keeps your brain creative – because you always want to break them, and when you do break them it makes sense."

McBess, illustrator, director and Dead Pirates noise-maker
mcbess.com

19 "If I've hit a creative wall playing with colour, and pushed hues in a direction that appeals, but not created a cohesive image, I'll make duplicates of the image, add a layer of colour and go through blending modes to see what more is possible. I'll then pull colour ideas from these variations."

Autumn Whitehurst, Brooklyn-based illustrator of streamlined figures
awhitehurst.com

20 "To get inspired and think of fun new ideas, half an hour hula-hooping in the garden usually does the trick."

Alex Godwin, illustrator and owner of Tikki Tembo greeting cards company
alexgodwin.co.uk

21 "Don't rely on tricks and plug-ins. Have ideas that are interesting and communicate effectively. Visual art and design is nothing if it doesn't make a connection with the viewer and solve the communication problem. Learn how to use visual language to communicate in a way that is simple and smart."

Danny Yount, creative director at Prologue, title designer for *Kiss Kiss Bang Bang* and *Iron Man*
sixteentwenty.tv

22 "When starting a project, I grab visual reference. With a blobby, blocky sketch as a background, I layer reference images in Photoshop, with a Hue/Saturation adjustment layer topmost that knocks back the colour to a low-contrast greyish look. I assign a layer mask to each layer image and invert the mask, turning the image invisible. Using a radial gradient, I work into the mask, exposing parts of hidden images, moving through the layers until something takes shape.

"The vagueness and lack of precision allows for happy accidents, where bits of exposed image work on other exposed images. From that foundation, you can refine masks, resize or reposition images or start the illustration proper."

Mark Harrison, concept artist for TV and videogames, and comic-book artist
2000ad.org/markus

23 "Every few years, a creative group or individual affects the immediate culture of artistic individuals and their peers. It's then up to those people that find it inspiring to go off and make their own innovative solutions, not just copy what inspired them."

Stan Zienka, associate creative director at Attik
attik.com

24 "You need to work on being original and make work you're passionate about – don't let people tell you what's cool."

Noah Conopask, associate creative director at Emmy-winning VFX and animation studio Shilo
shilo.tv

25 "Don't spend much time looking at other people's work. Know what's going on and be aware of it, but do what you want, how you want to do it, and worry about who else is doing it later."

Sean Freeman, illustrator, published in *Wired*, VH1 and the *Guardian*
thereis.co.uk

26 "The Photoshop Brush tool comes with loads of soft-edged airbrush-type brushes. Everyone uses them, which is why so much Photoshop painting looks like bad airbrushing. Seek out the one hard-edged pressure-sensitive brush and make copies of it at different sizes. This will give your work a much more organic, hand-painted look."

Matt 'D'Israeli' Brooker, comic-book artist and illustrator
disraeli-demon.blogspot.com

27 "We keep a library of 3D models we've built or purchased. This enables us to quickly mock up 3D scenes for style frames, preliminary composition or a rough pre-viz.
"Also, a 'dirt' pass – otherwise known as ambient occlusion – enables clients to get an idea of form without getting into texturing and lighting, which may complicate the approval process."

Scott Sindorf, principal and co-founder, UVPHACTORY, designers of Lady Gaga's MTV Video Music Awards set
uvph.com

28 "Keep a collection of sketchbooks. One for ideas, concepts and thoughts, One for inspiration and accumulated stuff you like, and one for your own work, stuff in progress, experimentation, and alternate client proposals.
"Keep the ideas sketchpad handy as you never know when that 'Eureka!' moment will hit you – on a bus, out in the park, or in bed just before you fall asleep"

Johann Chan, art editor, *Digital Arts* and CIO
www.digitalartsonline.co.uk

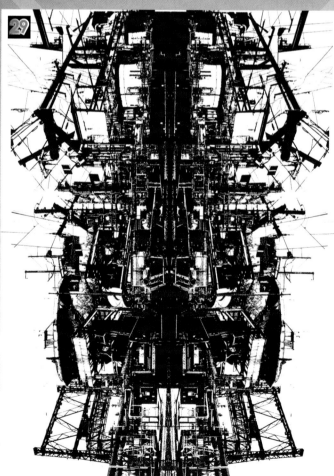

30 "Try to find time to read, listen to music, watch movies and do sport. I spend so much time in front of the computer that I need to give my eyes, mind and spirit a break from time to time."

Catalina Estrada, illustrator and designer for print, fashion items and consumer goods
catalinaestrada.com

31 "I favour roaming antiques markets for the aesthetics encoded within their archaeology. It's there I find the DNA that shapes my work and where I picked out the trembling chromosomes that determined the shape of my current body of work, *Animalia*."

Mauricio Ortiz, painter and winner of Shelter's House of Cards competition
mauritium.com

32 "If in doubt, turn your work upside down, flip it, watch it in a mirror, play it backwards – anything to get a fresh perspective. Then you'll notice all the faults. As a last resort, show your mum. She'll spot the flaws immediately, but it won't be pretty."

Ubik, directing duo, BTACA winners (best animation in a commercial) for *3650*
ubik.tv

33 "I sometimes walk the streets for hours, sketching and taking photographs. Getting lost in the city can be a great thing. I often get off the Tube at a random station to see what I can find. I stumbled across a fair in south London one day and took a picture, returned to the studio the same day and was inspired to create the accompanying illustration."

Jimmy Turrell, graphic artist, art director for the *Guardian* at Glastonbury 2009
jimmyturrell.com

34 "Loosen up with the oldest exercise in the world: drawing a nude model. Make it new by doing it on a tablet in Photoshop. If the legs look too short, try 'perspective' to make them longer; if the colour is too drab, bump it up in layers. No mess, no mistakes! And if you're timid, try it first with a mirror, in the privacy of your own home!"

Jan Pienkowski, artist, pop-up book pioneer and creator of *Meg & Mog*
janpienkowski.com

29 "The capacity to endlessly experiment with Illustrator is fantastic. You can start with an outlined letter and apply all manner of functions to see what happens. Duplicate combinations of tools to create unusual patterns, scatters and vortexes. Have no expectations or plan – just slice, dice, duplicate, stretch and repeat, and the results may surprise."

Seldon Hunt, designer, and cover artist for *ISIS* and *Kid 606*
seldonhunt.com

20 tips for better art in Photoshop

Photoshop gurus Mark Mayers and Fabio Sasso reveal 20 techniques that will make you a better artist

Alongside our in-depth guides to creative techniques in Photoshop, here are 20 quick tips that will help you produce even better artwork in this enormously powerful application.

Photoshop includes a huge number of tools, and here we expose some of its less well-known features and reveal new ways to use some familiar favourites. Some will help you achieve results faster – so you can concentrate on fine-tuning your compositions – while others unlock the possibilities of what can be achieved in Adobe's flagship tool.

Many of these tips will work in Photoshop CS or later – though some require newer versions. We've noted these in the tips concerned.

1 Brush up on clouds

The best way to create realistic clouds in Photoshop using brushes is to select the Texture tab in the Brushes panel (**F5**), then, for the pattern, use Clouds 128x128 (it's in the predefined list named 'Patterns'). Also make the Scale much bigger than the brush size and use Color Burn for the blending mode.

2 Lighten up

To create a streaming light-ray effect, use the Gradient Tool: in the Gradient Editor, set the Gradient Type to Noise with 100% roughness, then use the Angle Gradient.

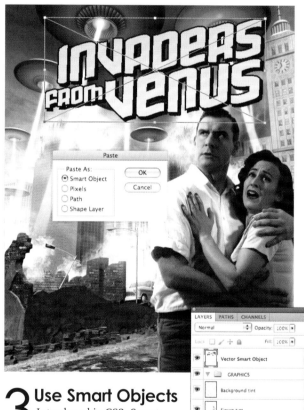

3 Use Smart Objects

Introduced in CS2, Smart Objects are layers that can be edited on-the-fly simply by double-clicking their layer icon. Once changes have been saved, the objects update automatically along with any duplicates (or instances). To paste artwork from Illustrator as a Smart Object, check the relevant option.

4 Bitmap it

Convert images to Bitmap mode (**Image > Mode > Bitmap**) to create super-stylish halftone and woodcut effects. Colour images will need to be turned into greyscale first (**Image > Mode > Grayscale**).

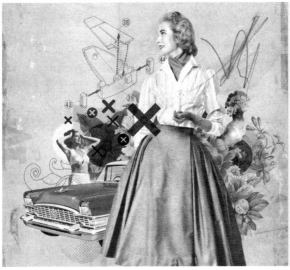

5 Be a better selector

Creating selections accurately is an essential Photoshop skill if you're going to perform tricky compositing tasks. The Refine Edge command and its cousin, Refine Mask (both introduced in CS5), make the process less tedious and enable you to extract difficult subjects – such as wispy hair.

6 Recycle it

We know it's important to recycle – and with one kind of retro sensibility or other always in vogue, why not do the same in your artwork by incorporating imagery from vintage magazines? They can often be picked up for next-to-nothing at car boot sales and junk shops.

7 Talk to your printer

When creating Photoshop files for screenprinting, talk to the printer for advice on the limitations of the process. It's good to find out where you might need to expand or contract areas to allow for slight misalignment when the garment is printed.

8 Use layer comps

Layer comps capture the state of the Layers panel and are a neat way to show clients variations of a design without having to save multiple documents. The other great feature is the ability to add annotations.

With layer comps you can show variations of a design to clients without having to save out multiple versions

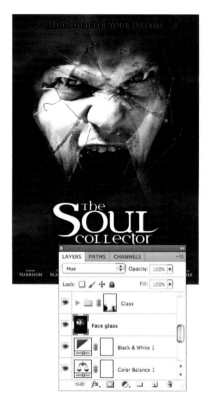

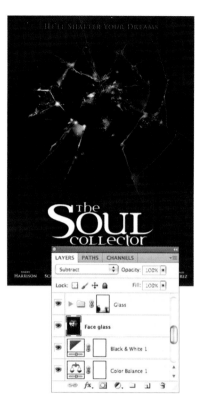

9 Glide between blends

To cycle quickly through layer blending modes, hit **Shift + +** or **Shift + -**. These shortcuts are great for previewing how overlaid textures interact, and they also work when painting with the Brush tool and when the Move tool is active.

11 Dodge it

The Color Dodge blending mode can be used for soft lighting effects, but applying it to elements that sit over black backgrounds won't elicit any results. Instead pick a background colour with a slight amount of red, green or blue to it.

10 Large formats can be low-res

Check with your printer when creating illustrations destined for large-format printing, such as exhibition graphics. One rule of thumb is to work at 400dpi in a document a quarter the physical size of the output. At actual size, therefore, the output will be at 100dpi, which is usually fine for the distance at which people will view it.

12 Burn it

Color Burn works in precisely the opposite way to Color Dodge. Use it to create a logo that looks like it was scorched into wood, for example.

Create textures with actual brushes, digitise them and blend to add a gritty look

13 Add real-world textures

Dig out those seldom-used paint brushes and create some textures on board or canvas. Digitise them and experiment with different blend modes to add a gritty, urban look to illustrations. Paint splashes can also be used to create your own personal library of grunge brushes.

14 Mesh it up

Create super cool mesh effects using **Transform > Warp**, and then selecting Fisheye from the Options bar menu. The example was created by Fabio for *msnbc.com*.

15 Glow with success

An easy way to add a glow effect is to create a layer with all other layers merged into it (see **18**). Now apply a Radial Blur of 10-20 pixels and the Screen blending mode. Drop the opacity to 15%, then raise it until you get the desired effect.

16 Work in depth

Even if you don't have the Extended versions of Photoshop, you can still incorporate renders from 3D applications. Most of them can output separate channels, which you can use as masks to make selective adjustments. Some 3D programs can also render depth maps which Photoshop can apply to 2D images.

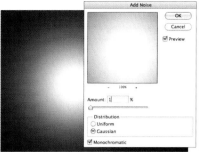

17 Noise is neat

It can be tough to achieve a silky smooth transition of shades when you work with subtle gradients – so apply a little Noise.

18 New layers from old

One handy shortcut that is less used than it could be is **Cmd/Ctrl + Alt + Shift + E** (CS3 or higher), which creates a new layer with all existing visible layers merged into it.

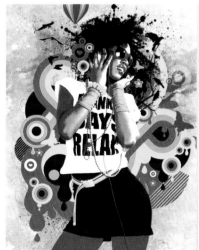

20 Channel your creativity

Channels are mostly used to store commonly used selections, but they can also hold information that is beyond the capabilities of four-colour printing, including metallic and fluorescent spot colours. With a little practice and patience, you can selectively add inks to the CMYK set to produce absolutely stunning effects. ■

19 Cloud the picture

Apply the Render Clouds filter as a mask to make your design less uniform.

A little noise will smooth transitions in very subtle gradients

> **DOWNLOAD** A NEW WAY TO GET YOUR HANDS ON YOUR FAVOURITE TITLES

Read our magazines on your iPad

Enjoy your favourite magazines on your iPad, tablet, Mac, PC and iPhone with
our amazing digital editions from Zinio

You can now read all your
favourite magazines on your
tablet, phone or computer –
including Apple's iPad and iPhone.

At the Zinio UK store at *gb.zinio.
com* you'll find digital versions of
great magazines like *Digital Arts*, *iPad
& iPhone User*, *Macworld*, and *PC
Advisor* – as well as other titles such as
the *NME*, *InStyle* and *Men's Health*.

Each title contains exactly the
same material as appears in the print
version – with a saving of over 20 per
cent on the newsstand price. The
great thing about reading digital
editions on your iPad or Mac is that
it's quick and easy to search through
for the content you are most
interested in, and it's the only feasible
way to carry a whole library of
magazines around with you.

Get ready to join the new digital
magazine revolution – it's easier
than you think!

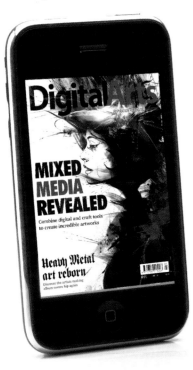

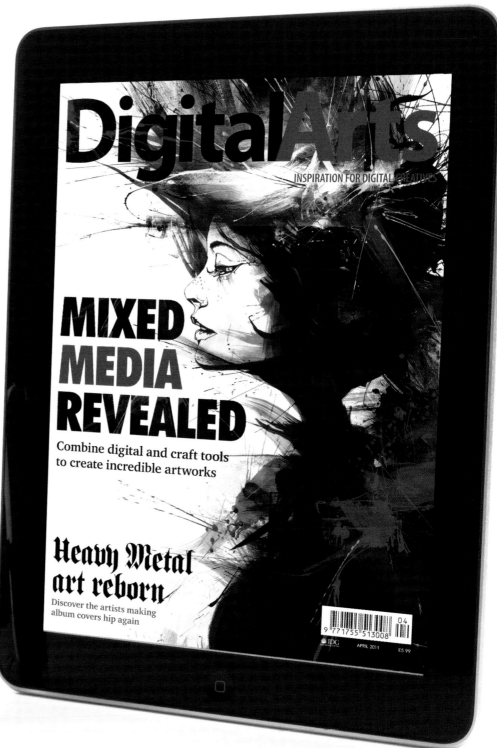

Join the digital revolution at
digitalartsonline.co.uk/zinio

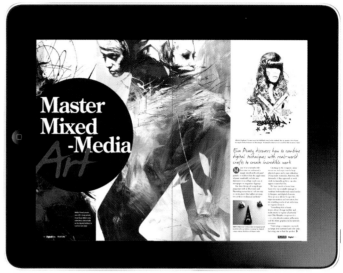

01 There are two ways to buy magazines for your device or computer. Visit the Zinio store at *gb.zinio.com/magazines* on your Mac or PC, or install the free Zinio app on your iPad and tap Shop. Once the app is installed you will be able to browse the store for magazines, purchase and download them.

02 Reading magazines on the iPad is great: you can zoom in and out of the text using a pinch gesture, and flick left and right between pages. You can also click on web links from within the magazine to read the content of the website inside the magazine. Tap Close to return to the magazine.

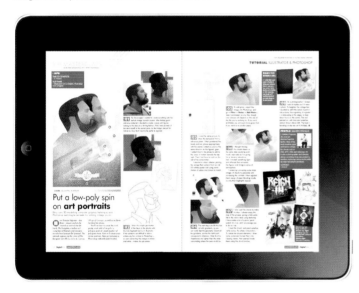

03 You can view each page individually – or turn your iPad landscape to view each spread in turn. This is especially good for tutorials and step-by-step guides, where you can quickly zoom in and out of each step by double-tapping on the text.

04 There are many ways to browse the magazine: you can tap underlined linked text to take you straight to a particular section; you can scroll through thumbnail pages by tapping the bottom of the screen; or you can flick through pages by swiping your finger.

macworld.co.uk/zinio *digitalartsonline.co.uk/zinio* *ipadiphoneuser.co.uk/zinio* *pcadvisor.co.uk/zinio*

DOWNLOAD ZONE

VIDEO TRAINING, STOCK IMAGES AND PROJECT FILES FOR OUR TUTORIALS

> **DOWNLOAD** GOODIES JUST FOR YOU

Free resources on the Download Zone

Get your hands on over £750 of images and video training for Adobe Photoshop – plus the files you need to complete our Masterclass tutorials

The Download Zone is a fantastic online source of additional content for buyers of *The Artist's Guide to Photoshop*. It provides instant access to video tutorials, images and project files for the tutorials from wherever you are.

The Download Zone includes more content than could fit on a CD or DVD – so we can bring you over 80 minutes of video training, 50 high-resolution stock images and an abundance of tutorial project files, without having to leave anything out.

To obtain this exclusive content, visit *theartistsguide.co.uk/downloads*

EXPERT VIDEO TUTORIALS

> The Download Zone includes a full set of Photoshop video tutorials from the Learn by Video series. Presented by expert trainers, the lessons are wrapped in an interface that lets you jump to any topic and bookmark individual sections for later review. To use the software, enter the code **PSHOP2BRAIN**. The project files used in the lessons are included. *pearson-books.com/lbv*

PROJECT FILES FOR OUR MASTERCLASSES

> The Download Zone includes files to help you complete our tutorials, helpfully divided by chapter and topic.

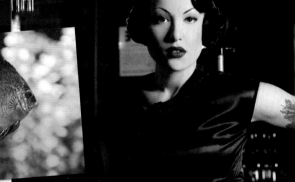

50 STOCK IMAGES FROM photosto *Go* WORTH £750!

> *The Artist's Guide to Photoshop* has teamed up with top stock image library Photos To Go to bring you a full collection of amazing high-res photos that you can use in your commercial projects.

Here you'll find a wealth of incredible images from stunning portraits to abstract textures. They are all around 3,000 x 2,500 pixel in sizes.

To download these files you will need this code: **AGPHOTO11**.

Photos To Go is the brand new resource for cost-conscious image buyers. The site has thousands of images, available from 2p each. *photostogo.uk.com*

To get your hands on this incredible content, go to
theartistsguide.co.uk/downloads

THE ARTIST'S GUIDE TO
PHOTOSHOP
The ultimate tutorial collection

Get creative with a wealth of incredible tutorials for Photoshop. Learn amazing techniques step-by-step as the world's best artists reveal the secrets of their best work – so you can produce yours. Brought to you by the team behind **Digital**Arts magazine, this special edition gives you exciting tips and tricks across a huge range of styles including photomontage, illustration, painting and graphics.

The tutorials are accompanied by a wealth of project files – plus 50 fantastic stock images and video training. These can all be accessed from our Download Zone wherever you are and whenever you want.

MASTER THESE TECHNIQUES

LIGHTING & TEXTURE EFFECTS

LAYERS & BLENDING MODES

DIGITAL PAINTING TECHNIQUES

NEW SPINS ON CLASSIC EFFECTS

USE PHOTOSHOP WITH ILLUSTRATOR

Free with this edition
- Photoshop video tutorials
- 50 pro-quality stock images
- Over 100 project files

IDG
COMMUNICATIONS

new success

Pre-Intermediate
Students' Book

with Active Book

A2–B1

eBOOK

Stuart McKinlay
Bob Hastings

ALWAYS LEARNING

PEARSON